The Art of Co

Penelope Jackson

The Art of Copying Art

palgrave
macmillan

Penelope Jackson
Tauranga, New Zealand

ISBN 978-3-030-88917-3 ISBN 978-3-030-88915-9 (eBook)
https://doi.org/10.1007/978-3-030-88915-9

This Palgrave Macmillan imprint is published by the registered company Springer Nature
Switzerland AG.
The registered company address is: Gewerbestrasse 11, 6330 Cham, Switzerland

For my creative sisters, Amanda and Eleanor.

Preface

Copying has existed simultaneously alongside the creation of authentic art since the earliest artists set to work. Copies have enjoyed a different status from authentic artworks and though often acknowledged, very rarely have they been considered collectively as a genre in their own right. My objective is to showcase the variety of examples, examine the motivations for making copies, and reflect on the reception of copies. Spoilt for choice, I chose examples that I have a personal connection with or ones that are considered both significant and topical. Copies fill voids in collections and are very much part of any art history. Readers will know of more examples of copies than discussed here and ultimately I hope they will interrogate them to ascertain a copy's role, its quality and, lastly, if viewing a copy changes their experience and perception of an artwork.

Tauranga, New Zealand

Penelope Jackson

ACKNOWLEDGEMENTS

I am grateful to the following people for their assistance during the course of my research and writing. Many others are cited within the text. Direct contact and assistance came from: Janet Abbott (Christchurch Art Gallery Te Puna o Waiwhetū), Melissa Ashley, Erica Atkins (Olveston, Dunedin), Arik Bartelmus (Dahesh Museum of Art, New York), Anna Beazley (Auckland War Memorial Museum), Charlotte Bolland (National Portrait Gallery, London), Fiona Brown (Western Australia Museum, Perth), Alex Buck (Royal Collection Trust), Tracy Chevalier, Loren Culver (Norton Art Gallery, Los Angeles), Sarah Crouch (Nottingham Central Library), Jon Culverhouse (Burghley House, Stamford, England), Tim Carpenter (Defence Academy of the United Kingdom), Suzie Davies (Production Design, England), Ann Dinsdale (Brontë Parsonage, England), Lynley Dodd, Louise Dunning (Nottingham City Museums and Galleries, England), Patricia Durdikova (Cheffins Fine Art, England), Anne Gerard-Austin (Art Gallery of New South Wales, Australia), Euan Gray (Dreambox, New Zealand), Andrew Gregg (The Elms, New Zealand), Sarah Hillary (Auckland Art Gallery Toi o Tāmaki, New Zealand), Helen Hillyard (Dulwich Picture Gallery, London), Erica E. Hirshler (Museum of Fine Arts, Boston), Eileen Hudson (Nottingham City Museums and Galleries, England), Emma Jameson (Auckland Art Gallery Toi o Tāmaki, New Zealand), Tim Jones (Christchurch Art Gallery Te Puna o Waiwhetū, New Zealand), Isabelle Kent (University of Cambridge), Mary Kisler, Jacqueline Lee (National Library Board, Singapore), Shujuan Lim (National Gallery Singapore), Elizabeth Lorimer (Auckland War Memorial Museum), Andrew Loukes (Petworth House, West Sussex), Caroline McBride

(Auckland Art Gallery Toi o Tāmaki, New Zealand), Melinda McCurdy (The Huntington, California), Holly Macgregor (Sotheby's, London), Reiner Maisch (Albrecht Dürer House, Nuremberg), Sophie Matthiesson (Auckland Art Gallery Toi o Tāmaki), Goh Yu Mei (National Library Singapore), Teo Hui Min (National Gallery Singapore), Emma Milnes (Zoological Society of London), Laura Noble (National Gallery Research Centre, London), Adam Partridge (Partridge Antiques, England), Andy Paterson (Sympathetic Ink Ltd), Peter Raissis (Art Gallery of New South Wales, Australia), Marion Richards (Art UK), Eric Riddler (Art Gallery of New South Wales, Australia), Neil Roberts, Luisella Romeo, Beckett Rozenthals (National Gallery of Victoria, Melbourne), Elisabetta Sacconi (Ufficio Turismo-Commune di Castelnuovo Magra, Italy), Alison Smith (National Portrait Gallery, London), Nicholas Smith (National Gallery, London), John Shaw (St Michael's Church, Remuera, Auckland, New Zealand), Ann Sylph (Zoological Society of London), Jennifer Taylor Moore (Sarjeant Gallery Te Whare o Rehua Whanganui, Whanganui, New Zealand), Letizia Treves (National Gallery, London), Rachel Turnbull (English Heritage, London), Todd van Hulzen (Todd van Hulzen Design), Stephen Whittle (The Atkinson, Southport, England), Susan Wilson, Jenny Wood (Central Library and Archives, Halifax, England) and Robin Woodward (University of Auckland, New Zealand).

With thanks to Creative New Zealand and the Michael King Writers Centre, Devonport, Auckland, New Zealand.

Thank you to the team at Palgrave Macmillan, Lina Aboujieb, Imogen Higgins, Poppy Hull and Emily Wood, for their ongoing interest, patience and editing.

A special thank you to New Zealand artist Heather Straka who kindly let me use an image of her exhibition, 'The Asian', for the cover.

Thank you to Noah Charney and Arthur Tompkins for their wonderful endorsements of my book. I couldn't have wished for better praise!

And last, but not least, thank you to my family who continue to encourage me in my pursuit of writing about art.

Author Note

I have endeavoured to fairly represent the artists, dealers, galleries, museums, collectors, professionals, and others involved in matters written about in this book, and to seek permission where possible for use of sensitive content. In some cases, the person or organisation did not wish to engage in a dialogue or was deceased.

A Note About Currencies

Currencies have been given in the country that the crime/event took place or in the currency where the media report was filed.

A Note About Measurements

All measurements are given height before width.

Cover Image

Installation of Heather Straka's exhibition 'The Asian' at Dunedin Public Art Gallery, New Zealand, in 2010. (Photo: Bill Nichol).

CONTENTS

About the Author

Penelope Jackson is an art historian and curator. A former gallery director, Jackson is a founding trustee, and current chair, of the New Zealand Art Crime Research Trust. She is the author of *Art Thieves, Fakers & Fraudsters: The New Zealand Story* (2016), *Females in the Frame: Women, Art, and Crime* (2019) and has contributed to *Art Crime and its Prevention* (2016) and regularly contributed to *The Journal of Art Crime*. Jackson has curated major exhibitions, including: award-winning 'Corrugations: The Art of Jeff Thomson' (2013), 'The Lynley Dodd Story' (2015), 'An Empty Frame: Crimes of Art in New Zealand' (2016) and 'Katherine Mansfield: A Portrait' (2018). In 2020, she was the recipient of a University of Auckland/Michael King Writers Centre Residency. Jackson is based in New Zealand and also enjoys writing short fiction.

LIST OF FIGURES

Limitations of space prevent each work discussed being illustrated. However, the ones that are not reproduced here are easily accessed on the Internet.

Introduction: A Case for Copies

As a teacher of classical studies at a regional New Zealand state secondary school during the 1980s I faced a major challenge – the lack of access to original artefacts dating from the Greek and Roman period of history. The closest experience for my students was a day trip to the Auckland War Memorial Museum, where there were a few Greek vases, fragments of domestic ware, and the trump card – plaster casts of antique sculptures, the most imposing being the *Death of Laocoön and His Sons*. With a height of 2.22 metres, and positioned at the time on a stairway landing, the monumental Hellenistic sculpture of a group of writhing muscle-bound men and snakes, gives the Pacific viewer – and a teenage one at that – little insight into the world in which it was made. In lieu of the marble finish of the original, Auckland's copy has a smooth plaster finish, over-painted in glossy white paint, giving it an odd flattish finish, devoid of texture and colour as seen in the original at the Vatican. Unfortunately, something is lost in translation between the original and the copy made centuries later, or is this perception arrived at because we know they are copies? But arguably for my students, experiencing a copy was better than experiencing nothing at all.

Plaster copies of antique sculptures can be found throughout the Southern Hemisphere; for decades, students at art schools spent at least a year of their undergraduate fine arts education studying and making drawings of plaster cast copies. This was a prerequisite for drawing from life. Their European counterparts were more fortunate, having access to the great sculpture halls in museums and public art galleries. Furthermore

© The Author(s), under exclusive license to Springer Nature Switzerland AG 2022
P. Jackson, *The Art of Copying Art*,
https://doi.org/10.1007/978-3-030-88915-9_1

European historic homes, especially those that collected avidly during the Neo-Classical era, often had superb examples of both original and copies of sculptures. Added to this is the complexity of generations of copies; in other words, copies of copies and how much of the original might change during the process of it being made. This can be complex to measure; yet surely the original artist's intent and delivery is lost especially when size and materials are adjusted, or completely changed, from the original. Or, if the copyist is working from a drawing or a photograph, a degree of detail may well be misinterpreted or altered altogether.

In short, there are four basic premises about copying:

1 A copy is the replication of an image by the original artist or by another
2 Copying has historically been used as a tool for students and emerging artists to learn about process and technique
3 Copying an artwork is legal
4 Copies (or works in the style of an artist) become forgeries when the intent is to deliberately defraud

There are many different kinds of copying and often the correct term is not assigned correctly to an item or process – all copies being lumped together, regardless of agenda, motive and intent. Copying can have negative connotations, but there are many positives to be championed, of which many examples will be showcased in this book. Copying comes in many forms and is produced for many different objectives. Process and intent vary greatly. To demonstrate the wide range of copies, here are three cases showcasing different kinds, and motivations, of copying.

The first one is found in Norwegian crime writer Jo Nesbø's book *Headhunters*. Nesbø's protagonist, the art thief Roger Brown, steals to support his extravagant lifestyle. He helps himself to an Edvard Munch (1863–1944) lithograph, swapping it out with a copy he's printed at home. It took just four minutes to execute the swap.[1] Okay, so this is fiction but the truth is that the technology for making copies is advancing all the time and that Brown's actions are totally feasible and realistic. In fact, in mid-2021 a report emerged from Italy stating that 120 original artworks, owned and displayed at the office of public broadcaster RAI (Radiotelevisione Italiana), had been found to be copies. Original etchings by artists such as Monet, Sisley and Modigliani had been switched out of their frames and replaced with copies. Clearly, the copies were convincing

as some of them had been on display since the 1970s without anyone twigging to their lack of authenticity.

The second copy is located in the Australian town of Ballarat. A large painting, titled *Ballarat*, hangs in a prominent position in the public art gallery.[2] Painted by the English artist James Edwin Meadows (1828–1888), the work depicts the town from a bird's-eye view. Meadows never visited Australia, let alone flew above the burgeoning town that was built quite literally on the proceeds of gold mining. Meadows copied an engraving made by Samuel Calvert (1828–1913) for inclusion in the *Illustrated Australian News* on 11 June 1884. Calvert's work was not completely authentic either for he'd copied a drawing by another artist, A. C. Cooke (1836–1902). In effect, Meadows' interpretation is from a copy of an original drawing; though Meadows' painting is original in a physical sense, its content is not. It is a third generation image of the same scene.

There's another way of looking at *Ballarat*; given it was made by hand, and not a commercial reproduction, it could therefore be considered original. Plus there are no other paintings the same, or similar. Therefore, is it a copy? Perhaps a better way to catalogue *Ballarat* is to think of it as an interpretation, or an appropriation, of someone else's image. In other words, the idea behind the image wasn't Meadows' but the way it is presented was. This is why copying – both the process and labelling – is complex. Meadows' intent was to celebrate and record the thriving town and, interestingly, a British artist was commissioned to undertake the task rather than an Australian, though he relied heavily on Calvert and Cooke who both resided in Australia. Today the painting, which hangs proudly in the town's public art gallery, is incredibly useful as an historical reference especially for the layout of the town and is early architecture.

The third example is located at the Louvre, or rather the original is. You could choose almost any work on display at the Louvre and someone at some stage will have copied it. Randomly, I've chosen *La cruche casseé*, by French painter Jean-Baptiste Greuze (1725–1805), dating from 1771. As the title suggests, *La cruche casseé* (*The Broken Pitcher*) depicts a beautiful young woman carrying a broken pitcher, the contents of which she has hastily gathered in her ruched-up skirt. The subject matter alludes to the loss of her virginity. A quick Internet search reveals several copies worldwide – some are very good, others not so good. Most copies are labelled 'after' or 'copy'. However, one that came up for auction in March 2021 was labelled 'Manner of Jean-Baptiste Greuze'. Such labelling is an oddity given it is clearly a copy of Greuze's original painting, but it does highlight

the different labels associated with copies. *La cruche casseé* was popular with copyists in the nineteenth century; between 1893 and 1903 there were 259 copyists registered to copy *La cruche casseé*, while Jean Massard (1740–1822) and Alfred Revel (d.1865) both made an etching of the painting and these regularly come up for sale. Certainly Greuze's painting was popularised because it was copied. Like many paintings at the Louvre, *La cruche casseé* was copied by emerging artists, including James McNeill Whistler (1834–1903), as a way to learn the craft of painting. Copying in this context was very much about honing one's painting skills. However, if one of these copies was sold as an authentic Greuze then that is a very different story. There's another aspect to looking at the history of copies made of a particular artwork used for copying, and that is an indicator of taste and fashion. As noted, Greuze's *La cruche casseé* was particularly popular during the late nineteenth/early twentieth centuries. This is basic supply and demand indicating taste. Twenty years later, tastes changed dramatically from Greuze's sentimental academic style.

This book goes some way to showcase not only the breadth and depth of the topic of copying, but also that since humans began making art they have also copied and yet copying is not captured in mainstream art history narratives. It used to be that no copy was the same as the next. Technological advancements have assisted in curtailing this nuance. Each chapter of this book interrogates copying in relation to the motivation and intent for making copies. Case studies have been selected on the grounds of being good examples to illustrate these motivations. There are, however, endless examples and readers will know of, perhaps even own, many others.

As suggested, my interest in copying was piqued by living in New Zealand, as well as making regular visits to Australia. Copies are plentiful 'down under'.[3] On one level, this is due to our history of being nations at the edge of the empire. We are now proud Pacific nations who continue to forge our country's identities, including our indigenous cultures. However, our European history includes copies in public and private collections, churches, government buildings, educational facilities, and so on. Some copies have been stored as long as records exist, and have been superseded by authentic original works, are in bad condition, or are an embarrassment since they reflect colonial attitudes to collecting. But copies of art are part of our history and, more specifically, our art history and visual culture. This study looks at copying as a collective, as a genre in its own right.

Copying is a generic overarching term. There are many types of copies and these can be broken down into: legitimate copies, replicas, editions, and handmade prints after an original such as etchings and engravings, knockoffs, commercial reproductions and facsimiles. The various categories are often used interchangeably, incorrectly and ad hoc. At times, the term copy is used to describe a fake or a forgery. This can be deliberate on the seller's behalf for copy sounds better and has more positive and legitimate connotations, especially when compared with such fraudulent terms. Each type of copy represents a different kind of process, intent and motivation. For the sake of clarity, a copy is not an original work of art. It is made after another artwork; in other words, the concept of the image and the process of making it is not that of the copyist. The copyist borrows everything about the image from the original authenticated artist. Copyists will also make slight alterations, especially when it comes to size or media. Some will see the art of making a copy as a form of flattery to the original artist. In fact, economists Françoise Benhamou and Victor Ginsburgh have gone as far to say: 'A work that does not inspire copies is a dead work.'[4] In some instances, copies are used deceitfully; in others, they replace works that are not accessible or are too vulnerable to exhibit.

Copies should not be confused with fakes or forgeries. A fake is something pretending to be what it is not. For instance, fake lawn looks like lawn and has the same function, but it is not lawn in the natural sense of the term or object. Generally speaking, fake art is not made to deceive but it does have the ability to, especially if an amount of time has lapsed since its making and/or information pertaining to its history is lost. Fraudulent art is made with the intent to deceive. The act of trading a forgery, the object, is fraudulent and therefore illegal.

For the most part, my focus here deals with paintings and sculptures to illustrate the motivations for copying. Printmaking is discussed only when it relates to these cases. However, I have not looked at printmaking singularly as an art form as that deserves a book in its own right. In short, however, an artist who makes a limited numbered edition screen-print, for instance, is making original works of art. Historically, printing plates for etchings and engravings were sometimes passed into the hands of another artist, both legitimately and fraudulently. The history of printmaking is layered with copying of different forms. In some cases artists oversaw, and still do, others actually doing the printing. This too is considered original. However, there are multiple cases where prints are made fraudulently. Take, for example, New Zealand artist Dick Frizzell (b.1943), who is

constantly on the lookout for 'knock offs' of his prints. In 2016 his prints appeared on an online auction platform for sale. They were not his work, but rather came from a con artist who photographed the original print and then had it copied onto photography paper. Fortunately for Frizzell, the name of the printer was on the back of the work, making it easy to track down the seller.[5] Fraud aside, the would-be buyer had viewed a digital image of a print of a photograph of an original print. Even with good technology something of the original has to be lost in translation here. In a contemporary context we are more attuned to this kind of behaviour. However, historically plates of etchings and engravings were sold, and re-worked. When printed with alterations made to the original plates, these are known and numbered as a 'state'. Take Rembrandt van Rijn's (1606–1669) most celebrated etching, the *Hundred Guilder Print* of 1647–9. The image depicting scenes from the Gospel of Matthew: 19, has several other names, including *Christ Preaching* and *Christ Healing the Sick*, but became known as the *Hundred Guilder Print* for, as the legend goes, that's how much Rembrandt had to pay to purchase one of his prints back. Rembrandt made two states of his work and then in 1775 Irish printmaker William Baille (1723–1810) acquired Rembrandt's copper plate and printed 100 impressions from it. They can be found in collections around the world and are accepted as the third state of Rembrandt's groundbreaking work; stylistically and technically, the *Hundred Guilder Print* has been likened to his painting *The Night Watch* in terms of its influence and significance. Baille went on to cut the copper plate into four, and print and sell them as separate works. And we might ask if, by making four separate works, they should be considered as originals?

Before leaving Rembrandt and printmaking, I want to mention one more type of copying: the counterproof. In 1641 Rembrandt made an etching titled *The Windmill* (which interestingly also cost 100 guilders in his time). It depicts the Little Stink Mill with an adjacent dilapidated cottage on the outskirts of western Amsterdam. In the centuries that followed, Rembrandt's original copper plate was reworked by others; it was legitimately countersigned by the later artists who were well known for their reprints. However, in New Zealand's national museum there is a copy of *The Windmill* that was reworked by the Smith brothers of Chichester, England, to be included in an eighteenth-century art book that was acquired by New Zealand's former Dominion Museum in 1910.[6] However, at some stage plate marks were added to *The Windmill* as can only be assumed in an effort to sell it as an original Rembrandt.[7] A

counterproof print is made from taking an impression off a wet print; to do this you have to have an etched plate, which is usually made after the original. Given it is easier to copy the image directly onto the plate this means that when printed it prints in reverse. In turn, the counterproof is the original way around. In this instance, *The Windmill* looks to be original as the plate's indention on the paper is visible. However, there are tricks to mimic a plate's impression. If the counterproof is put back through the press with a blank copper plate, an indentation will be forced into the paper. Alternatively, a line can be scored around the edge of the image to mirror a plate mark. Counterproofs are usually lighter in tone too given the reliance on reusing ink off the first print. The counterproof is yet another kind of copy, albeit with a different motivation behind its production. In 2016 auctioneers Christie's offered one of Rembrandt's *The Windmill*; it sold for £98,500, confirming, as always, that Rembrandt's work is highly valuable (and therefore of interest to the forger).[8] This example, and those discussed above, goes some way to demonstrate the complexities around printmaking and copies of prints. Rembrandt, and Albrecht Dürer (1471–1528) two centuries earlier, were trailblazers when it came to intaglio printmaking and now art history has shown that their oeuvres are the most copied of all artists.

As a subject the art of copying prints has been studied and publicised through such exhibitions as 'The Art of Copying: Copycat' at The Clark Art Institute in 2014, where the focus was very much on technical and interpretative skills rather than originality.[9] In the exhibition an example from Dürer's *The Life of the Virgin* was shown next to Marcantonio Raimondi's (1480–c.1534) copy of the same image. *The Life of the Virgin* (1502) consists of 19 woodcuts and a frontispiece. It was an instant sellout success for Dürer. Raimondi acquired a set and copied them in the form of etchings. In 1506 he had Dal Jesus – a family-run printing house – to print them. Raimondi's copies were good, which was no mean feat given he was translating woodcuts into etchings. In fact, they were so good that Dürer only realised they were fake copies when he spotted Raimondi's own monogram secreted within the compositions. He'd kept Dürer's famous AD monogram too. Dürer brought legal proceedings against Raimondi:

> The Venetian court ruled that Raimondi wasn't at fault for being such a skilled artist that buyers mistook his work for Dürer's and told Dürer he

should be flattered that such artists wanted to copy his work. The German master was unimpressed with the court's decision.[10]

In fact it was this case that is seen as a pioneer in issues of artistic copyright and intellectual property. However, Raimondi didn't stop copying the work of others; he was banned from using the AD monogram – though not from making Dürer reproductions altogether. Unrelatedly, in 1526 Pope Clement VII had Raimondi imprisoned for his work *I Modi* (*The Positions*), which was an illustrated pornographic manual of sexual positions. Perhaps this was some kind of comeuppance for breaching copyright!

Relatively speaking, copying was accepted up until the eighteenth century, when the idea of copyright was formalised and introduced. The Statute of Anne (1709–10) was initially introduced to protect writers against others copying their publications but soon it became apparent that artists too needed protection from those stealing their original artistic ideas. The great British artist William Hogarth (1697–1764) became fed up with others making inferior copies of his images and selling them. By this time newly developed techniques for making engravings meant that copying was cheap and easy. Hogarth lobbied Parliament for the protection of artists' rights and in 1735 the Copyright Act, colloquially known as the Hogarth Act, was passed. Copyright law is complex but essentially an artist, as a matter of right, has copyright over their original work. Copyright is the automatic right to protection against infringement. However, in America, for example, artists are also encouraged to register their works with the United States Copyright Office. The original artist also has the right to make copies, or adaptations, of their own work (think, for instance, of Raphael's (1483–1520) two *Virgin of the Rocks* – the Louvre version painted in 1483–6 and London's National Gallery one dating from 1495–1508). The length of copyright differs from country to country; in the United Kingdom copyright lasts for 70 years after the artist's death whereas in New Zealand it is 50 years.

There is certainly a role for copies – as demonstrated with my opening example of *The Death of Laocoön and His Sons*. Not all copies should be written off as bad or as an insult to the original artist. Indeed, copying in some contexts is seen as flattery. If we took the attitude that copies are bad, then we would have to discount the monks of the Middle Ages for they copied the Gospels. Admittedly, they added their own personal touches, but fundamentally they copied. Technology put a stop to this practice, with the printing press revolutionising the written word and the

image in the fifteenth century. However, the printing press went on to create copies of a different variety, a form of expression that is continued in contemporary society through high-quality commercial prints.

As copies can be and are often passed off as authentic, they also play a place in the world of art crime. This fraudulent practice is a thorn in the side of the art world. As copying becomes more sophisticated – as does, fortuitously, the ways of detecting copies – there is big money to be made from selling copies under false pretences. Only some such sellers get caught, as in 2006 when Tatiana Khan, a West Hollywood art dealer, sold a Pablo Picasso (1881–1973) pastel drawing titled *The Woman in the Blue Hat* (*La Femme Au Chapeau Bleu*) (1902) to Victor Sands for USD 2 million (see Chap. 9 for more about Tatiana Khan). The quantity of fraudulent sales practice is impossible to measure with any accuracy.

Today, copying is big business; those who desire a Claude Monet (1840–1926) or a Rembrandt can simply order a copy online from Dafen, China (or rather an 'original copy', as a headline read in *Artforum* magazine).[11] A copy will be painted – to your size specification – and couriered to you anywhere in the world. It is cheap and easy. The purist art collector does not support this practice, but ultimately it means that people are engaging with art and purchasing images they want to see on a regular basis, which perhaps should not be scoffed at.

There is an element of snobbery when it comes to original versus copy. We are conditioned to admire and value the original over the copy. Art is meant to be unique and, therefore, original. Sadly, it comes down to value, in a monetary sense. Monetary value is also a moveable feast; a 1998 exhibition in Paris made it clear that Vincent Van Gogh's (1853–1890) copies of Jean-François Millet's (1814–1875) works were possibly more valuable than the Millet's originals. Millet was influential in the nineteenth century, but Van Gogh is an artistic global superstar. An artwork's value can plummet if it is found to be a copy or fake; a case in point is Gottfried Lindauer's (1839–1926) *Portrait of Kewene Te Haho*, which went from NZD 121,000 in 2001 to a fair-value market insurance value of NZD 5000 in 2016 (see Chap. 6: Copies in Public Collections for more about this portrait). In reverse, if a copy is discovered to be an original, the value can change astronomically. Raphael's wee painting *Madonna of the Pinks* (*'La Madonna dei Garofani'*) (c.1506–7)[12] is a great example; in 1991, with a status of being a copy, it was worth an estimated £8000.[13] In 2004, after it was confirmed to be an authentic Raphael, London's National Gallery acquired it for £22,000 (and substantial tax advantages for the seller, the Duke of Northumberland).[14] Since its acquisition, *Madonna of*

the Pinks has regularly been exhibited including featuring in 'Close Examination: Fakes, Mistakes and Discoveries', an exhibition about artworks in the National Gallery's collection whose status has changed or altered in some way. At the time, this 2010 exhibition was heralded as a first of its kind in bringing scientists, conservators and art historians together.

The art of copying should be viewed as an alternative prong of Western art history; at the very least, it needs to be acknowledged more than it has been in mainstream art history. It should be written into the discourses, for copies have played, and continue to play, a vital role in the art world – private, public and commercial. This is not always the objective for making a copy. This book explores the various motivations for making and the reception they receive. Without copies our art history would be very different for information about art can and has been lost over time. As cultural historian Hillel Schwartz suggested:

> We use copies to certify originals, originals to certify copies, then we stand bewildered.[15]

In other words, there is a place for both originals and copies.

For me, the motivation and intent of the copyist is integral to any study about copying. This is the premise for how this book is organised. Chapter 2 scopes the artist apprentice and how over time the student artist has learnt by copying works worthy of hanging in public spaces. Colonial collections contain many copies, and that is the subject of Chap. 3. Much can be gleaned from studying paintings of interiors that showcase collections of art. In Chap. 4, several examples of paintings-within-paintings are discussed including how they are a useful resource to the contemporary art historian. Chapter 5 explores how copies are used for educational purposes, especially in exhibitions and displays, and examines how copies are made and used as props for movie sets. Copies have infiltrated collections and Chap. 6 looks at case studies of what, how, and why copies have been collected globally. Copies can have a positive role especially when it comes to the safekeeping of vulnerable artworks. Chapter 7 scopes the role and intent of protecting the past for future generations. Chapter 8 looks at how money can be made from the trading of copies. I've titled my conclusion, 'Separating the Wheat from the Chaff' to capture the enormity of the topic; copying has a long and varied history. Authenticity is at the core of how we measure an artwork's worth. But value is not only defined by originality.

In my opinion, the art of copying art deserves its own place in art history. It should be taken more seriously and positioned as a genre in its own right. Copying has been the subject, or theme, for exhibitions that have explored and pushed the boundaries of copying with strict objectives. The New Zealand artist Heather Straka (b.1972) based her 2009 exhibition

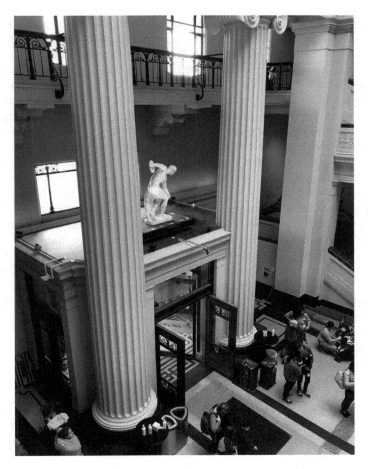

Fig. 1.1 Plaster of Paris copy of Myron's *Discobolus* (c.1878) above the front entrance of the Auckland War Memorial Museum in 2020. Collection of the Auckland War Memorial Museum. (Photo: Penelope Jackson)

'The Asian' on having 59 copies made of her original portrait of a 1920/30s Shanghai poster girl (see Fig. 1.1). Exhibited in three rows of 20, Straka's viewers were challenged to find her original work amongst the copies made by copy artists working at the Dafen Oil Painting Village in the Longgang District of Shenzen, China. In part, Straka's message was about mass production – of both the plastic *tiki* worn by her sitter and also her paintings.[16]

Worthy of attention, admittedly copying has historically and contemporaneously caused conjecture and confusion amongst collectors and thus is often viewed in a negative light. Evidence of copying gaining its own status can be seen in the Old Masters Copies auctions hosted by major auction houses such as Sotheby's and Christies. This goes some way to confirm, and assists in legitimising, a following for copies and thus an invitation to study it! On a personal level, researching the history of copying combines two of my art historical interests: art crime and the history of women artists (for many women made a living from producing copies). These are just two aspects explored, and there are many more. At times, researching copies, apart from during a global pandemic, was problematic. Many historical copies were acquired by institutions in a time prior to having good collection management practices in place. In other cases, copies have been deemed second-class and not received attention such as conservation or the research that they might deserve. And some copies have simply been lost over time. This book is not about judging the quality of copies; rather, it seeks to view them within the bigger picture of art history. Of course, sometimes we do not even know we are looking at a copy. As consumers, copies surround us; whether it is the replica chair we sit on, the tribute rock band we listen to, or Diana's facsimile wedding dress viewed on the television series, *The Crown*. Perhaps after reading the following chapters, readers might take a double look next time they see what they believe to be an *original* artwork.

NOTES

1. Nesbø, Jo. *Headhunters*, London: Random House, 2008, pp. 50–1.
2. Collection of the Art Gallery of Ballarat [1881.21]. *Ballarat* (1886), presented in 1887, 175 × 226 × 8.5 cm, oil on canvas.
3. 'Down under' is an expression used to reference Australia and New Zealand.

4. Benhamou, Françoise and Victor Ginsburgh, *Copies of Artworks: The Case of Paintings and Prints*, in *Handbook of Economics of Art and Culture*, December 2006, Amsterdam: North Holland, p. 269.

5. Livingston, Tommy and Marika Hill. 'Frizzell vows to take legal action after finding 'fakes' on Trade Me', *Stuff*, 14 May 2016.

6. Collection of the Museum of New Zealand Te Papa Tongarewa [1910-0001-1/66-80], etching, 14.4 × 21 cm (plate size).

7. Rigg, Anna. 'Faking Rembrandt: Copies in the Collection', *Museum of New Zealand Te Papa Tongarewa Blog*, 16 February 2016.

8. Lot 21, Fifty Prints by Rembrandt van Rijn: A Private English Collection, Auction 11965, 5 July 2016.

9. Gallant, Aprille J. 'The Art of Copying: Copycat at The Clark Art Institute', *Art in Print*, Vol. 2, No. 1, May–June 2012, p. 21.

10. https://hyperallergic.com/497448/copies-fakes-and-reproductions-printmaking-in-the-renaissance-blanton-museum-of-art

11. Tinari, Philip. 'Original Copies: The Dafen Oil Painting Village', *Artforum*, October 2007, pp. 344–51.

12. Collection of The National Gallery, London, [NG6596], oil on yew, 27.9 × 22.4 cm.

13. For the fascinating story about Raphael's *Madonna of Pinks* see: https://www.nationalgallery.org.uk/research/research-papers/close-examination/the-madonna-of-the-pinks

14. Beck, James. 'Raphael's "Madonna of the Pinks": A Connoisseurship Challenge', *Source: Notes in the History of Art (Special Issue: Problems in Connoisseurship)*, Vol. 24, No. 2, Winter 2005, p. 50.

15. Schwartz, Hillel. *The Culture of the Copy: Striking Likenesses, Unreasonable Facsimilies* (Revised and Updated), New York: Zone, 2014, p. 176.

16. A tiki is a carved humanoid form made from greenstone (pounamu) and worn as a pendant.

Apprentice Artists

Melissa Ashley's 2019 novel, *the birdman's wife*, is the story of real-life illustrator Elizabeth Gould (née Coxen) (1804–1841), who made illustrations of numerous bird species to accompany the work of her naturalist husband, John. Leaving their young family behind in England, Elizabeth and John sailed to Australia in search of new species. Her work is superb yet, until recent times, was overshadowed by her husband's. Gould's illustrations feature in Charles Darwin's *The Zoology of the Voyage of H.M.S. Beagle* (not that she is credited for her work) and the Gould's tome, *The Birds of Australia*.[1] Elizabeth Gould's training was typical for the time and her gender; as the novel tells us, in 1828 she was assigned a tutor, Miss Overland, by her brother Charles. She studied flowers in public gardens and illustrations of flora in the volumes kept at the brownstone library where Miss Overland instructed her to 'make a copy of something that deeply appeals to your senses'.[2] The artist she chose to copy was the German artist, Maria Sibylla Merian (1647–1717). Though the book is a work of fiction, it is historically correct in providing an insight into nineteenth-century art education, especially for females. Copying was central to training to be an artist for both genders, although for females this was often the total sum of their art education.

During the eighteenth and nineteenth centuries, copying illustrations, drawings and prints was the first step of an artist's professional art education. Drawing from plaster casts, and original sculptures, was followed with working from a life model. However, for the majority of this period

© The Author(s), under exclusive license to Springer Nature
Switzerland AG 2022
P. Jackson, *The Art of Copying Art*,
https://doi.org/10.1007/978-3-030-88915-9_2

women were usually deprived of the latter on moral grounds. Copying in a museum context complemented this rigid structure, although it depended on access to collections. The mid-nineteenth century in particular, saw Paris become the temporary home of colonies of artists from America, as they made their homage to make copies, especially at the Louvre. Copying in art museums came into its own, enjoying a heyday during what is referred to as the golden age of museums – the nineteenth century – when many were first opened to the public. Copying in a museum's galleries became accepted practice and was encouraged, so much so that some museums had specific days allocated for students and copyists to work uninterrupted at their easels and spread out all their equipment without hindering the flow of visitors.

It was not only students that could be seen copying; copying was also undertaken by established artists who either wanted to continue their self-education or were making works to sell. There was a demand for copies of Old Masters, driven largely by those from the colonies who did not have access to established collections. Not only was copied art popular among buyers, but there was also demand for paintings depicting copiers copying. Of the many images made of copyists at work in museums, it is often impossible to differentiate between the two groups at work. Images of copyists became a genre in its own right, providing a wealth of information about who made copies and how they were made, as well as depicting the types of works copied. Some are caricatures, some realistic, while others romanticise the practice of beautiful young women copying.

Today, copyists can still be seen at work in major museums; it is a tradition that continues to attract those wishing to have their own Van Gogh or those who simply want to understand another artist's technique. Whatever their motivation, they provide another level of experience for visitors.

ART-STUDENTS AND COPYISTS IN THE LOUVRE GALLERY, PARIS BY WINSLOW HOMER

Winslow Homer's (1836–1919) much-reproduced woodcut depicts copyists at the Louvre.[3] Initially, it was reproduced in *Harper's Weekly* in 1868, the American artist having spent 1867 based in Paris (see Fig. 2.1). The accompanying text championed the Paris Louvre as a valuable resource for wannabe artists, including Homer.

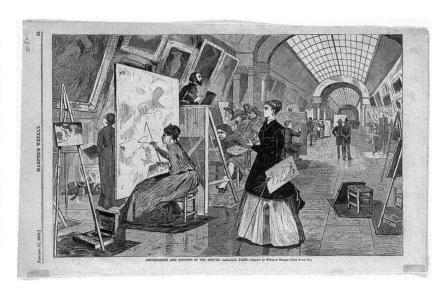

Fig. 2.1 Winslow Homer, *Art-students and Copyists in the Louvre Gallery*, as reproduced in *Harper's Weekly* in 1868. (Photo: Library of Congress Prints and Photographs Division Washington, D.C. 20540 USA [LC-USZ62-130129])

Art-students and copyists in the Louvre Gallery, Paris, is interesting for several reasons. Firstly, Homer's picture is busy. There are numerous artists at work; some paint while others watch on. Each artist has a certain amount of paraphernalia – easel, paints, mahlstick, canvas, and so on. For visitors, this all had to be navigated with the upmost caution in order to view the works on display. For this reason, the Louvre had set days when copying was allowed; regulations for copyists has changed over the course of the Louvre's history. By its third year of operation, after opening in 1793, permission was granted to 500 artists alone. The Louvre became overwhelmed with copyists, necessitating the need to tighten up regulations and restrict numbers. The following timetable demonstrates how the demands from students and copyists continued to cause the Louvre to make changes to their policy for copying:

1793	Louvre opens, displaying 538 paintings. Copyists are allowed to copy 5/10 days and then it was increased to 7/10. *'The general public came to the museum to order copies, and copying was free.'*
1797	Copyists are made to register and a master of a school had to provide a certificate to legitimise the copyist. *'The only constraint was that the works could not be moved while copying was going on.'*
1824	Copying days are now Tuesday–Friday. Rules around silence and health are introduced. Around about this time a new rule was introduced of one artist, one work. This was to keep numbers down. By comparison, Amsterdam's Rijksmuseum only allowed copying on Monday–Wednesday (1852–6).
1908	The concern for living artists became stronger: Copyists of works 'whose rights to be reproduced [were] "reserved" could do so but not sell their work without being authorised'.
1913	New rule: one copyist per room. This was especially enforced in the smaller galleries. The importance of access to museums for copyists was demonstrated in March 1914 when suffragette Mary Richardson slashed *The Rokeby Venus* at London's National Gallery. They closed the gallery to the general public for two weeks, yet it remained open for students of which many would have been copyists.
1927–1932	Time limits put on copyists. No more than two months could be spent on the same work. Copyists could not negotiate the sale of works within the museum. Copies had to be clearly labelled (stamped) as copies.
1946	Copies could not be the same size as the original work. Copying in museums became therefore a totally regulated activity.[4]

The various changes introduced by the Louvre clearly came about as issues arose; the potential sale of a copy as an original, for instance, was lessened with the Louvre regulating the size of a copy and having it clearly labelled. That does not preclude the fact that further copies could be made off-site from the initial copy and sold.

As seen in Homer's illustration, the popularity of copying increased the congestion of gallery spaces. Again, regulating the number of copyists and limiting them to one copy per artist helped keep a lid on numbers. Other images of the Louvre, such as Thomas Allom's (1804–1872) *The Grand Gallery of the Louvre* (c.1844), shows how much the copyists made themselves at home, with several stretched canvases leaning up against the wall directly under the artworks and behind the viewing rail, making it all the more difficult for visitors to view the works on display.[5] Photographs taken at about the same time of the Louvre, after hours, show the copyists' equipment left in situ overnight, including a number of ladders.

What perhaps is of greatest interest with Homer's image is the number of female students and copyists, and how he has put them centre stage. Homer has certainly used the female form as a pictorial device (though it is not as staged as in Samuel Morse's painting – see Chap. 3). The three figures in the foreground provide other messages too. The most significant is perhaps what they are copying. The large canvas is to be a copy of Eugène Delacroix's (1798–1863) *The Death of Sardanapalus* (1827).[6] The painting is large and violent, and the antithesis of the usual subject matter chosen by female artists of the time – portraiture and the still life. The standing figure looks on at the other woman sitting in profile working at her large canvas. Given women had been excluded from studying from life models, the choice here of Delacroix's work demonstrates a clear pushing of artistic boundaries.

Homer's image also includes male artists at work, but increasingly during the nineteenth century copying was seen as a:

> ... legitimate career for women artists once it had been discarded as an appropriate activity for the male artist.[7]

Homer's image reflects the high numbers of female artists, both student and professional, who studied abroad, especially during the post-Civil War era. America, unlike Europe, could not provide the Old Masters required for both student and copyist alike. Interestingly, Homer spent the year in Paris, but he did not make any copies himself. Homer's woodcut featured in a popular newspaper and perhaps encouraged others to follow in the footsteps of the artists that feature in his image.

At the Louvre by Étienne Azambre

Étienne Azambre's (1859–1933) oil painting of two copyists at work in the Louvre makes for a good comparison with Homer's image made three decades earlier. *At the Louvre* is a perfectly composed and balanced picture; one woman works on her copy of Renaissance artist Sandro Botticelli's (1445–1510) *Venus and the Three Graces Presenting Gifts to a Young Woman* (1483–1486) standing on the third rung up her ladder, while a fellow artist watches on.

The Botticelli was perhaps a popular choice given the subject of multiple female figures in billowing and voluminous drapery. Its graceful quality was luring, as was its soft palette; a fresco, and therefore much lighter in its palette than oils, the work was only acquired by the Louvre in 1882 having been discovered at the Villa Lemmi, near Florence, in 1873.[8]

Azambre's overall finish and treatment of the two contemporary figures is similar to Botticelli's soft and delicate treatment of his figures. Botticelli was regularly copied; the Louvre kept a register of those copying Italian works between 1893 and 1912 with a high number being foreign artists, especially Anglo-Saxon females.[9]

Azambre's depiction is romantic when compared with Homer's *Art-students and copyists in the Louvre Gallery, Paris.* The left-hand figure in *At the Louvre* has a particularly dreamy pose and expression as she studies the other's work. It is an intimate scene and does not show the chaos of artists and their paraphernalia, as in Homer's work. What is significant here is Azambre's faithful copying of Botticelli's fresco. As an aside, the fresco is now exhibited in its original form at the Louvre, without the ornate frame as seen in Azambre's painting.

Azambre's copyist makes a smaller version of the Botticelli; to copy the size exactly would have been logistically difficult. Even before the 1946 size regulation came into effect, many copyists, especially students, made smaller copies, as it was the technique they were motivated to study not so much as to make a same-sized version. Smaller canvases were more portable, took less paint to cover and were more economically viable. Copyists took up much space in the Louvre, indeed too much, hence the introduction of the regulations limiting numbers and canvas size. Congested as the Louvre got at times, visitors expected to see, and move around, copyists and their equipment.

At the Louvre is more than a documentary of copyists at work; it epitomises the copyist at work as a genre in its own right. Azambre copied Botticelli's fresco with exactitude; the copyist's result is harder to see as she is placed at right angles to the fresco. Painted in profile, the copyist makes for an elegant figure, heightened by her central place in the composition on the ladder. This aside, the copyist enjoyed their heyday during the nineteenth century at the Louvre and there are numerous images to support this. As the century drew to a close, copying became less significant; the Ecole des Beaux-Arts had made a curriculum change in 1863, which saw greater emphasis on originality as opposed to copying Old Masters. Having said that, many artists – especially women – continued to paint and make a living from copying. There was also some expectation that women would continue to do so over the remainder of the nineteenth century and into the twentieth.

With exclusions from life classes at art schools, women had begun the tradition of copying and it was a hard one to completely shed. A case in

point was the Swiss-born artist Angelica Kauffman (1741–1807). From 1766 until 1781, she was based in London where, in 1768, she became a Founder Member of the Royal Academy. Along with Mary Moser (1744–1819), she was one of only two women to enjoy membership of a very male-dominated establishment. Kauffman was a particularly able painter – though often described up until the 1970s as a *decorative* painter – her success is described by art historian Germaine Greer, in *The Obstacle Race*, as extraordinary given that her work was engraved more than 600 times.[10] Greer goes on to note of Kauffman:

> ... her designs were used in all conceivable kinds of media, on fans, painted furniture, flower vases, chocolate cups, snuff-boxes, wine-coolers, tea-sets, and even as the basis for porcelein figure groups, from Worcester to the Wiener Porzellan Manufaktur.[11]

Such exposure was in addition to Kauffman being a leading history painter. In short, she enjoyed much success despite her gender. A clear indication of the importance of copying to an artist's income at this time was that Kauffman was frequently commissioned by clients to copy not only her own work but also that of others.[12]

At the Louvre was gifted to the Louvre in 1978 by the Society of the Friends of the Louvre, who purchased it for 5000 francs. Its acquisition endorses the important role copying plays in the history of the Louvre.

In the Scottish National Gallery by Arthur Elwell Moffat

Paris was not alone in accommodating copyists. Arthur Elwell Moffat's (1861–1944) watercolour image of the National Gallery in Edinburgh, painted in 1885, depicts a quieter gallery space than the Louvre, with just one female copyist at work. Scattered about the floor are several drop cloths ready and waiting for the other copyists to set up for the day, or perhaps they have already done a day's painting.

Moffat's painting is a realistic representation, in contrast to the romanticised work by Azambre; the walls are heavily laden with paintings, the floor cluttered with sculpture plinths, seating and cabinets. One of the main objectives for establishing the National Gallery when it opened its doors in 1859 was to have a cross-section of art – old and new – for artists and students to copy. The founders saw the facilitation of copying as a

primary goal of the gallery and to accommodate copying they charged admission to the general public on Thursdays and Fridays to keep numbers low and thus free up the space for copyists.

The salon-styled hang presents a wide range of works, including Francesco Furini's (1603–1646) *Saint Sebastian* of c.1633 and his *Personification of Poetry*.[13] On the top row is Guercino (Giovanni Francesco Barbieri)'s (1591–1666) 1639 painting, *St Peter Penitent*.[14] Free-standing sculptures and busts complement the two-dimensional works; thus, Moffat includes a bust of Queen Victoria dating from 1865 by Alexander (c.1829–1867) and William Brodie (1815–1881) and in the background William Calder Marshall's (1813–1894) *Hebe Rejected* (c.1857), of which we see the back of the sculpture in the foreground.[15] The reason for listing these works is that it shows each one Moffat recorded is easily identifiable; the gallery's installation was a mixture of loan works and those from their permanent collection. This goes some way to proving just how realistic a scene Moffat painted. In addition, the wide range of works gave copyists plenty of scope to learn from.

The European and British tradition of copying in museums and galleries was carried further afield to include Australia and New Zealand.

BRITISH COURT, NATIONAL ART GALLERY, SYDNEY

At about the same time Moffat and Azambre were painting gallery interiors with copyists in situ, Scottish photographer Frederick Hardie (1864–1941) was recording scenes of the Australian city, Sydney. He took five images of the National Art Gallery, including one in the British Court that included a copyist at work.[16] Photographed in 1892–3, the British Court showcases contemporary British artists; paintings hang en masse with sculptures and seating arranged down the centre of the gallery (see Fig. 2.2). The lone copyist works on a landscape of approximately the same size as the work she copies to her right.

Fine arts education in Australia and New Zealand followed the British curriculum into the twentieth century, including copying. The idea of copying Old Masters was inherited, even though, especially early on in the nineteenth century, permanent collections of Old Masters were thin on the ground. Loan works and visiting exhibitions helped fill this gap. The works in the British Court are a combination of works from the gallery's permanent collection, which was extensive given the gallery only opened in 1876, and loan works. Several of the works in Hardie's photograph are

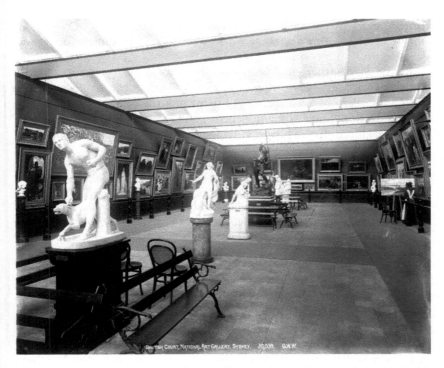

Fig. 2.2 British Court, National Art Gallery, Sydney, 1892–3. (Photo: Frederick Hardie for George Washington Wilson & Co [30,039])

identifiable. Paintings seen include: Eleanor Bell's (1848–1907) *The Burgomaster* (c.1880s), Frederick Leighton's (1830–1896) *Wedded* (1882), Frank Dicksee's (1819–1895) *Hermione* (1874), and Marcus Stone's (1840–1921) *Stealing the Keys* (c.1866). Sculptures include: John Gibson's (1790–1866) *Hunter and Dog* (1838) and *Narcissus* (post 1829), and Charles Birch's (1832–1893) *Retaliation* (1878).

Some, such as *Hunter and Dog* and *Narcissus*, were acquired in 1892, so were very new additions to the collection when Hardie took his photograph. Listing these works showcases the taste of those governing the gallery at the time. As with other Australian collections, these works were seen as good examples of British art. They were not particularly

contemporary or cutting edge in subject, with some having heavy moralistic overtones. Moreover, these works were seen as exemplars for art students to study and copy.

By the 1890s, there had been some reforms made to art education in Australia. Two decades earlier, students in Melbourne studying at the National Gallery of Victoria School spent months copying from the gallery's collection. Some students rebelled and around 1880 changes began to be introduced. As art historian Janine Burke noted about art education in Melbourne:

> The curriculum under Eugene von Guerard, who was both Master of the School of Painting and the first Curator of the National Gallery of Victoria from 1870–1881, involved copying paintings in the Temporary Picture Gallery.... it was a hopelessly inadequate way to conduct an art school. The collection of paintings they copied was hardly inspiring.[17]

Travelling scholarships were offered into the twentieth century and saw artists from Victoria copy Old Masters in Europe that were, in turn, returned to Melbourne. The terms and conditions of their scholarships engineered this to happen. The Old Master copies, in turn, were then copied on Australian soil.[18]

The copyist in Hardie's photograph is copying a British landscape. The irony here is that the copyist perhaps had not experienced the Northern Hemisphere's landscape or climate, and so was copying something quite alien from the bright, sun-filled Australian landscape. This is more pertinent given that by the early 1890s there was a group of Australian artists working en plein air. Artists such as Tom Roberts (1856–1931), Jane Sutherland (1853–1928), Frederick McCubbin (1855–1917)and Emma Minnie Boyd (1858–1936) changed the course of Australian painting by adapting to their environment rather than trying to replicate their European or British forebears. Lastly, the copyist was surrounded with an abundance of landscape to paint, including the building she was in, which is positioned on the edge of the fabulous Sydney Harbour.

The copyist performed another role, that of inspirer. In 1887 the Australian artist Margaret Preston (1875–1963), who went on to become one of that nation's leading artists, was just 12 years of age when she visited the Art Gallery of New South Wales. Preston would reminisce later in life about her visit:

A big, quiet, nice smelling place with a lot of pictures hanging on the walls and here and there students sitting on high stools copying at easels.[19]

According to her autobiography, it was this visit that made Preston decide to become an artist. After lessons in China painting and private lessons with William Lister (1859–1943), she attended the National Gallery of Victoria Art School under the tutelage of Frederick McCubbin. Preston would go on to be a leading modernist and in 1929 she was the first woman (and modernist) to be invited to contribute a self-portrait to the Art Gallery of New South Wales' collection. Her depictions of indigenous flowers and appropriation of Aboriginal motifs have become iconic to Australia's art history.

The above examples – from Paris, Edinburgh and Sydney – showcases how and why students (both formal and informal) copied Old Masters. But we might ask: how do their results measure up when compared with the originals? This is an area where measuring the quality of copies is possible, for surely the student copyist – and then the professional copyist – was trying to render as close a likeness as their ability would allow. European students were fortunate in having original Old Masters, or contemporary examples, to copy, but in the colonies students at times worked from prints, a form of copy in itself. Frances Hodgkins was a case in point.

THREE COPIES BY FRANCES HODGKINS

In New Zealand, Frances Hodgkins (1869–1947) began her stellar artistic career by making copies. From an artistic family, Hodgkins was fortunate enough – after her mother realised she would not make a career of music – to be encouraged to follow her passion for art. Along with her sister Isabel, Hodgkins attended private lessons with the Italian artist Girolami Nerli (1860–1926) in their hometown of Dunedin. Prior to Hodgkins attending the Dunedin School of Art, she made copies to further hone her painting.

The Dead Robin dates from c.1891 when Hodgkins stayed with her relatives, the Carricks, in Christchurch.[20] Allegedly, they owned the original watercolour painting by Victorian artist Frederick Walker (1840–1875), titled *Boy looking at a Dead Bird*.[21] However, there is little evidence to support this claim. It is more likely that they were the owners of a commercial heliogravure print made en masse. Hodgkins was therefore faced with an artistic challenge – painting an image in watercolour from a

monochromatic print, which was made from Walker's original waterco-
lour. Hodgkins' version is slightly larger at 27 × 21 cm versus 12.7 × 21.6 cm
of Walker's prints. The subject is sentimental and in keeping with the kind
of work Hodgkins tended to favour at this time and into the next decade.
Hodgkins gave the work to the Carricks. In 1958 it was sold to the city of
Christchurch's public art gallery by one of their descendants. Hodgkins
never intended this work to be anything but a copy – albeit she gave it a
different title – as she clearly wrote in the right-hand corner of the paint-
ing, 'From a Drawing by F. Walker. F.H.'. Given her contribution to mod-
ernism, you have to wonder what she'd make of this early work being in a
public collection.

Hodgkins was somewhat restricted in what she copied given the narrow
selection of art available at the time in New Zealand (even less than
Australia). Still in Christchurch, she took advantage of a work – one of
five – selected by Lord Frederick Leighton from the Royal Academy to
travel to New Zealand and be 'guest exhibits' at the annual exhibition of
the Canterbury Society of Arts. Works were chosen on the grounds of
being worthy for art students in Christchurch; they were morally sound
and good examples of Victorian painting, according to Leighton. In other
words, they were not in any way risqué, in fact, rather staid. Christchurch's
daily newspaper, *The Press*, described the five '"guest exhibits" as "delight-
ful examples of contemporary English art"'.[22]

Baby was painted in 1891 and is a copy of *The Tyrant* (1887) by English
artist Marie Seymour Lucas (1855–1921). Exhibited at the Royal Academy
in 1887, where it 'hung on the line', the oil painting made its way to
Christchurch to be exhibited in March/April of 1888. The work is a figure
study, a portrait of a plump grumpy baby, possibly one of Lucas' children
(see Fig. 2.3). Hodgkins copied the work in watercolour on a smaller scale
than the original (see Fig. 2.4). Given the different media, Hodgkins' like-
ness is very good. One of her early biographers, E. H. McCormick, noted
of *Baby*:

> ... initialled 'FMH' and dated 1891, is quite startling in its accomplishment.
> But it turns out not to be an original. Following illustrious precedent,
> Frances Hodgkins was educating herself by copying pictures she admired.[23]

The Tyrant was clearly a hit with its Christchurch audience, with the
Canterbury Society of Arts purchasing it for £26.10s for its own collec-
tion. As an aside, of the five works selected by Leighton, it was the

Fig. 2.3 Marie
Seymour Lucas, *The
Tyrant* (1887).
Collection of
Christchurch Art
Gallery. (Photo:
Christchurch Art
Gallery)

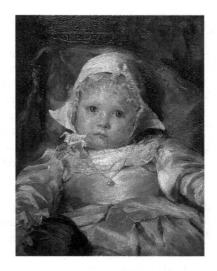

Fig. 2.4 Frances
Hodgkins, *Baby* (1891).
Private collection.
(Photo: The Complete
Frances Hodgkins,
Auckland Art Gallery
Toi o Tāmaki)

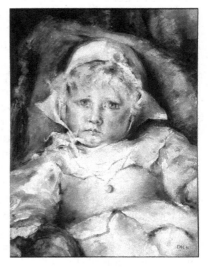

cheapest (and the only one by a woman artist). In 1932, when
Christchurch's public art gallery opened, the Canterbury Society of Arts
gifted Seymour Lucas' *The Tyrant*, along with 109 other works, to form
the gallery's founding collection. There are at least two other known stu-
dent copies of *The Tyrant* in Christchurch.

Both *The Dead Robin* and *Baby* show Hodgkins' early penchant for painting the figure rather than the more popular – in New Zealand at that time – genre of landscape painting. Hodgkins' formal art classes began in 1893 under the tutelage of Italian artist G. P. Nerli (1860–1926), who was based in Dunedin. Following on from his lessons Hodgkins attended the Dunedin School of Art. There is, however, one more copy that she completed in the intervening year of 1892, a copy commissioned by Dr John Halliday Scott, a lecturer in anatomy and physiology at the Otago Medical School and amateur artist. Hodgkins was paid £2.2s to make a copy of *The Anatomist Andreas Vesalius (1514–64)* and she followed – and highly likely unknown to her at that time – in the footsteps of many others who copied the same painting.[24] In a letter to her artist sister, Isabel, Hodgkins made mention that she wanted to make the copy gratis for Dr. Scott, but he insisted on paying her.

The original painting of Andreas Vesalius – the Renaissance founder of modern anatomy – was painted by Edouard Hamman (1819–1888) and was first exhibited at the Brussels Salon in 1848. It is a large canvas measuring 99 × 79 cm.[25] Within a couple of years of its showing, lithographs were made of what would become a popular image. *Medical News* of 1884 noted that you could purchase the lithograph for USD 1.50 a piece. Described as draughtsmen, the lithographs were made by Adolphe Mouilleron (1820–1881) and Joseph Schubert (1816–1885). Interestingly, Mouilleron reversed Hamman's image (was this deliberate or a failure to remember the image would be reversed once printed?) putting the cadaver on the right-hand side. Dr. Scott owned a Mouilleron lithograph, which Hodgkins used to execute her watercolour. Historically, Hamman's image has been a favourite with the medical profession; a 2017 article by American medical historian, Burt Hansen, revealed eight different copies of Hamman's original painting, of which several are in the collections of universities and medical schools.[26] Hodgkins' copy was not on his list.

Hodgkins went on to have a prolific and successful career; being the first New Zealand artist to be 'hung on the line' at the Royal Academy and being chosen to represent Britain at the Venice Biennale in 1940 were just two of her accomplishments. Her copies should be seen as integral to her art education, albeit they were made as part of her self-education. They reveal not only so much about artistic taste at the time but also about what was available to copy in artistically conservative New Zealand. Above all else, they show Hodgkins' ability to transcribe from one medium to another, for instance, from original oil on canvas to watercolour on paper

and, perhaps more significantly, from a monochromatic lithographic print to a watercolour in the case of the Vesalius image. Curiously, Hodgkins gave her copies new titles; perhaps this was to distinguish them from the originals and avoid any future confusion or possibly to give the works a little of her own individuality.

MORE *WELCOME MORSELS*

On occasion, student copies have caused confusion. One of the other works that came from the Royal Academy to Christchurch along with *The Tyrant* was Leonard Nightingale's (1851–1941) *Welcome Morsels*.[27] A sentimental painting dating from c.1887, it depicts a young girl feeding cabbage leaves to two goats that have arrived at the door of her country cottage. Early on in my career I worked at the Christchurch Art Gallery (formerly the Robert McDougall Art Gallery). Each fortnight I profiled a work from the gallery's collection for publication in the daily newspaper, *The Press*. In one such article I profiled *Welcome Morsels*. The day it appeared on 23 July 1991, I received a telephone call from a very miffed owner of *Welcome Morsels*. They were unhappy that I had written about a work owned by their family and published it, with image, in the daily newspaper without their permission. Soon afterwards, I received another, almost identical call.

Both callers were correct. They did own a *Welcome Morsels*. Both the owners had relatives who had studied at the Canterbury College School of Art, which was situated at the time just across the road from the gallery. As part of their art education, their relatives had made copies of *Welcome Morsels*. As art historian Noah Charney notes in *The Art of Forgery*:

> ... copying has always been the way young artists learned their trade – copying or imitating another artist's style is only a crime if someone tries to pass off the copy as an original.[28]

When copies by art students are handed on, as in these two cases, many later owners innocently believe their painting is an original.

In 2016, I was determined to find at least one of these copies to hang next to the original in an exhibition I was curating about the history of art crime in New Zealand. One of the exhibition's objectives was to educate viewers about legitimate copies of artworks. During the intervening 25 years, Christchurch – where the two copies were in 1991 – had suffered catastrophic earthquakes. Many homes, along with their possessions, had

been destroyed. After much searching and with the help of the daily newspapers, one copy was located. It was the first time the copy and the original hung side-by-side and even without a label it was very easy to distinguish which one was the original.

MARY CASSATT'S CAREER BREAKTHROUGH

American artist Mary Cassatt (1844–1926) had a career breakthrough when she was commissioned by the Catholic Archbishop Michael Domenec to complete two paintings for the newly built St Paul's Cathedral in Pittsburgh. Having been down on her luck – in 1871, many of her works were burnt in a gallery in Chicago when the Great Fire tore through the city. This contract would turn out to be more than a one-off much-needed commission in that it allowed her greater artistic freedom, in Europe no less. The commission was to copy two paintings located in Parma, Italy. Both were by Antonio da Correggio (1494/8–1534), whose work was seen as progressive at the time in that it looks forward to the Baroque, especially his incorporation of illusionistic effects seen later in domes and ceilings. Cassatt was commissioned to copy *Madonna of Saint Jerome* and the *Coronation of the Virgin*. In fact, the latter was a copy made by Anibale Caracci (1560–1609).

From December 1871 to October 1872 Cassatt, along with her travelling companion, the American artist Emily Sartain (1841–1927), was based in Parma. She was paid USD 300 to complete the copies which also funded her trip to Europe. Although the funds were well received at the time two other advantages of the payment are more significant. Firstly, Cassatt's work was to be hung in the new cathedral, albeit not her original work but copies. Secondly, the USD 300 was literally her ticket to Europe. As an American, a woman, and an artist this must have felt like she had won the trifecta! Cassatt stayed on in Europe after working on the copies. Armed with letters of introduction from the Archbishop, a Spaniard, she travelled to Seville, Holland, Belgium, Rome and Paris. In 1872 she exhibited her painting titled *Two Woman Throwing Flowers During the Carnival* at the Paris Salon.[29] The work is heavily reminiscent of Correggio's style. The opportunities that followed, or were because of, the Cathedral commission were life-changing. Cassatt spent six months in Spain and was very taken with the work of several artists, especially that of Diego Velázquez (1599–1660). She made a copy of his portrait of the child prince Baltasar Carlos. About Spain she commented to Sartain, 'I think that one learns *how to paint* here.'[30]

The two commissioned pieces set Cassatt on a new path. As biographer Griselda Pollock noted:

> Focusing on these internal and structural relations of gesture and space, as was the custom of copyists, two key features of Cassatt's own subsequent fascinations with compositions of child and adult can be identified: the expressive or contemplative head and the signifying potential of the linking gesture.[31]

The blissful serenity that Correggio employed would greatly influence Cassatt. Of the commission, Cassatt's *Coronation* made its way back to Pittsburgh but was destroyed by a fire in 1877. She never completed her copy of *Madonna and St Jerome*. Cassatt successfully exhibited at the Paris Salon in 1873 and 1874, and then, at the invitation of Degas, with the Impressionists in 1877. Today her name is synonymous with Impressionism and she is heralded as a major player in nineteenth-century painting. Without the commission and opportunity to travel to Europe, her story may have been very different.

This chapter is very female-centric. Historically, men copied artworks but the evidence, as in who made the copies, and the texts highlight the rise of the female copyist in the latter part of the nineteenth century for the following reasons. Firstly, women, especially in the late eighteenth and nineteenth centuries, copied for longer than man and there was a greater number of them due to the lack of opportunities for the female student to follow the same formal art training as their male counterparts. More specifically, the lack of access to life classes meant more women ended up copying the nude figure from two-dimensional artworks. In 1893 the Royal Academy finally allowed female students access to life drawing, albeit that the male genitalia was covered up with a cloth of light material measuring 2.7 metres long by 0.91 metres wide. In addition, just in case the cloth might slip off, a thin leather strap was fastened to secure the cloth.[32] In other words, they worked from a draped male figure.

Secondly, a 'good' copyist could make a mediocre living from selling copies. For instance, during the Second Empire in France, copyists were commissioned to make portraits and history paintings for state institutions. An agreement between church and state saw copies of paintings from larger city cathedrals made to be sent to small provincial churches. Women were contracted to carry out these commissions, demonstrating there were formal employment opportunities for the female copyist. Being

able to copy was seen as an accomplishment for women in a similar ilk as playing the piano or being proficient at needlework. Getting paid for copying was an added bonus.

Thirdly, copying in a public space was an outing with clear objectives. For many, the long hours spent copying was a welcome change to domesticity, whether it was for informal art education or for a paid commission. In short, it got women out of the home, albeit that often they were chaperoned. The curator of the exhibition 'The Art of the Copy' Anne Koval goes as far as to make a biological connection:

> Not only were women at home relegated to their biologically reproductive role as mothers but also, culturally, the role of reproducing copies was seen as a natural occupation for the female artist as creativity was characteristically the domain of the male artist.[33]

During the latter part of the nineteenth century, galleries and museums were increasingly populated with women copyists for the male artist, generally speaking, had moved away from copying, as original art became more significant and lucrative.

Lastly, the female copyist became the subject in her own right for artists, from the academic realist to the caricature. As the nineteenth century wore on, images showed the female copyist precariously balanced higher and higher up her ladder to work at her easel, and as the bustle became fashionable, she was depicted in profile more and more. For the male artist, this new genre posed the challenge of copying paintings and sculptures within another painting as well as portraying the female figure at work.[34]

Though many female copyists would do little beyond copying, others used it as a stepping-stone to unleash their creativity. As a stage in one's training, copying was a useful activity. Frances Hodgkins is a case in point; copying features early on in her pursuit to be a professional artist. It can be viewed as a forerunner to her formal art education. Her copy of *The Anatomist Andreas Vesalius* remains at the University of Otago's School of Medicine 130 years later after she created it, thus demonstrating the role of a legitimate copy.

* * *

Copying for the purposes of learning certainly played a significant role, as seen from the examples discussed here. For women especially, it provided

another crucial layer to art education (or, in some cases, the only layer). In a time before art museums existed, students learned by copying works in churches and private collections. Admittedly, access to private collections was limited to those who had the right social contacts. The sixteenth-century nun Suor Plautilla Nelli (1523–1587/8) is an early example of an artist who began her artistic career as a painter of miniatures and copies. As the great biographer of Renaissance artists, Giorgio Vasari (1511–1574) noted of Nelli, in his *Lives of the Artists*, 'she would have done marvellous things if, like men, she had been able to study and to devote herself to drawing and copying living and natural things'.[35] In 2019 a major work of Nelli's was unveiled in Florence; a 6.4 metre long painting of the *Last Supper* had undergone major restoration after its discovery, in storage, in 2015. In 1979 it was noted in the book, *Women Artists 1550–1950*, that Nelli painted the *Last Supper* for the refectory at Florence's S. Maria Novella, but its whereabouts were unknown.[36] Fortunately, it has been found and there is no doubt it is her work given the signature, *Sister Plautilla – Pray for the Paintress*. This is the story, with a happy ending, of a nun who did not have access to the art education of her male contemporaries but learnt through copying and then established an all-women painter workshop at her convent, Santa Caterina di Cafaggio.

Copyists gave art museums a reason to exist and collect, sometimes to the annoyance of visitors. As early as 1841, John Waters, a writer for New York's *Knickerbocker* magazine, described copyists as 'infesting' the galleries of Europe. It would become a worldwide trend, though perhaps not in the kinds of numbers that justified the word 'infested'. Art museums in America and across the British Empire followed suit in allowing students and artists to copy in situ. Secondary school art curriculums have upheld the traditions of copying. In New Zealand, senior students of practical art are compelled to copy a New Zealand artist in order to develop their own style. Some artists are definitely the chosen ones and copied ad nauseam. In a nutshell, as arts commentator Justin Paton noted in the 100th issue of New Zealand's longest-standing art journal, *Art New Zealand*, about his own art education, 'that the art syllabus demanded that students find an artist model, and *copy that sucker down*' (his italics).[37] For decades, little has changed since Paton's time at secondary school in the 1980s.

Copying in the formal art school context would be rare today, if in fact possibly extinct; however copyists can still be seen at work in all the major museums. Public art museums offer copying programmes, some with the

objective of getting visitors to look longer and harder at artworks (and not via their smartphones). The National Gallery of Art in Washington runs such a programme; between opening in 1941 and 2018, more than 8000 permits to copy have been issued.[38] Visitors watch on in awe as professional copyists go about their work. Similarly, there is still a waiting list at the Louvre to this day, with the daily limit being 250 permits. With limitations on permits, artists can wait up to two years to be granted a session at the Louvre. Easels remain free of charge, hours are limited, as is the total amount of time allowed to work on a given painting (up to three months), copies are inspected by officials, and canvases have to be one-fifth of the original work's size. The Louvre's website safeguards against fraudulence explaining:

> Once these safeguards against forgeries are met, they are stamped and signed by the head of the Louvre's copy office and escorted from the building with their work.[39]

Reading between the lines, it is obvious that the level of trust between artist and museum is still tested. There is, of course, nothing to stop the deceitful copyist making another copy at home to on-sell.

NOTES

1. Gould, John. *The Birds of Australia*. London: printed by Richard and John E. Taylor for the author, 1840.
2. Ashley, Melissa. *The birdman's wife*, Melbourne: Affirm, 2016, p. 17.
3. Copies of Winslow Homer's *Art-students and copyists in the Louvre Gallery, Paris*, are held in numerous collections. Homer's original woodcut is 23.3 × 35.2 cm.
4. All dates and information sourced from: Ginsburgh, Victor A. and David Throsby, *Handbook of the Economics of Art and Culture, Volume 1*, Amsterdam: North Holland, 2006, p. 274.
5. See: https://commons.wikimedia.org/wiki/File:Grande_Galerie_Louvre_by_Thomas_Allom.jpg
6. Collection of Louvre, Paris, [RF2346], oil on canvas, 392 × 496 cm.
7. Gaze, Delia. 'Copyists' in *Concise Dictionary of Women Artists* (ed. Delia Gaze) (first edition), New York: Routledge, 2001, p. 59.
8. The fresco was detached from the wall and mounted on canvas. It is now installed and can be seen in the Salle Percier et Fontaine, Louvre, Paris.

9. https://www.amisdulouvre.fr/acquisitions/au-louvre [Society of Friends of the Louvre].

10. Greer, Germaine. *The Obstacle Race: The Fortunes of Women Painters and Their Work*. London: Secker & Warburg, 1979, p. 80.

11. Ibid.

12. Gaze, Delia. 'Copyists' in Concise Dictionary of Women Artists (first edition) (Ed. Delia Gaze), New York: Routledge, 2001, p. 58.

13. Collection of the Scottish National Gallery, Edinburgh [NG30], oil on canvas, 50.5 × 38.5 cm/ and [NG31], oil on paper on panel, 41.4 × 34.5 cm.

14. Collection of the Scottish National Gallery, Edinburgh [NG39], oil on canvas, 126.8 × 109.3 × 6.8 cm (framed).

15. Collection of the Scottish National Portrait Gallery, Edinburgh [PG1068], marble, height 67.7 cm and [NG447], marble, height 137 cm.

16. The National Art Gallery became the Art Gallery of New South Wales in 1880.

17. Burke, Janine. *Australian Women Artists 1840–1940*, Victoria: Greenhouse, p. 25.

18. See more on this topic in Chap. 3: Copies for the Colonies.

19. Margaret Preston, 'From Eggs to Electrolux', *Art in Australia*, (3rd Series), No. 22, December 1927, unpaginated.

20. Collection of Christchurch Art Gallery Te Puna o Waiwhetū Collection [FH0057], watercolour, 27 × 21.2 cm. To see the *Complete Frances Hodgkins Catalogue* visit: https://completefranceshodgkins.com

21. Commercial prints of the work are also titled *A Harsh Winter. Boy Looking at a Dead Bird* is the title given in the book, *Frederick Walker and His Works* by Claude Phillips, London: Seeley and Co, 1897, p. 73.

22. Jackson, Penelope. 'The Tyrant: fine 1880s English sample', *The Press*, 19 March 1991, p. 13.

23. McCormick E. H. *Portrait of Frances Hodgkins*, Auckland: Auckland University Press, 1981, p. 16.

24. Collection of Department of Anatomy, University of Otago, Dunedin, New Zealand [FH0067], watercolour, 19.7 × 26.7 cm.

25. Collection of Cornell University, New York [W84–65.2], oil on canvas, 99 × 79 cm.

26. Hansen, Bert. 'Serendipity in the Discovery of New Vesalius Paintings', *The Osler Library Newsletter*, No.126, Summer 2017, p. 15.

27. Collection of Christchurch Art Gallery Te Puna o Waiwhetū [69/569], oil on canvas, 758 × 508 cm.

28. Charney, Noah. *The Art of Forgery: The Minds, Motives, and Methods of Master Forgers*. London: Phaidon, 2015, p. 16.

29. Collection of Mrs. James J.O. Anderson, Baltimore, USA, oil on canvas, 63.5 × 54.6 cm.

30. Tinterow, Gary and Geneviève Lacabre, *Manet/Velázquez: The French Taste for Spanish Painting*, 2003, New York: Metropolitan Museum of Art (1st Edition), p. 521.
31. Pollock, Griselda. *Mary Cassatt: Painter of Modern Women*. London: Thames and Hudson, 1998, pp. 92–3.
32. Royal Academy Annual Report, 1894.
33. Koval, Anne with Jane Tisdale and Adam Karpowicz. *The Art of the Copy*, Owens Art Gallery, Canada, October–December 2009, unpaginated.
34. See Chap. 4: Paintings-within-Paintings for more on this topic.
35. Nelson, Jonathan K. 'Sister act – Plautilla Nelli and the painter nuns of 16th century Florence', *Apollo*, 21 November 2019. https://www.apollo-magazine.com/plautilla-nelli-last-supper-santa-caterina/
36. Harris, Ann Sutherland and Linda Nochlin. *Women Artists 1550–1950*. New York: Alfred A. Knopf and Los Angeles County Museum of Art, 1977, p. 21.
37. Justin Paton, 'Dear Editor', *Art New Zealand*, Spring 2001, p. 63.
38. Casey Lesser, 'How artists are copying masterpieces at world-renowned museums', *Artsy*, 15 March 2018, https://www.artsy.net/article/artsy-editorial-artists-allowed-copy-masterpieces-worlds-prestigious-museums
39. Jessica Steward, 'How Skilled Copyists Leave the Louvre with a Masterpiece Every Year', *My Modern Met*, 16 November 2017. https://mymodern-met.com/ivan-guilbert-louvre-copyists/

CHAPTER 3

Copies for the Colonies

On her first day in art school, in Auckland early in 1959, my friend Lynley Dodd (b.1941) was tasked with making a drawing of a plaster cast (see Fig. 3.1).[1] Her light and shade rendering was of a plaster of Paris cast of the Greek sculpture, *Aphrodite Venus Genetrix*. Dodd went on to specialise in sculpture, in which she was instructed by the sculptor John F. Kavanagh (1903–1984); having studied in Italy, it was unsurprising that he taught in the classical tradition. The original *Aphrodite Venus Genetrix* is lost but numerous Roman copies exist, with perhaps the best example being in the Louvre's collection.[2] *Aphrodite Venus Genetrix* measures 1.64 m in height, taller than the scaled-down version from which Dodd worked. The Louvre's copy is made from Parian marble and dates from the late first or early second century AD. The original Greek *Aphrodite Venus Genetrix* dated from the fifth century BCE, and unusually was made of bronze. The history of Roman copies of Greek sculptures is well documented and although some may think the large numbers they copied shows a lack of creativity it also demonstrates the skill required to observe and copy with precision. Simply, the Romans were enamoured with Greek sculpture. Technically adapting and adjusting materials was no mean feat. The Romans did not have the same kind of access to materials, especially marble and stone, as the Greeks and so adapted accordingly. By making copies the Romans educated and disseminated centuries of knowledge about Greek art, life and culture. Without their copies we would have a far

© The Author(s), under exclusive license to Springer Nature Switzerland AG 2022
P. Jackson, *The Art of Copying Art*,
https://doi.org/10.1007/978-3-030-88915-9_3

Fig. 3.1 Lynley Dodd
(née Weeks), pencil
sketch of *Aphrodite
Venus Genetrix* (1959).
Collection of the artist.
(Photo: Tauranga Art
Gallery)

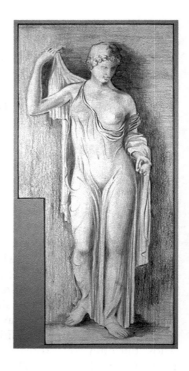

narrower picture of Greek civilization today. Going forward, the trajectory of Western art history – especially the Renaissance – would have taken a very different course without Roman copies.

Greek and Roman sculpture has been revered and copied for centuries. Copies have been copied. The plaster cast came into its own for newly opened museums and galleries as well as the development of art schools in the eighteenth and nineteenth centuries. Art students had to be accomplished at drawing from the cast before being promoted to drawing from life models. Auckland's art school originated at the museum in 1878. A generous donation of plaster casts – the Russell Statues – was the catalyst for the beginning of formal tertiary art education in Auckland, New Zealand's largest city. However, by 1890 the art school had acquired its own building and its own set of plaster casts (all copies of classical works). The drawing from casts went out of favour in the early twentieth century and there are reports of the director Archie Fisher (1896–1959), who had arrived from the Royal College of Art in London, dumping three lorry

loads of plaster casts. This took place in the 1920s, when Fisher's pedagogy was based on working from life models. Despite this, Dodd and her fellow students were still drawing and sculpting from plaster casts as late as 1960, as she recalls making a drawing of the bust of Julius Caesar in that year.

Dodd's drawing is competent and shows her powers of observation as an 18-year-old. Interestingly, her drawing is at least a fourth-generation piece: Greek, Roman, plaster and drawing. The point being that art students in the 'colonies' did not have access to original Greek or Roman sculptures. Plaster copies, on a different scale with a different texture to Roman copies, had to suffice in order to comply with the syllabus, which was based on the British system.

There was a fair share of plaster casts in New Zealand secondary schools, in classrooms where either art or Latin were taught. Dodd recalls making sculpture copies of Michelangelo's *David's* nose and hand while at secondary school. Plaster casts, especially of friezes, were commonplace in schools; they were easily sourced, purchased from catalogues, and then shipped to New Zealand. Even if art education in Auckland seemed outdated by the late 1950s when Dodd enrolled at art school, it stood her in good stead. Six decades later, she maintains the studying and copying of plaster casts was a good grounding before moving on to life classes; she went on to become the creator of Hairy Maclary and his friends, which remains an international success. Arguably, majoring in sculpture helped her on her course to being an internationally recognised illustrator (and writer).

THE RUSSELL STATUES, AUCKLAND WAR MEMORIAL MUSEUM

High above the internal front entrance porch of the Auckland War Memorial Museum, New Zealand, is a badly placed life-size plaster cast copy of Myron's *Discobolus* (see Fig. 1.1). It is not until you go upstairs to level one that you're able to view the *Discobolus*, and then only from a distance (though close enough to see that he is missing his left hand!). He is inaccessible given his location. In fact, he is lost amongst the giant fluted Ionic columns flanking the museum's main entrance and is surrounded by museum paraphernalia such as security cameras, electrical conduits and lights. The only advantage of his location is that visitors cannot touch him, so he remains pristine white. This is a sad position for the *Discobolus*. His

companions, *Laocoön* and the *Dying Gaul,* are like white elephants too, as they appear to have been plonked where there is available space.[3] There is no context for the three plaster copies and yet the collection, of which they are a part, played a significant role in the early years of the institution and the establishment of Auckland's first free school of design in 1878. Their history is intriguing and one that was close to impossible to unearth partly because plaster casts of this nature went out of fashion for a long time and also because the temporary nature of the medium has meant many are in a bad condition or have disappeared completely. As a collection, the Russell Statues are no longer together in its entirety.

The Russell Statues were a gift from Thomas Russell (c.1830–1904), a prominent lawyer and businessman. The generous Russell gift numbered 22 life-size statues and 11 busts. The majority were made at the workshop of Domenico Brucciani (1815–1880) of Covent Garden, London. Luigi Finili (c.1823–1904), another major London *formatore,* made the *Bust of Socrates.* The busts of the *Prince of Wales* (later Edward VII) and the *Princess of Wales* are terracotta copies of marble busts made by Count Gleichen (1833–1892), whose death mask was coincidentally made by Finili; the originals were exhibited at the Royal Academy in 1876 and are now in the Royal Collection.[4] The collection included copies of such well-known pieces as *Venus de Milo, Young Bacchus, Diana à la Biche* and the fighting *Gladiator.* The busts were of notable historical figures such as *Caesar* and *Homer,* as well as the goddess *Juno* and the mythological character *Ariadne.*

Like other collections of antique plaster casts, the Russell Statues were, on the whole, third generation. Take the *Bust of Socrates,* for example. Greek sculptor Lysippos made the original, in the fourth century BCE, out of bronze. In turn, an unknown Roman sculptor, in the second half of the first century AD, made a marble copy. And then, in the nineteenth century, a plaster cast was made in Covent Garden, London, and shipped to New Zealand. Given the original no longer exists there is no way of telling what, if anything, is lost or changed with each successive copy. One thing added, to several of the life-size figure casts, was the ubiquitous fig leaf, as was the fashion in the eighteenth and nineteenth centuries; a fig leaf covered genitalia providing modesty. As an aside, at the Victoria & Albert Museum (hereafter V&A) a plaster cast of a fig leaf, for the cast of the six-metre-tall Michelangelo's *David* was kept at the ready should Queen Victoria, or other important women with a propensity to blush, visit. It was easily attached with a pair of hooks. Today, the fig leaf (which has its own accession number: REPRO.1857A-161) is on exhibition as

object in its own right at the V&A. It would seem that *David's* genitalia still have the ability to offend. In late 2021 a three-dimensional printed replica *David*, measuring just over five metres in height, went on display at the World Expo at Dubai. Made of resin and finished off with a brushing of marble dust, the copy had to be positioned in such a way that *David's* genitalia were covered up so as not to offend Muslim visitors.

The 33 Russell Statues were accessioned on 5 August 1878 and displayed alongside Māori taonga and natural history objects such as the skeleton of a giraffe (which was then thought to be that of a moa) and stuffed alpine birds. At that time the museum was located in Princes Street, downtown Auckland, not its current location in Parnell, a short distance away from its original location.

The annual report following the gift is glowing in terms of their reception:

> The plaster copies of 'the unequalled productions of ancient Greece and Rome' posed an instant drawcard, and took credit for increased visitor numbers to the Museum.[5]

Not only did the statues attract the interest of the general public; they were also a catalyst for Auckland's inaugural free school of design. Local artist Kennett Watkins (1847–1933) was appointed as the teacher and students were divided into three classes: copying, drawing from casts and figure or statue drawing.[6] Within the first year of the statues arriving, some 15–20 students had enrolled in classes. Regulations were established and students wishing to be admitted had to prove they could use their pencil.[7] As in Britain and Western Europe, drawing from plaster casts was integral to a formal art education. The free classes were seen as part of a bigger plan for the burgeoning city. As it was delightfully put, they were '… in reality to serve as a wet-nurse to the School of Design of the future'.[8] In 1890, with growing numbers of individuals interested in studying the fine arts, the Elam School of Art was established, with its own set of plaster casts to draw from. The Russell Statues remained on display at the museum and in 1910 it was reported that they were carefully painted with distemper and a new barrier was erected to prevent visitors from touching them.[9] Being made of plaster of Paris made them vulnerable, however. In addition, their porous nature attracted dirt. In 1916 the Russell Statues were moved; it was proposed and accepted that they would be transferred across town to Auckland Art Gallery Toi o Tāmaki (formerly Auckland City Art

Gallery), a location in which it was thought they might be better suited.[10] As an aside, keeping the statues in pristine condition was not entirely possible due to their porous nature and the lack of ongoing maintenance; in the 1920s, when the art school disposed of some of their plaster casts, they were described as grey in colour from too much touching. Antique plaster casts were often painted to cover up graffiti, which in turn peels off, creating another problem.

The twentieth century saw a rapid decline in the drawing of copies. In addition, plaster casts in many museums and galleries increasingly made way for original art. This was the case in Auckland. In fact, plaster casts and their role became obsolete; they took up valuable space in a building that was rapidly filling with a growing collection. The disparate collection has been given ad hoc attention over the past decades; the *Bust of Socrates*, made by *formatore* Finili, has been conserved and is in a good condition. In 2008 it featured in the museum's exhibition 'Secrets Revealed: the backstage mysteries of our museum'; objects from the collection were exhibited as if they were still behind the scenes in storage, including all their packaging (see Fig. 3.2).[11] With 98 per cent of the museum's five million objects usually in storage, this was an opportunity to showcase objects that are kept long-term storage. This was *Socrates'* first moment to shine in decades but unfortunately, in my opinion, he was completely wrapped up with just a tag alluding to what was under the shroud. He was flanked by the busts of the Prince and Princess of Wales, which were covered in sheets of plastic.

Dancing Faun (*The Sprightly Faun*) was destined for inclusion in the museum's celebratory centennial anniversary publication, '150 Treasures' and exhibition. However, conservation work was not completed on the cast until 2002 so it was not included and nor was a substitute exhibited. It is important to note that the work was conserved and not restored so you can see where it is damaged; for instance, the *Faun's* left arm has been broken off at some stage and, though re-attached, there is a gap indicating a loss of plaster. I like this for it not only visually shares the story of the statue's existence but also shows what it is made of (plaster of Paris, metal armature, paint and wood) and therefore has the ability to continue its educative role. On the other hand, close-up examination of the surface of the *Dying Gaul* reveals several attempts at restoration. Brushstrokes are visible and the sculpture's glossy white surface is far removed from its original state. In 1988 art historian Roger Blackley reported on the state of the Russell Statues for *Art New Zealand*. He described the *Dying Gaul*

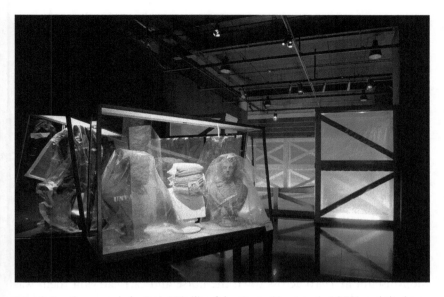

Fig. 3.2 Copy made by Luigi Finili, of the *Bust of Socrates* (c.1878) and the busts of the *Prince of Wales* (later Edward VII) and the *Princess of Wales* (1878), terracotta copies of marble busts made by Count Gleichen in the 'Secrets Revealed: the backstage mysteries of our museum' exhibition, Auckland War Memorial Museum, 2009. (Photo: Auckland War Memorial Museum)

as expiring, sporting a broken neck and arm.[12] Since then the *Dying Gaul* has been pieced back together.

Trying to account for each of the Russell Statues today is complex. Though cared for now to international museum standards, there was a time when this wasn't always the case. When the casts were first installed, security was minimal. As reported at the time:

> Dr. Campbell has undertaken to fittingly place on the required pedestals and brackets this donation, thus relieving the Institute of the attendant expense.[13]

It may have saved the Institute employee costs, but at the expense of the Russell Statues. In November 1900 *Apollino* was knocked over and destroyed completely by three girls. The caretaker took chase, but lost sight of them. The newspaper report suggested the eldest girl was possibly 11 years of age. What is alarming – by today's standards – is that there was

just a single staff member on duty at the time (which meant either that when he left the building to follow the girls, it was completely abandoned or that his chase was delayed while he locked up). *Apollino* was not replaced as the cost was estimated to be at least £20.[14] Around 1915 it is believed that a group of schoolchildren were responsible for breaking *Demosthenes* and in 1945 the *Bust of Caesar* met a similar fate.[15]

Since the late 1980s two published articles, in particular, have gone some way to cement the story and history of the Russell Statues.[16] The works are not the easiest to research; due to time and their size, the statues – or bits of them – have been stored in various places onsite and offsite. Many of the casts today are represented on the museum's website by historical photographs showcasing them in their former glory. In some instances, it is all that exists of them today. There is no definitive evidence for what actually happened, but it is worth sharing two theories about the fate of some of the Russell Statues. One is that the casts were buried in the sand underneath an extension built onto Auckland Art Gallery Toi o Tāmaki in the 1960s; the other is that when they were being moved from the Museum in 1916 across town the horse and cart carrying them was upturned and many of the statues were smashed to smithereens. This makes for entertaining contemporary reading but without evidence, all bar an exhumation, these stories only add to the statues' colourful history. Theories might exist but the bottom line is that from the original collection very few are now in an exhibitable condition; there is only one plaster cast bust (*Socrates*), the two terracotta busts of the royal couple and the four free-standing figures, three of which are on permanent exhibition, that exist close to their original condition. Others have vanished, for instance *Ilissus* has not been seen since it was displayed at the Princes Street building.

Although the *Dancing Faun* didn't make it into the '150 Treasures' exhibition two decades ago, it was included in the 2021 exhibition, 'Manpower: Myths of Masculinity', hosted by the Auckland Art Gallery Toi o Tāmaki.[17] It is empowering to see a work that has languished in storage for decades have a new opportunity to be seen, albeit in a different, yet engaging way about eroticised male bodies underpinning works in the public art museum context.

Returning to the Russell Statues, it would seem that they have had several homes over the years. When they first arrived and were installed at the Princes Street museum building they never really suited the space; large and, by their very nature, intended to be viewed from all angles, they

were packed in amongst the other wide-ranging collection of objects. In 1897 they were relocated into a purpose-built statue hall at the same location. The hall was 15.2 square metres with walls painted a deep Pompeii red, to showcase the white sculptures off to their best. They were well-lit and label information was provided for visitors.

During World War I the museum faced the perennial issue of not having enough space. It was decided that the Russell Statues be moved out of the Statue Hall to make room for the George Grey Collection of Māori antiquities and foreign ethnological articles. Twenty statues were transferred to the city's public art gallery. Along with *Apollino*'s demise, *Demosthenes* had vanished. The full complement of 11 busts was also transferred. It was agreed that the statues were better placed at the gallery, making way for the museum to accommodate its ever-increasing collections. In 1929 the new museum opened its doors in the Auckland Domain. The Russell Statues were moved to the new premises. At some stage, and this is where there are gaps in the records, *Theseus* and *Ilissus* both disappeared. The two statues were seen at the original Princes Street building, where they flanked the entranceway. A conservation report from two decades ago accounts for 11 of the life-sized statues, including several that were in need of repair (in pieces, badly damaged and/or with badly deteriorated surface coatings).[18]

Some might see the Russell Statues as a burden with no clear contemporary objective. However, they do speak to the building that has housed them for nearly a century; a Greek Revival building, the museum has a commanding position atop a hill overlooking the harbour. The statues' upkeep is problematic, expensive and time-consuming. So few exist from the original tally, meaning that arguably those that do should be exhibited better, including access right around them so their three dimensions can be enjoyed and some form of contextual information provided. Behind the scenes of the museum, remnants of the rest of the Russell Statues are carefully stored for present and future researchers. What should never be forgotten is that this gift was instrumental in establishing formal art education in New Zealand's largest city and therefore they served a purpose. The set of antique casts can never be returned to its former glory, yet they do represent a very specific time and place – colonial New Zealand.

The relevance of keeping copies – not just because of the costs involved or storage required but also because of increasing questions around colonialism and also the fact that they were copies – is not just an issue for New Zealand but an international one. Take, for instance, the V&A, which

opened in London in 1873, with the Cast Courts proving very popular.[19] The Cast Courts are a kind of cultural mash-up – you can see in very close proximity a Syrian mosque and Trajan's Column and Michelangelo's *David*. The ceramicist Edmund de Waal (b.1964), an admirer of the Cast Courts, describes it as a cultural pandemonium; they are wonderful records of the past and for those unable to travel at the time of their creation to see the originals, they could study and view copies closer to home.[20] Copies continued to be added to the collection, but by the 1920s their relevance was questioned. As an aside, some questioned that when copies were made there was the potential to damage the original piece in the process (nowadays such copies could be made with totally non-invasive 3-dimensional printing!). In 1928, a report to the V&A suggested disposing of the cast collection believing it was 'injurious to students'.[21] The advice was not taken and in recent times there has been a resurgence of interest in the Cast Courts, with a total refurbishment and re-opening in late 2018.

There's another way of exhibiting the Russell Statues – just as they are. There's no question that they will be de-accessioned, but I worry that they will continue to languish long-term in storage – in the too hard to deal with basket. There is no need to try and restore them to their former glory (*Socrates* looks too new to me); a conservator might suggest that consolidation and stabilisation is the best way to treat such objects. A new way of thinking, coined 'palliative curation', would see a shift from 'curatorial burden' to simply caring for them in their current end-of-life state. And it is worth noting here that the word 'curate' comes from the Latin, 'curare' – to care.[22] Currently the Russell Statues are in an awkward position; a cultural geographer describes such a state as a ' ... tense place between abandonment and attention.'[23] We must never lose sight of the fact that the Russell Statues are made from plaster of Paris, which is, by its very nature, a material with a short life (see Figs. 3.3 and 3.4). The Russell Statues could be displayed as they are today – in various stages of disintegration and, in doing so, museum visitors could see how they were constructed. There's life left in them yet!

SIR STAMFORD RAFFLES, SINGAPORE

Hurtling along on a bus through downtown Singapore in late 2019 I did a double take upon seeing a replica of the iconic statue of Sir Stamford Raffles standing outside the Royal Plaza on Scotts Hotel. It turned out that the statue was simply a gimmick to 'commemorate' 200 years since

Fig. 3.3 Detail of base of plaster of Paris copy of *Polyhymnia*, (c.1878) from the Russell Statue Collection. Collection of Auckland War Memorial Museum. (Photo: Penelope Jackson)

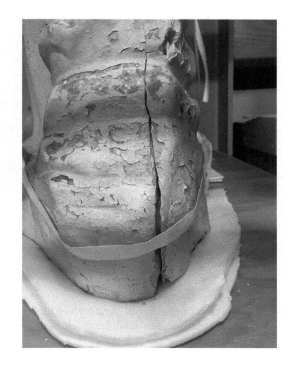

Raffles' arrival in Singapore and to promote a fundraiser for a worthy charity. Clearly Raffles, who changed the course of Singapore's history, is still revered by some. The statue, like Singapore's *Merlion* sculpture, is a brand in its own right. Just six months later, beginning in England, statues around the world were toppled. Others followed suit as the Black Lives Matter (BLM) movement took hold. Not Raffles though, which might have something to do with Singapore's zero tolerance for crime as well as how Raffles has been used as a tool, a catalyst, for new and ongoing conversations. Seeing a 'new' Raffles in front of a hotel made me curious about the original statue and its past.

The statue of Raffles on Boat Quay is well known to me. Having spent my formative teenage years living in Singapore I was aware of its history – albeit a colonial history – and had visited the statue, at the edge of the once-filthy Singapore River, many times. Raffles has historically been labelled the 'founder' of Singapore; the location of the statue on the edge of the river is allegedly the very spot where Raffles first stepped ashore in

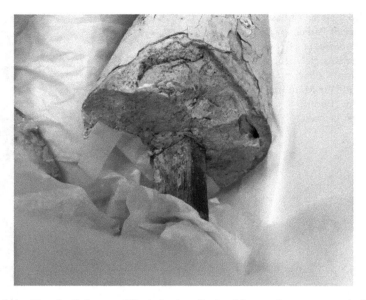

Fig. 3.4 Detail of plaster of Paris broken limb with wooden armature (c.1878) from the Russell Statue Collection. Collection of Auckland War Memorial Museum. (Photo: Penelope Jackson)

1819. On the other side of the river is the *Merlion* sculpture; with a lion's head and a fish body, the *Merlion* is the island city-state's national symbol. A brand, the *Merlion* was unveiled in 1972.[24] Since that time several copies of it, in varying sizes and media, have been installed across the island state.

Standing 2.4 metres high head to toe, Raffles is hard to miss. Atop a plinth, the statue's whiteness is glaringly bright against the backdrop of colonial architecture and tropical vegetation. His stance says so much; arms crossed, chest puffed out and head held high, Raffles is both dapper and commanding. He arrived in Singapore in 1819 (when tigers still roamed around the island). The British Colonial Official secured a deal for the island to be controlled by the East India Company. Raffles died in 1826 and 50 years later Pre-Raphaelite sculptor Thomas Woolner (1825–1893) was commissioned to make a statue of Raffles for Singapore.

Given Raffles was deceased, Woolner must have worked from various portraits to achieve a likeness. Potential sources employed by Woolner were a portrait by George Francis Joseph (1764–1846) dated 1817 in the

collection of the National Portrait Gallery in London (as an aside, there is a copy of this work by John Adamson (1865–1918) dated 1912 at the National Museum of Singapore),[25] a marble sculpture of a seated Raffles in Westminster Abbey made in 1832, and a bust of Raffles by Francis Chantrey (1781–1841), though this was subsequently lost at sea. Raffles' wife Sophia acquired the plaster model used by Chantrey and, in turn, Edwin Roscoe Mullins (1848–1907) made a copy of it; in 1877 this copy was presented to the Zoological Society of London (Raffles was its founder in 1826). What is interesting is that over time this copy came to be regarded as the original and in 1929 it was used to make a bronze model for the 150th anniversary of the Royal Batavian Society of Arts and Sciences; in effect, however, this was a copy thrice removed.[26] In 2005 the Zoological Society of London's copy was stolen. It was replaced the following year with a copy made from glass fibre resin using Chantrey's original plaster model, which is held in a private collection.[27] Sophia Raffles commissioned two further copies of the bust. One copy was for the Singapore Institution and the other for Raffles' cousin Thomas.[28] In short, Woolner had plenty of source material to work from.

Woolner's statue was made in England, cast at Thames Ditton, near London, and then shipped to Singapore. It was unveiled on 27 June 1887, in commemoration of Queen Victoria's Golden Jubilee. Progress of the making of the statue was followed closely in Singapore with *The Straits Times Weekly Issue* announcing in February 1887 that:

> The likeness is striking, and has been considerably improved during the process of finishing.[29]

The statue's home on The Padang proved problematic as spectators took to climbing onto it to secure a better view of cricket matches taking place. At the time of its unveiling, Raffles was criticised for not wearing a hat. Given Woolner had spent 1852–4 living in Australia, perhaps his critics thought he would have had a better understanding of the need to wear a hat in the heat! In 1919 the statue was moved from The Padang to Empress Place in front of the Victoria Concert Hall. During World War II, it was stored at the Syonan Museum for fear of the Japanese melting the bronze down during their occupation of Singapore from 1942–5.[30] In 1946 the Raffles statue was returned to Empress Place.

The white statue that most visitors see today, at Boat Quay, was made in 1972. It is a copy and was made (albeit three years too late) to mark the 150th anniversary of Raffles' landing. A plaster cast mould was made of

Woolner's black bronze statue in situ – with scaffolding erected around it. It took just a few months to complete the copy. To the untrained eye, the statue looks as if it is made from marble. In fact it is made of polymarble, a far cheaper material and one which is much easier to work with than authentic marble. Polymarble is a popular utilitarian material used primarily to make bathroom sink tops. Its cost was an expected S$80,000.[31] At the time there was much debate about Raffles' actual 'landing spot', but finally it was agreed upon.

Apart from the obvious difference of materials – black bronze versus white polymarble – the other point of difference is the text on the plinths. A competition for the wording on the copy was won with these words:

> On this historic site, Sir Thomas Stamford Raffles first landed in Singapore on 28th January 1819 and with genius and perception changed the destiny of Singapore from an obscure fishing village to a great sea port and modern metropolis.

This text was also translated into Chinese, Malay and Indian. Woolner's original sculpture has STAMFORD RAFFLES on the curved base of the statue. The copy does not. When the original was unveiled in 1887 it did not have an information plaque. However, in 1919, when it was re-located, the opportunity was taken to add a plaque given it was a century since Raffles had landed. The plaque reads:

> THIS TABLET TO THE MEMORY OF SIR STAMFORD RAFFLES TO WHOSE FORESIGHT AND GENIUS SINGAPORE OWES ITS EXISTENCE AND PROSPERITY WAS UNVEILED ON FEBRUARY 6th 1919 THE 100th ANNIVERSARY OF THE FOUNDATION OF THE SETTLEMENT.

It is only presented in English.

Installation artists have more recently used the statue to facilitate different perspectives about Raffles. Jimmy Ong (b.1964) has used the copy to 'mock the stance of the statue and provide different perspectives of Raffles as a colonial master'.[32] Ong's *Raffuse Bins/Catchall Trays* (2019) consists of three resin lookalikes of Woolner's statue, minus their heads and feet. As explained it 'is customary to the Javanese sultan's (tradition) of punishing its traitor and enemy'.[33] This alludes to the view that Raffles invaded and looted Java. There is no doubting who the resin-casts are; their stance, body language and clothing replicate Woolner's work to a tee. In *Open*

Love Letters (2018), Ong fashioned a metal copy of the Raffles statue, cut it lengthways, and used it as a charcoal barbeque grill. Cooked on the grill – with the public encouraged to eat them – were thin crispy wafers known as 'love letters' or 'kue kapit'. Significantly, Raffles' role in Ong's work had gone from hero-gentleman to one of a utilitarian stove. Ong's work facilitated conversations and challenged how Raffles has been traditionally perceived and presented.

In a bid to tell and showcase a more inclusive and diverse history of Singapore, the Raffles copy at Boat Quay, was joined in January 2019 by four other statues of significant male leaders (see Fig. 3.5). They are:

1 Sang Nila Utawa (Palembang prince who established the Singapura Kingdom in 1299.
2 Tan Tock Seng (merchant, philanthropist and community leader).
3 Munshi Abdullah (Raffles' secretary, interpreter and regarded as the founder of modern Malay literature).
4 Naraina Pillai (Chief clerk at the treasury and local leader of the Indian community).

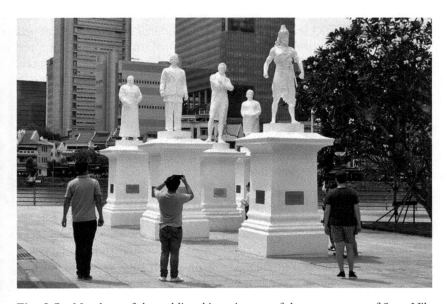

Fig. 3.5 Members of the public taking pictures of the new statues of Sang Nila Utama, Tan Tock Seng, Munshi Abdullah and Naraina Pillai with the 1972 polymarble copy of Thomas Woolner's statue of Sir Stamford Raffles, on Jan 4, 2019. (Photo: Lim Yaohui, *The Straits Times*, Singapore)

Each one is made of fibreglass and stylistically modelled to match Raffles. These four additional figures represent major contributors (albeit all male) to Singapore's history dating back some 700 years. Curiously, the Boat Quay copy of Raffles was made in Singapore a decade following independence and the plastic hotel one even more recently; some would see these examples as a nod to colonialism! When the four new statues were installed in early 2019, Raffles quite literally disappeared, albeit for a week. As part of the installation, Raffles was painted out with grey paint to blend into the building seen directly behind him. The optical illusion – he was completely camouflaged – added to the overall installation organised by the Singapore Bicentennial Office. Interestingly, it was the polymarble copy used for this and not the original Raffles statue around the corner! Perhaps this wasn't so much about the location but that painting over an original statue, and a bronze one at that, would not have been acceptable.

Arthur Pan's *Portrait of Queen Elizabeth II*

Staying in Singapore, which hosts many examples of colonialism, there hangs a portrait of Queen Elizabeth II. Painted in 1953, the portrait was commissioned by the Singapore City Council to commemorate the Queen's coronation. Delivered to Singapore by the Royal Air Force, where it was unveiled by removing the Union Jack at the Council's Chambers on 30 May 1953 along with the opening of the Queen Elizabeth Walk and Esplanade Gardens. The event made the front page of the *Sunday Standard* with the headline, 'Her Big Moment'.[34]

Hungarian artist Arthur Pan (1894–1983) painted the portrait in England. A portrait specialist, in 1943 he painted Winston Churchill, a copy of which was commissioned for the White House. Pan also copied others' works, including *The Shore at Sheveningen* and *Dutch Vessels Close Inshore at Low Tide* both by Dutch artist Willem van de Velde the Younger (1633–1707).[35] Pan signed each copy with his own signature.

Pan's Singapore painting is a formal portrait of the Queen; she wears a strapless evening gown, The Girls of Great Britain and Ireland tiara, and the Royal Family Orders broach. The painting hit the headlines later that decade. In early 1959, when Lee Kuan Yew's People's Action Party came to power, Pan's portrait was removed from the council chamber. *Time* magazine reported the move as:

... the most provocative thing Lee's forces did last week – as if determined to show how untrue were all those stories abroad that the Communists had now taken control of Britain's great Far East naval base.[36]

There were conversations about replacing the Queen's portrait with Yang di-Petruan Agong, the King of Malaya.[37]

The year after Pan painted the portrait he made a copy. The copy is larger than the original and has a couple of subtle differences: the Queen wears a different tiara – George IV State Diadem – and an additional broach, the Deviant de Corsage. Otherwise it is a copy of his earlier work. Records are scant about its provenance; however, the Royal Military College of Science, where the portrait is held, was founded in 1953 (now the Defence Academy formed in 2002), so it is likely it was commissioned for that. Pan must have had good records and photographs of his original work for the copy is remarkably close to it.

Pan's Singapore portrait is now in the collection of the National Gallery Singapore. It was included in the 2016–17 exhibition, 'Artist and Empire: (En) Countering Colonial Legacies', a thought-provoking examination of ways of looking at the empire and how we might use them as tools to redress and revisit such perceptions.[38] Interestingly the extended label and catalogue made no mention of the portrait's removal and its use as a political pawn in 1959. The exhibition was a collaborative project between the National Gallery Singapore and the Tate Britain, yet the copy of Pan's portrait was not included at the Tate Britain. The Singapore exhibition had a different selection of works, with a South East Asian bent. As an aside, it is interesting to note that in a reversal of tradition, Pan's copy for Britain was made after the Singapore original.

FOUR BRITISH MONARCHS

Housed also at the National Gallery Singapore, which is located in the spectacular former colonial buildings (the Supreme Court and City Hall), are four portraits, all copies, of four different British royals. Their role today is very different from when they first arrived in Singapore. Perhaps one of the best examples of 'repurposing' colonial copies I've seen, is the *display* of four portraits of British monarchs and their consorts at Singapore's National Gallery (see Fig. 3.6). Each image is 'famous' in that it was commissioned as an official portrait. Numerous copies were made and distributed, not just to the colonies, but also to the far corners of the

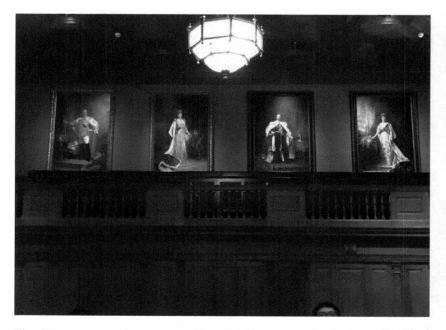

Fig. 3.6 Copies of the portraits of four British monarchs in the former Supreme Court Room, National Gallery Singapore in 2019. Collection of National Museum of Singapore. (Photo: Penelope Jackson)

globe. Today, they can still be acquired in the form of painted reproductions. The four portraits are:

1 Artist unknown (after Sir Luke Fildes), *King Edward VII*, c.1902, oil on canvas.
2 Attributed to F. H. Michael (dates unknown) (after Sir Luke Fildes), *Alexandria, Queen Consort of King Edward VII*, c.1905, oil on canvas.
3 Artist unknown (after Sir Luke Fildes), *King George V*, c.1911–12, oil on canvas.
4 Artist unknown (after Sir William Llewellyn), *Mary of Teck, Queen Consort of King George V*, c.1912–35, oil on canvas.[39]

As the extended label noted, the portraits:

... were displayed in key public buildings serving as symbols and reminders of the British Empire's power and reach.[40]

The earliest work – well the original version of it – is Sir Luke Fildes' (1843–1927) portrait of *King Edward VII*.[41] The Singapore copy is dated c.1902 as its exact maker or date is unknown. The original was painted in 1901 when Edward became King, though his coronation was not until the following year. The King sat for Fildes – in fact, he literally sat, even though Fildes painted him in a standing pose – and the King suggested a few tweaks (he thought he had been presented too short by Fildes) that the artist obligingly made. The canvas was reduced in size at some point and it is assumed that it was signed and dated 1902 on the piece of canvas now tucked under post re-sizing.[42] Queen Alexandria liked the work very much, including how Fildes had captured the King's droopy eyelids. Portraits of this ilk of monarchs varied little and are best described as formulaic. Thus, when reporting about the portrait of *Mary of Teck*, *The Straits Times* noted that 'every picture has to contain the same accessories, the only difference being the person represented'.[43]

Once the originals were completed, the copyists set to work. How many were made of each portrait was not recorded; however, it was anticipated that approximately 30 were required of *King Edward VII's* as they were to be distributed to embassies and institutions around the world.[44] Orders outstripped this anticipation and Fildes, who supervised and oversaw the copying, felt overwhelmed. Copying was carried out at St James' Palace between 1903 and 1907 and Fildes was personally responsible for quality control. The Royal Collection alone holds three copies. George V donated another copy to the National Portrait Gallery, London, in 1912.[45] Fildes also made copies of his own work; one such work is held at St Bartholomew's Hospital Museum and Archive. Professional engravers and publishers, Thomas Agnew and Sons Ltd., made an engraving of the Fildes image, furthering the spread of the official image of the King.

Singapore's copy of *King Edward VII*, along with the three other royal portraits, was originally hung at the Victoria Memorial Hall followed by Government House (now the Istana) until 1961. In 1965, when Singapore gained independence, the four portraits became superfluous to requirements. Consequently, they were put in storage until they became part of the National Museum's collection. As is often the case, such portraits are part of a country's history but their role has changed over time. Their relevance and importance is diminished. To dispose of them – or allow to them languish in storage – is to write them out of history and deny an audience of experiencing formal portraiture, albeit British and not Singaporean art history. However, there is no singular art history and such works have a place, if only for catalysts for debate or decoration.

Colonialism is ever-present in Singapore. The phenomenal National Gallery is housed in the former Supreme Court (opened in 1937) and City Hall (opened in 1929). Both are iconic exemplars of colonial architecture at its finest. And this is where, fittingly, the four portraits have found a very suitable home. At the beginning of this section I used the term 'display' deliberately to describe their location and role. The reason for this is that the portraits are not in or on 'exhibition' per se, but rather are part of a display in the former Supreme Court room that contextualises the building's original role, and its present role as a gallery. Permanently on display on the upper storey, the four monarchs look majestic. The room has been restored to its former glory, including an amazingly intricately designed wooden coffered ceiling. Original documents in display cases and didactic information panels explain the original function of the Court Room in its original form. When the National Gallery took over the building, part of the mandate was to retain the Court Room. Its legacy lives on. The portraits are seen as a foil to the other exhibits; they are very much about presenting Singapore's history from an Asian perspective rather than a colonial and/or European one. To this end, the portraits do not provide an artistic experience, but rather are part of the décor. Described in the accompanying text panel as 'colonial relics' these four portraits provide an insight into taste and are good examples of how the curatorial team have re-worked the programme to include them, with a strong revisionist approach; the transparency of this is refreshing when put simply, such portraits are often seen as past their 'use-by' date. The Court Room showcases a new role for the copies.

As an aside, occasionally copies of the four British monarchs come up for sale. At the time of writing, the Mayfair Gallery in London, had a copy of Fildes' *Portrait of King Edward VII*, attributed to Charles Willis (1878–1963), available for £35,000. In November 2011 another copy of the same work sold for £9375 at auction.[46]

THE WATTLE PORTRAIT

When Queen Elizabeth II visited Australia for the first time, in February 1954 her wardrobe of formal gowns included one inspired by Australia's national flower, the Golden Wattle. It was this particular yellow gown that the Queen wore the following December when she sat at Buckingham Palace for her portrait to be painted.[47] The artist behind the easel was William Dargie (1912–2003),[48] one of Australia's most eminent portrait painters. At the time of painting the Queen, Dargie had been awarded one

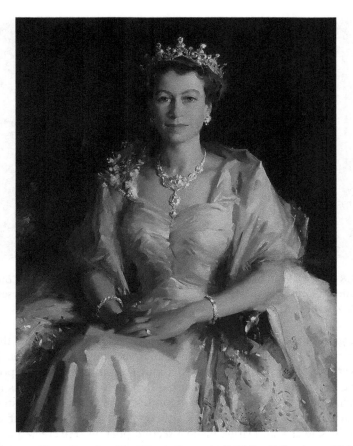

Fig. 3.7 William Dargie, *The Wattle Portrait* (1954). Collection of National Museum of Australia, Canberra. (Photo: National Museum of Australia, Canberra)

of the most coveted art prizes Australia offers – The Archibald Prize – seven times which remains a record (and he went on to win it once more in 1956).

The *Wattle Portrait*, as it affectionately became known, was painted for Australia; the Queen's dress, designed by Norman Hartnell, was worn on her first night on tour in Sydney and the last night in Perth (see Fig. 3.7). Made of gold tulle and adorned with sparkling gold wattle motifs, the dress became a symbol of her Australian tour, the first visit by a reigning monarch.[49] When compared with photographs taken on tour, Dargie's portrait bears an excellent likeness.

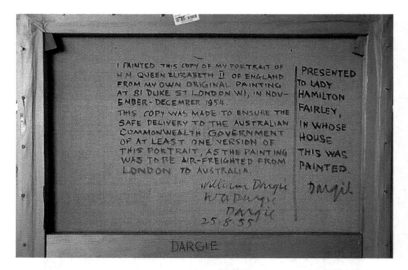

Fig. 3.8 Verso detail of William Dargie, *The Wattle Portrait* (1954). Collection of National Museum of Australia, Canberra. (Photo: National Museum of Australia, Canberra)

Dargie went to London to paint the portrait. He later reported that the Queen posed for her portrait four times in one-hour sessions. James P. Beveridge, an industrialist from Melbourne, commissioned the portrait. Having completed the portrait, Dargie became worried about its trip to Australia and so decided to courier it himself. The portrait was destined to hang at Australia's parliament in Canberra. But before he set off and to ensure its safe arrival, Dargie made a second portrait. He created an exact copy from the original at the home of Lady Hamilton Fairley. His 'Plan B' is clearly articulated on the verso of the copy (see Fig. 3.8). It reads:

> I painted this copy of my portrait of H. M. Queen Elizabeth II of England from my own original painting at 81 Duke St, London W1, in November–December 1954.

He went on to state his objective for making the copy:

> This copy was made to ensure the safe delivery to the Australian Commonwealth Government of at least one version of this portrait, as the painting was to be air-freighted from London to Australia.
> William Dargie
> 25.8.55

The original arrived safely in Australia and therefore the copy was not required; Dargie presented it to his hostess, Lady Hamilton Fairly. The Queen admired the portrait so much that she had Dargie make another copy for her personal collection. Today the original portrait hangs at Parliament House, Canberra. The copy Dargie painted, as a back-up work was later acquired for the National Museum of Australia in Canberra in 2009; it had remained in the Hamilton Fairley family before being offered up for auction.[50] The estimated price was AUD 50,000–70,000; however it sold for AUD 120,000, a record at the time for a Dargie sale.[51]

The reason for the inclusion of the *Wattle Portrait* here is twofold. Firstly, and this is an interesting detail – Dargie made the copy by painting it upside down. He wanted an exact copy; by painting upside down there was no room for change or tweaks to be made. The exactness of his copy is precise. Secondly, Dargie had good reason to be nervous about the transportation of his portrait. There is a catalogue of artworks that have met their end in transit. Courbet's *The Stone Breakers* was destroyed during World War II en route from a Dresden Gallery. In 1962 American Airlines Flight 1 went down along with 15 paintings by Arshile Gorky en route to an exhibition in California. And two Picasso paintings went down with Swissair Flight III in 1998. Sadly, such accidents happen. Further back, when artworks were transported by ship there were also disasters. For example, in 1860 a shipment of 70 plaster casts arrived in Melbourne broken, requiring extensive restoration, and the bust of Sir Stamford Raffles went down in the ship *Fame* on 2 February 1824 when it caught fire and sank (everyone on board survived).

In recent years, there has been much talk of Australia becoming a republic. However, the second *Wattle Portrait* has been a welcome addition to the country's national collection for its iconic Australian quality, by Dargie who was much revered, including being Australia's official World War II artist. Many Australians are well familiar with the *Wattle Portrait* as commercial reproductions graced the walls of schools, libraries, hospitals, and town halls throughout the land. It was also reproduced on Australian naturalisation papers in the form of a cameo-shape so that 'new' Australians became au fait with it. Interestingly, and perhaps indicative of the era, it was estimated that 75 per cent of Australians caught a glimpse of the young Queen when she visited in 1954, making her tour and image truly memorable and cemented in Australia's history.[52]

RAPHAEL'S *MADONNA DELLA SEDIA*[53]

For decades, art historian Frederick Hartt (1914–1991) was the world authority on Renaissance art and architecture. His 1969 tome, *History of Italian Renaissance Art: Painting, Sculpture, Architecture*, is over 600 pages long and went into several editions. Even in New Zealand it was a high school textbook. Of Raphael (Raffaello Santi 1483–1520), Hartt waxed lyrical: 'As a portraitist Raphael was second to no Renaissance painter.'[54] High praise indeed and when you engage with his *Madonna della Sedia* you can see why Hartt drew his conclusion.

Raphael's Madonna in *Madonna della Sedia* took on the appearance of a young Italian woman; clad in peasant dress she cuddles the Christ child as St John looks on. They are a tight-knit group, an everyday scene in many ways. And it was this treatment that was a visual revelation; his breakthrough in treatment – of humanising and normalising the Holy Family – is undoubtedly the reason for its popularity and for the myriad of copies made of it, over time and place. Many copies found their way to the colonies for secular, domestic and religious collections in the colonies.

Pope Julius II summoned Raphael to Rome at the end of 1508. It was in Rome that he would execute his finest, largest, and most adventurous works of his career – the frescoes for the Papal Apartments at the Vatican. But Raphael managed to find time to make some other works, including the relatively small – 71 × 71 cm – *tondo* oil painting, the *Madonna della Sedia*. Painted during 1513–14, legend has it that the work is round in shape as it was painted on the base of a wine barrel. The resulting oil on wood gives it a richness and depth of tonal range that enhanced the subject matter. Its earthiness worked well with the figures. A heavy ornate gold frame surrounds Raphael's original work and today it hangs in Florence's Palazzo Pitti.[55] From 1798 until 1815, the *Madonna della Sedia* was in Paris having been scooped up my Napoleon for the Louvre's collection.

Copies of the *tondo* – including the frame – hang in public and private collections worldwide. Greatly admired, there are too many copies, in varying media, scale, and quantity to count or discuss here. A work of great beauty, it is easy to see why the image is universally adored; appealing to copyists particularly in the nineteenth century, when ease of access to copy it, and global expansion to America and the Pacific region, saw numerous copies made. Queen Victoria commissioned a copy in 1851 for her beloved Prince Albert, who greatly admired the work. The watercolour copy was painted by Royal Academician Robert Thornburn

(1818–1885). To this day it hangs in the Prince's Drawing Room and Writing Room at Osborne House on the Isle of Wight.[56]

Trying to understand why copies were acquired and who made them helps to build a picture about colonial collectors and collections. Visiting the historic Elizabeth Bay House on the edge of Sydney's harbour some years ago, I recalled seeing a *Madonna della Sedia*; its lavish gold frame makes it visually memorable. It occurred to me too that it was a very Catholic painting in a secular home. Built for Alexander Macleay, the Colonial Secretary, in 1835, the imposing home was based on houses found at London's Regent Park area. Knowing the painting was a copy I saw it as showcasing the family's wealth, status, European heritage and appreciation for fine art. Each of these reasons was important in nineteenth-century settler society. As it turns out, the painting was on loan from the Art Gallery of New South Wales when I visited, to embellish the home's décor. The gallery often loans works out in a bid to share their collection to a wider audience and work in partnership with heritage organisations.

The helpful staff at the Art Gallery of New South Wales offered to answer my questions about their copy. It turned out to be a bigger task than first intended, as they found that they actually had two copies of the *Madonna della Sedia* in their collection. Closer investigation has revealed more about the makers of the copies and also some similarities.

Michel Angelo Orsi of Pisa painted the copy on display at Elizabeth Bay House, in 1868, by which stage he had been copying for at least two decades. Although Orsi's copies come up regularly at auction, very little is known about him. He did, however, paint another copy of the *Madonna della Sedia* in 1869.[57] The one in Sydney one was purchased by Josiah Mullens (1826–1915) in 1890; the copy was gifted to the Art Gallery of New South Wales and upon its arrival at the gallery was hung with the other Old Master copies. In 1976 the copy went to Elizabeth Bay House on what is termed a 'furnishing loan'. In other words, it was seen as part of the house's décor. Orsi's copy was formally accessioned in May 2021, over 130 years since it first arrived at the gallery.[58]

The other *Madonna della Sedia* copy held by the Art Gallery of New South Wales was painted in 1861 by an artist from Hamburg called Herr Arnold.[59] Two years after the copy was made, John N. Dickinson purchased the work from the artist and in 1899 it was gifted to the gallery. It differs from Orsi's copy in that the frame is far more elaborate – though now damaged – and mimicking the original at the Pitti Palace.

Of a similar size to the original painting, Helen Mary Dickinson gifted Sydney's copy to the gallery in 1899, along with 35 other Old Master copies and five original works. Her father, Sir John Nodes Dickinson, a former Judge of the Supreme Court of New South Wales, commissioned all 36 copies. His daughter decided to make the gift to the gallery in his memory. Again, this comes down to nineteenth-century taste and attitude; Australian art in the Western tradition at the time was truly exciting and innovative with the late development of its own brand of Impressionism, remaining popular to this day. However, having a set of Old Masters, albeit copies, in the city's public art collection was typical of the era and the philosophy around European art, which was regarded as being of a higher, and more educative, value. The gifted works hung in the gallery for some time, as reported in 1937, especially while permanent displays were in vogue.[60] The inclusion of copies on permanent exhibition didn't go without criticism, however. In fact, some comments were scathing. In 1914 the *Daily Telegraph* recorded the attitude of the Premier of New South Wales, William Holman, towards copies:

> There are, it is true, copies of old masters – copied vilely done, copies which, with a new trust, and an energetic fire brigade to make sure that there is no spreading of the conflagration, will probably be burned some of these days. The sooner they are gone the better for the taste of our art students and the extension of art.[61]

In more recent times, the desire to show copies has continued to decline; hence the loan to Elizabeth Bay House. Neither copy has been exhibited in the Art Gallery of New South Wales for decades.

Perhaps it is unsurprising that the two works were conflated into one. They have several similarities. Both copies were made in the 1860s and both were made in situ at the Pitti Palace. We know this because on the verso of each work is an inscription from the gallery's inspector authenticating them as copies of Raphael's original. Both are signed by Inspector Chiaviacci and have a red wax seal. In addition, their canvas sizes are almost identical, just shy of the original's size of 71 × 71 cm. And both copies were gifted to the Art Gallery of New South Wales in the 1890s.

Even further from Florence, more copies of the *Madonna della Sedia* are to be found in public art galleries; in New Zealand, for example, there are two such examples. One is held at Auckland Art Gallery and the other at the Sarjeant Gallery in Whanganui.[62] The latter is the superior copy of two (see Fig. 3.9). How it got to small-town New Zealand is significant in understanding the role and perceived importance of copies. John Armstrong Neame and Henry Sarjeant's widow, Ellen Neame, gifted the Sarjeant's copy

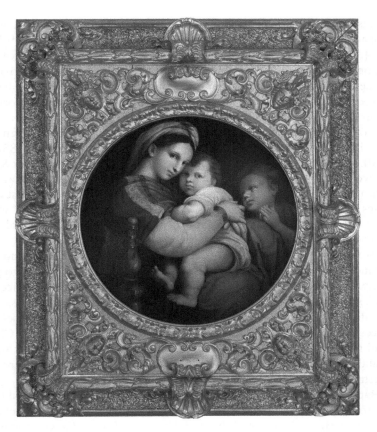

Fig. 3.9 Copy of Raphael's *Madonna della Sedia*, Collection of Sarjeant Art Gallery, Whanganui, unknown artist. (Photo: Sarjeant Art Gallery, Whanganui, New Zealand)

in 1914. When Henry Sarjeant died in 1912, he bequeathed substantial funds to build and maintain a public art gallery for the people of Whanganui, a town with a population of just under 15,000 in 1911.[63] Ellen, 40 years his junior, remarried and throughout the rest of her life continued to acquire works for the Sarjeant's collection on her regular trips to Europe. It was on her 1914–15 trip that the Neames purchased, in Florence, a copy of *Madonna della Sedia*. The copyist is unknown, but a note on the painting's verso reads:

J Armstrong Neame/Florence 26th March 1914

It was purchased in Florence from the picture dealers, Flor & Findel. The acquisition was recorded in the council meeting minutes of 19 May 1914, including the painting's cost of 675 francs.[64] Seen as a gem of this regional collection, the gallery's staff describes the copy as a 'crowd-pleaser'. It is not just the painting that intrigues visitors – it's the hand-carved wooden frame too, which is close in design and level or ornate detail to the original, but with just a few subtle differences. The frame is one of the Sarjeant's most ostentatious in the collection. Though the copy is undated, the frame gives a clue to its age as it dates from 1850 to 1880. In the context of the era, the acquisition of *Madonna della Sedia* sat well with the extensive British and European art holdings at the Sarjeant. Today the collection spans the sixteenth to the twenty-first centuries thanks to Henry Sarjeant's philanthropy. Having a 'Raphael' was a coup for Whanganui. Indeed, this kind of acquisition was colonial collecting at its best.

Bringing a touch of the Renaissance to Australia and New Zealand was significant on many levels. As an exemplar of good art, you cannot go past a Raphael. The *Madonna della Sedia* was a particularly good choice for 'she' speaks to everyone, including the colonials. Her pose, dress and overall demeanour made it the kind of image that could be hung in secular spaces, not just in a church context. Both the Madonna and the Christ child have haloes, but they are so fine and subtle, making the work more palatable for secular audiences. For those who gifted the copies, there was a certain amount of kudos that went along with the act of giving.

Raphael's relatively small *tondo* was copied – and continues to be copied to this day – ad nauseam. Nineteenth-century American novelist Nathaniel Hawthorne noted that the *Madonna della Sedia* was 'the most beautiful picture in the world', having seen hundreds of engravings and copies of it.[65] The art critic John Ruskin, who visited Florence in 1845, noted that the work was 'very uncopiable'.[66] He has been proven wrong. But interestingly, the *Madonna della Sedia*, for all its copies and attention, did not make it into Hartt's tome!

In the era when these gifts were given to public art collections, institutions did not have the stringent collection policies and strategies or record keeping devices of a modern-day museum. It is unsurprising that Sydney ended up with two copies of the *Madonna della Sedia*. At the time, copies were warmly accepted to create European collections and to educate colonial audiences of high art (or perceivably higher than Australian and New

Zealand art). It is impossible to measure the number of copies of the *Madonna della Sedia* in existence. That Britain's National Trust has at least 15 copies gives an indication to its popularity for copyists and collectors alike. It is no wonder, then, that several made their way to the Antipodes.

THE ROBERT BURNS QUARTET

With the exception of the *Wattle Portrait*, the artworks discussed so far were made by artists other than the original artist. There is another exception however, that being a work that is part of an edition. An edition is an artwork that is made from, and after, the original, either by the autographed artist, or under the supervision of that artist, or as in the case of the Edgar Degas's (1834–1917) *Little Dancer Aged Fourteen* (1880–1) (cast c.1922) in the Tate, produced after the artist's death. In a way, being one of an edition can remove the stigma of being the poor colonial relative, or second-best. An artwork from an edition enjoys a different status to that of a copy or a replica. Furthermore, in some cases, such as with sculpture and printmaking, slight changes and adjustments can be made as more editions are made.

Gracing Dunedin's city centre in the Octagon is a statue of eighteenth-century poet Robert Burns. Appropriate for its location – Dunedin is the so-called 'Edinburgh of the South Pacific' – the statue is the fourth in an edition of four made by sculptor, Sir John Steell (1804–1891). Steell, like his subject, was a Scot. Cast in bronze, Burns is larger than life size, and sits atop a tree stump, quill in his hand, and a scroll at his feet, with the inscription 'To Mary in Heaven'. The poet gazes pensively into the distant sky; the youthful Burns is placed on a plinth of polished red granite, quarried in Scotland and shipped to Dunedin (this was obviously to mimic the other versions, even though New Zealand has its own fine stone that would have sufficed). Burns' dates – '25 January 1759–21 July 1796' – are inscribed on the plinth. An additional plaque was added in 2011 by the Robbie Burns Club to give a context for Burns and his achievements. It also provided the New Zealand link. The co-founder of the Otago Settlement in 1848, and Presbyterian Minister of Dunedin's First Church, was Thomas Burns, whose uncle was Robert Burns. This link was perhaps the icing on the colonial cake.

The first in Steell's edition is located in New York's Central Park, at the south end of the literary walk. It was dedicated on 2 October 1880 and,

two weeks later, Dundee unveiled their statue, the second version in the edition. In 1884 another was installed on the Thames Embankment, London. And lastly, on 24 May 1887, Dunedin's was unveiled. The order in which the statues were made – and unveiled – is significant. Dunedin's committee was outraged when news broke that London was to receive their statue earlier as Dunedin believed that London had jumped the queue.

Steell made changes as each new commission came along. Early on, he was criticised for the positioning of Burns' head; stargazing, some argued the angle was too severe. In Dunedin's version this was altered, as were the positioning of Burns' legs. Clearly, from a sculptor's perspective, the ability to make slight tweaks as the edition progresses is advantageous. Arguably, this gives Dunedin's sculpture a point of difference to its predecessors. Perhaps, on reflection, it was worth being fourth and last in line!

Steell was working with a deceased subject. To model Burns, Steell called upon Alexander Nasmyth's (1758–1840) 1787 painting *Robert Burns 1759–1796*, which is held in the collection of the Scottish National Portrait Gallery.[67] It is perhaps the best-known portrait of the poet and has been reproduced in many forms several times over. As an aside, Nasmyth made copies of his *Robert Burns 1759–1796*, including a version held in London's National Portrait Gallery which was commissioned in 1820 by George Thomson, a collector of Scottish songs.[68] Steell also took measurements from a plaster cast of Burns' skull at the Edinburgh Phrenological Society in a bid to get the best possible likeness for his subject.

Significant also is the fact that Steell made all four statues. In effect, he copied his own work, making him in control of it. Thus, there is no question of changing the artist's original intent. Even with studio assistants helping, Steell oversaw the casting. This is a very different scenario from other copies made long after an artist's death when processes and taste can change (I'm thinking here of fig leaves added to cover up male genitals on sculptures, a practice especially rife during the Victorian era). Steell carried out two castings. Dunedin's was the second. The head modification would have been relatively straightforward to change as sculptures of this size were made in parts – the head separate – and joined together. London's version is not an exact replica of the New York one either, as Burns' back is straighter and the angle of his head not as severe.

Steell's statues of Burns also raise questions about terminology and how to label them accurately. I have used 'edition', 'version', and 'replica' here. The *Scotsman* newspaper, referencing the New York Burns, wrote that 'carbon copies of the statue' existed elsewhere. Carbon copies, the

phrase coined for the use of carbon paper, are exact identical copies. The Burns statues are not exactly the same. Editions are generally numbered; Steell did not number his Burns statues but given the good documentation available about which order they were made in perhaps there was no need. Each one bears his name, the date of execution, and Edinburgh, being the place of execution. Fundamentally, Steell made copies of his original sculpture. Additional orders/commissions gave him the opportunity to make more, with slight adjustments. Steell must have been pleased with the additional orders for he described the Burns statue as the best work he had ever completed.[69]

Burns' fame is global; he is immortalised in approximately 60 sculptures worldwide. In Dunedin his name is synonymous with a writing residency, poetry competition and a public drinking house to name but a few. In the context of colonialism, Dunedin's was the fourth and last of this particular tribute to the poet, yet it feels more than just a copy for the artist very much had a hand in its making giving it equal status. Being a copy in this context does not diminish its status as a piece of public art.

* * *

Copies played significant and different roles within colonial contexts; those roles have changed and evolved over time. When scoping examples for this chapter I was overwhelmed with choice. The quantity is testament to how valued they were, whether for public or private or religious or secular venues and contexts. Today, there is a big question about what to do with copies; some are bound by collection policies and cannot be de-accessioned even if they are no longer used, surplus to requirements, or, do I dare say it, an embarrassment. Others, like the Art Gallery of New South Wales' *Madonna della Sedia*, have taken on new roles such as being loaned to other venues instead of languishing in storage. There is no doubt that the copies discussed in this chapter smack of colonialism, not only by subject matter and who and what they represent, but also how they were sourced and collected. We cannot lose sight of the good intentions of early donors and collectors; it was the right thing to do at the time. Some maintain that a way forward is to deny copies an audience. The 2020 BLM campaign, especially in Britain, demonstrated how public art is vulnerable with some, and many pieces vandalised or destroyed. The former colonies also faced the same opposition to continuing to display works of this ilk. As in the case of Delhi's Coronation Park – which once

showcased monarchs, governors and officials of the British Raj – is now best described as a graveyard of vandalised and destroyed statues. Copies are political on all kinds of levels. In the context of protest, there is no differentiation between copies and original artworks. It is what they depict and symbolise that is important. However, colonial copies – whether we like it or not – are one of our many histories. There is not a singular history and this is perhaps where they fit: they assist in telling a narrative. Copies can be catalysts for conversations and change in both attitude and how history is revisited. The example of Singapore's four royal portraits is a superb example of looking forwards; keep them, display them and use them to tell part of a rich and diverse history. Transparency is the key to the display of these works. They do not pretend to be anything but copies made in a time when it was accepted and expected practice. Their role has changed significantly, yet there is no denying their existence.

NOTES

1. Dame Lynley Dodd (née Weeks).
2. Collection of the Louvre, Paris [Ma525], marble, 1.64 m.
3. The *Dying Gaul* is also known as the *Dying Gladiator*.
4. Collection of the Royal Collection Trust, Britain [RCIN 2066 and RCIN 2067], 78 and 78.8 cm including base, marble.
5. Annual Report of the Auckland Institute for 1878–9, p. 8.
6. Stead, Oliver. *150 Treasures*. Auckland: Auckland War Memorial Museum, 2001, p. 12.
7. *The New Zealand Herald*, 14 October 1878, p. 2.
8. Ibid.
9. Annual Report of the Auckland Institute for 1910, p. 9.
10. Auckland City Art Gallery was renamed Auckland Art Gallery Toi o Tāmaki in 1996.
11. Exhibition dates: July 2008 to March 2009.
12. Blackley, Roger. 'The Greek Statues in the Museum' in *Art New Zealand*, Vol. 48, Spring 1988, p. 96.
13. *The Thames Advertiser*, 9 October 1878, p. 3.
14. *The New Zealand Herald*, Vol. XXXVII, Issue 11534, 20 November 1900.
15. Email correspondence with Anna Beazley, Auckland War Memorial Museum, July 2021.
16. Blackley, Roger. 'The Greek Statues in the Museum' in *Art New Zealand*, Vol. 48, Spring 1988, pp. 96–9 and Richard Wolfe, 'Mr Cheeseman's Legacy: The Auckland Museum at Princes Street', in *Records of the*

Auckland Museum, Vol. 37/38 (2001), pp. 1–32. Published By: Auckland War Memorial Museum.

17. Exhibition dates: 15 November 2021–16 July 2023..
18. Email correspondence with Auckland Art Gallery Library, July 2020.
19. The V&A was originally named The South Kensington Museum.
20. Fox, Killian. 'On my radar: Edmund de Waal's cultural highlights' in *The Guardian*, 9 October 2021.
21. https://www.vam.ac.uk/articles/history-of-the-cast-courts
22. 'Curatorial burden' was an expression Roger Blackley used in 'The Greek Statues in the Museum' (see endnote 16).
23. Desilvey, Caitlin. *Curated Decay: Heritage Beyond Saving*. Minneapolis: University of Minnesota Press, 2017, p. 21.
24. There was very little about the Merlion's unveiling in the media at the time as major daily newspaper, *The Straits Times*, as the staff was on strike.
25. Collection of the National Portrait Gallery, London [NPG84], oil on canvas, 139.7 × 109.2 cm. A copy of the work is held in the collection of the National Museum of Singapore [HP-0034], oil on canvas, 140 × 109 cm, dated 1912.
26. Archer, M., & Bastin, J. *The Raffles drawings in the India Office Library, London*. Kuala Lumpur: Oxford University Press, 1978, p. 13.
27. Email correspondence with Ann Sylph and Emma Milnes, Zoological Society of London, July 2021.
28. Glendinning, Victoria. *Raffles and the Golden Opportunity 1781–1826*. London, Profile, 2012, p. 299.
29. *The Straits Times Weekly Issue*, 21 February 1887, p. 3.
30. Syonan Museum was formerly Raffles Library and Museum.
31. 'Marble replica to mark landing of Raffles', *The Straits Times*, 30 July 1971, p. 9.
32. 'Tanya Ong, S'porean artist turns Raffles' statue into grill, gives alternative take on viewing history and Raffles', 1 March 2018, http://mothership.sg
33. www.pluralartmag.com
34. 'Her Big Moment', 31 May 1953, *Sunday Standard*, p. 1.
35. Present whereabouts unknown. Both copies sold at auction in 2001 (Lot 608 Dee Atkinson & Harrison, UK).
36. 'Singapore: The Takeover', *Time*, Vol. 73, Issue 24, 15 June 1959.
37. 'Replace picture when people are ready', *The Straits Times*, 21 February 1959, p. 4.
38. Exhibition dates: Tate Britain 25 November 2015 – 10 April 2016 and the National Gallery Singapore 6 October 2016 – 26 March 2017.
39. All collection of National Museum of Singapore [HP-0029/HP-0043/HP-0027/HP-0009], oil on canvas, 187 × 122 cm for each except HP-0009 is 188 × 123 cm.

40. Label information as at November 2019, National Gallery Singapore.
41. Collection of The Royal Collection Trust, London [RCIN404553], oil on canvas, 265.7 × 170.1 cm, dated c.1901/2.
42. Email correspondence with Alex Buck, The Royal Collection Trust, 11 August 2020.
43. 'The Queen's Portrait', *The Straits Times*, 14 July 1911, p. 3.
44. https://www.rct.uk/collection/404553/king-edward-vii-1841-1910
45. Collection of the National Portrait Gallery, London [NPG 1691], oil on canvas, 275.6 × 180.3 cm.
46. The Forbes Collection at Old Battersea House, 1 November 2011, Lyon & Turnbull Auctions.
47. Collection of Historic Memorial Collections of Parliament House, Canberra, oil on canvas, 1954, 127.6 × 102 × 10 cm (framed).
48. William Dargie was knighted in 1970.
49. https://www.nma.gov.au/explore/collection/highlights/queen-elizabeth-ii-wattle-painting
50. National Museum of Australia, Canberra [2009.0016.0001], oil on canvas, 1020 × 760 mm (canvas size), 1130 × 876 × 90 mm (framed size).
51. Lot No 47, Bonhams & Goodman, Melbourne, 6 May 2009.
52. https://www.nma.gov.au/explore/collection/highlights/queen-elizabeth-ii-wattle-painting
53. *Madonna della Sedia* is also known as *Madonna of the Chair* and *Madonna della Seggiola*.
54. Hartt, Frederick, *History of Italian Renaissance Art: Painting, Sculpture, Architecture*, New York: Harry N. Abrams, 1969, p. 467.
55. The *Madonna della Sedia* originally hung in the Tribuna at The Uffizi, Florence.
56. Collection of The Royal Collection Trust, London, [RCIN 450007], watercolour, 48.3 × 48.3 cm.
57. Location unknown.
58. Collection of the Art Gallery of New South Wales, Sydney [SID82483], oil on canvas, 75.5 × 75.5 cm (canvas).
59. Collection of the Art Gallery of New South Wales, Sydney [4494], oil on canvas, 74.9 × 73.7 cm (canvas).
60. 'Miss H M Dickinson obituary', *The Sydney Morning Herald*, 18 May 1937, p. 8.
61. 'Copies in the Art Gallery – Mr. Holman as critic', *Daily Telegraph*, Sydney, 31 July 1914, p. 4.
62. The *Madonna della Sedia* in Auckland Art Gallery's [1895/1/2] collection is a quarter of the size of the Sarjeant Gallery, Whanganui's copy [1977/40/1] which measures 1380 × 1165 × 160 mm. Both are oil on canvas.

63. New Zealand Census 1911 (Statistics New Zealand).
64. Whanganui District Council Archive AAF63:11.
65. Golzio, Vincenzo, 'Raphael and His Critics' in *The Complete work of Raphael*, NY: Reynal & Co, 1969, p. 637.
66. Comment from: http://www.nationaltrustcollections.org.uk/object/732245
67. Collection of the National Portrait Gallery, Scotland [PG1063], oil on canvas, 63.5 × 57 × 9 cm (framed).
68. Collection of the National Portrait Gallery, London, [NPG46], oil on canvas, 40.6 × 29.2 cm.
69. Edward Goodwillie, *The World's Memorials of Robert Burns*. Michigan: Waverly, 1911, p. 48.

Paintings-Within-Paintings

On the outskirts of the South Australian town of Hahndorf, artist Hans Heysen (1877–1968) and his daughter Nora Heysen (1911–2003), lived and painted at their large country property. The property, known as 'The Cedars', became the subject and inspiration for several paintings, including *Cedars interior* painted by Nora Heysen in the early 1930s (see Fig. 4.1).[1]

Typical of her generation of female artists, Nora Heysen painted interior scenes; close at hand, interiors provided free and available subject matter. Bathed in dappled light, *Cedars interior* depicts a corner of the music room at the family home. Painted in a Vermeeresque manner, Nora Heysen included two artworks in her composition. Centre stage is a reproduction of Johannes Vermeer's (1632–1675) *Girl with a Pearl Earring* of 1665. Her father was particularly fond of this work and ordered a reproduction – a copy – from Europe. Both artists admired Old Masters and in some way this painting can be seen as a homage to Vermeer. Perhaps of greater significance here (because there are Vermeer reproductions everywhere) is Nora Heysen's inclusion of a copy of her father's still-life painting, *Zinnias and Autumn Fruit*, dating from 1923.[2] This painting has an interesting backstory. In 1926, during the Australian leg of her world tour the renowned ballerina Anna Pavlova fell in love with *Zinnias and Autumn Fruit*. In fact, she wrote Hans Heysen a blank cheque for it. He refused, however, to sell the work he'd painted as a birthday present for his wife Sallie. As a snapshot in time and place, *Cedars interior* is an exemplar. For

P. Jackson, *The Art of Copying Art*,
https://doi.org/10.1007/978-3-030-88915-9_4

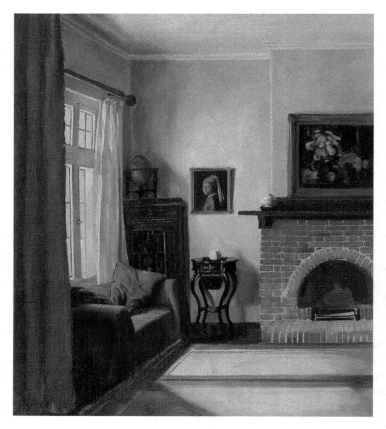

Fig. 4.1 Nora Heysen, *Cedars interior* (c.1930). Collection of Hahndorf Nora Heysen Foundation. (Photo: Lou Klepac)

Nora Heysen, the motivation for including the paintings was perhaps more to do with availability and familial surrounds. From a contemporary perspective, the work provides us with a glimpse into the lives and working practices of two artists, a generation apart. Today 'The Cedars' is a museum and visitors can experience both the home and studios, though the copy of the Vermeer has been moved from the left of the fireplace in the music room.

The motivations for including paintings within paintings are wide and varied. A genre in their own right, they are often referred to as 'museum paintings', especially when they depict the interiors of public art

museums.[3] The tradition is a long one with its heyday and greatest con-
centration being in the eighteenth and nineteenth centuries when artists
frequented the newly opened public art museums to study the work of
others by means of copying. From this practice we now have a catalogue
of paintings that contain copies – miniature paintings. They can be gran-
diose or low-key, depending on their size and context. The reasons for
viewing them today have changed from the situation in which they were
originally made. They also offer a level of curiosity; puzzle-like, it is enter-
taining to try and identify all the artworks copied. Prior to the advent of
photography – as well as touring exhibitions – these sorts of paintings
were a great way to share art and exchange ideas. The significance of Nora
Heysen having a Vermeer print in near proximity is explained in the open-
ing line of the *Cedars interior's* exhibition label:

> Even before she had seen it 'in the flesh', the colours and compositions of
> seventeenth-century Dutch painting manifested strongly in Nora's work.[4]

Furthermore, they were records of how art collections were hung in both
domestic and public contexts. From a copying perspective, this genre
offers different insights, namely reasons for choices, how close the copies
are to the original works and, lastly, the reception of this painting subject.

THE ART MUSEUM INTERIOR

Paintings depicting the interiors of art museums and galleries containing
copies of artworks were often made as a way of recording collections and
to share those images with those who could not afford the luxury of trav-
elling to view them in person. One of the best examples of this, not just in
a pictorial sense but also the artist's agenda, is *Gallery of the Louvre* by
American artist Samuel F. B. Morse (1791–1872) (see Fig. 4.2). The
painting showcases 38 paintings alongside visitors and sculptures on a
single canvas.[5]

Of the Morse Code fame, Morse was in Paris studying and making cop-
ies of paintings and sculptures during 1831–2. His studies ultimately came
together in a large canvas measuring 187.3 × 274.3 cm. Morse gave close
and careful consideration to his choice of paintings to include; from the
outset he saw the work as instructional as it was his intention to take the
painting back home for American audiences. In other words, he saw it as
an educational tool and a way of providing access to many significant

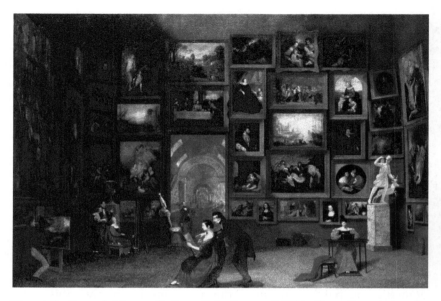

Fig. 4.2 Samuel Morse, *Gallery of the Louvre* (1831). Terra Foundation for American Art, Daniel J. Terra Collection. (Photo: Granger Historical Picture Archive/Alamy Stock Photo.)

artworks located in Paris. Additionally, all these mini paintings were in colour in an age when reproductions in books were monochromatic. To this end, the painting contains very accurate copies of the paintings but the order in which he has them installed is not true to life. All of the paintings are identifiable, ranging from Tintoretto to Poussin to Veronese to Rubens. It is a staggering line-up of the *crème de la crème* of the Louvre's collection.

Morse chose the Louvre's Salon Carré (Square Gallery) as the stage to showcase his chosen line-up. We, the audience, look onto the stage, where people are grouped according to their activities. Paintings line the three walls and the large doorway leads the eye through into another gallery space with its superb coffered ceiling. In 2012, the painting was conserved, bringing out the detail of the coffering more fully. This last detail gives the painting depth as well as showcasing Morse's artistic prowess at perspective.

What is interesting is the process behind the making of Morse's formal painting. He worked day in, day out at the Louvre, making miniature copies of his chosen works. At times Morse worked up on a stand, enabling him to get up close to the paintings. He may also have used a camera obscura to make his copies. Morse began *Gallery of the Louvre* in the autumn of 1831 and it took him 14 months to complete. Morse's composition also includes small groups of people, not only to give the artworks and gallery a sense of scale but also as part of the learning experience; Morse himself takes centre stage. His self-portrait is in profile as he leans over the shoulder of a female copyist. This too is evidence of copyists at work.

On completion of *Gallery of the Louvre* Morse envisaged that he would tour the painting to several cities, but the painting did not have the dramatic impact on the American public which he had hoped for. Morse's intention was to fill the void in American museums that lacked their own French or Italian masterpieces to exhibit. His plan did not materialise and after the work was shown in New York and Connecticut, Morse gave up trying to secure venues and audiences alike. By 1837, he had moved away from painting altogether and onto a new way of communicating, the electromagnetic telegraph. Morse eventually sold *Gallery of the Louvre* for half the asking price. In 1884 it was gifted to the University of Syracuse and in 1982 they sold it to Daniel J. Terra who paid USD 3.25 million for it, at that time the highest price ever paid for an American artwork. More recently, in 2014 the owners of the painting, the Terra Foundation, announced a nine-venue tour from 2015–18 of the painting. Enjoying somewhat of a comeback (or perhaps the launch that it never really got) the work was described and marketed as being ' ... recognised as a key work in the development of American art'.[6] *Gallery of the Louvre* received a belated welcome; for example, when displayed in Seattle in 2015 the painting was flanked with drapes adding to the overall theatricality of the work.

When Morse set out to paint what would be his pièce de résistance he knew that the proof of its success would be the accuracy of his copying. The photographic likeness he rendered makes for accurate copies. What Morse also gave us in this painting was the people and their roles. He reinforces for us the significance, and popularity, of the copyist at work. Morse wanted to take the *Mona Lisa* to his fellow Americans. As it turned out they were not ready for it, especially at being charged 25 cents each to view *Gallery of the Louvre*. Fortunately, its legacy has now come into play

and the 38 copies that make up this *tour de force* add to America's artistic and social history.

As Morse's painting was always intended to be instructional he organised his composition so that the majority of works could be seen face on, in contrast to Giuseppe Castiglione's (1829–1908) 1861 painting *View of the Grand Salon Carré* in the Louvre, where many works on the sidewalls are severely foreshortened and hard to recognise with great accuracy.[7] Castiglione's handling of paint is looser than Morse's – the date of the painting in the 1860s goes someway in accounting for this. The challenge, or dilemma, for painters of interior gallery scenes has always been do they (a) paint each miniaturised painting in its original style as Morse did – 38 individual styles?, or (b) paint the entire scene in their own style as Castiglione did? In the latter's work, you can still identify some works but the real-life detail is somewhat lost.

An artist who painted several interior gallery scenes was American Enrico Meneghelli (1853–after 1912). On a much smaller scale than Morse's or Castiglione's paintings, *The Picture Gallery in the Old Museum* of 1879 depicts an area on the second-floor Paintings Gallery as it appeared after the expansion of the Museum of Fine Arts, in Boston, in mid-1879 (see Fig. 4.3).[8] In line with contemporary artistic tropes, Meneghelli cuts off paintings to the left and right as well as the bench seat. But his works are accurate renderings of installations, unlike Morse's more imaginary hang. The largest work in *The Picture Gallery* is of Gustav Courbet's (1819–1877) *The Quarry* (1857); a decade earlier, the painting had been loaned to the museum and, much to Courbet's delight, in 1866 a group of young art students in Boston raised funds to acquire it for the museum.[9] Courbet was delighted.

True to its time, Meneghelli's work and the others he made of a similar ilk – including other galleries at the Boston Athenaeum and the Louvre – depict floor-to-ceiling salon-style installations. They are great records of early installations in the museum's history. Like other works in this genre, however, they took a backseat, falling out of fashion until the 1980s. Indeed, when Hollis French donated *The Picture Gallery* to the museum in 1912 he wrote to the director, Arthur Fairbanks, noting that the painting was 'not of course of any particular merit' and went on to suggest that it might be better placed in someone's office.[10] In more recent times, the painting has enjoyed a revival – just like Morse's – and for the last decade it has been regularly on display (though sadly never with Courbet's *The Quarry*). The Museum of Fine Arts owns six works by Meneghelli, all

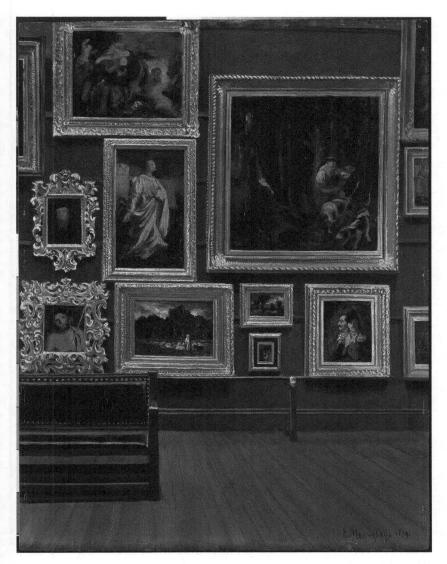

Fig. 4.3 Enrico Meneghelli, *The Picture Gallery in the Old Museum* (1879). Collection of Museum of Fine Arts Boston. (Photo: Museum of Fine Arts, Boston)

interior gallery scenes, five of which feature the Museum in both its earlier location at Copley Square and after its 1879 expansion.

Both Morse's work and Meneghelli's suite of works have increased gravitas today. A revival of interest in them as both paintings in their own right, and as documentary evidence, has seen them enjoy far greater exposure and respect. They document installations and the practice of the copyists in the nineteenth century.

COPYISTS IN THE GALLERY

The copyist in a gallery – either working or socialising – was a way of humanising art museum interior paintings as well as depicting the importance, and popularity, of copying. Examples were discussed in Chap. 2 *The Apprentice Artist*, but it was also established artists who painted gallery interiors as a subject. Perhaps the best example of an artist who took this genre seriously was Louis Béroud (1852–1930). Paris-based, Béroud painted at least 26 paintings of gallery interiors.

Béroud's *Copyists in the Musée du Louvre* (1909) depicts two female copyists taking a break from painting, their equipment abandoned as they chat.[11] Béroud being an able copyist, the paintings contained in his works are all identifiable. At this time, it was more the norm than not, to see the copyists at work in the Louvre, and other major art museums. The numbers of them only reduced with the advancement of commercial reproductions.

Béroud's painting is also important as a means of recording who was doing the copying and it is mainly women copyists who feature in his work. What they are copying in terms of contemporary taste is also relevant, for often they were copying to sell and secure patronage. For many, copying was their bread and butter money and helped to support or subsidise their more creative work.

Béroud's treatment of his subject matter is romanticised; always well clad (with little evidence of splashed paint), the working life on a copyist looks relaxed and enjoyable and perhaps this was the case for some. His idyllic scenes are in part due to his staging and posing of figures. This aside, his works show how busy the Louvre could get on copying days. Béroud himself spent a lot of time at the Louvre and he is credited for reporting the theft of the *Mona Lisa* on 22 August 1911, a painting he copied individually and as part of a larger work. His work is also useful for information around the size of copies made; larger works were often

copied on a smaller scale due to the practicality of transporting equipment and to adhere to the regulations set out by the Louvre. For some women, fashion dictated making it sometimes problematic to work on large-scale works, especially with long skirts and ladders. In an age when being a female artist had its limitations in terms of social and artistic acceptance, copying became a popular form of using one's skills and creating a source of income. Admittedly, the copyist had to be based in a large city with access to major collections, especially the Old Masters, which were popular choices for clients. For the visitor to art museums such as the Louvre, the copyist was part of the environment; paintings were often viewed through and around a copyist and their equipment.

The female copyist was also frequently subjected to unwanted attention from male visitors. As Aviva Briefel suggests in her study about art forgery and identity in the nineteenth century:

> The female copyist is always watched. Whenever she sets foot in a museum, eyes divert her every move.[12]

If Béroud's paintings are anything to go by, the female copyists were always glamorous; his typical female copyist, with her pinched-in-waist, was the epitome of charm and beauty. Unlike the clandestine forger, the copyist's profession was very public.

It was not just painters, such as Béroud, who found the female copyist an alluring subject; so too did the caricaturists. The subject was a rich one, especially given the practicalities; the combination of long fussy cumbersome dresses (with petticoats) and ladders required to get up high enough to view and paint works were great for a caricaturist to exaggerate and poke fun at. Despite their success at copying, and selling their copies, it took a woman with thick skin to be a copyist as it involved working in the public arena. What is more, some travelled great distances to carry out their work. The women in paintings such as those by Béroud are anonymous, but they certainly existed in real life. It is interesting to profile one such woman as an example of not only having great perseverance but to show how copying assisted her in achieving her artistic goals.

Emma Conant Church (1831–1893) was one such woman who had the will and motivation to leave her home in America and head for Europe. Admittedly she was in her thirties when she took on this adventure and although she was a single woman, she was initially accompanied by her brother, William. Church travelled to London, Paris and Rome. The

opportunity to accept commissions to copy paintings was a ticket to secur-
ing a career as a professional artist, albeit that for many women copying
would be their bread and butter income.

During 1862, when Church was in Rome, she was commissioned to
paint four works for the newly founded American Vassar College in
Poughkeepsie which opened in 1865. She was chosen for the commission
on the grounds of her painting ability; the choice of paintings to copy was
at her discretion. The only stipulation made by Vassar College was that she
should use good-quality canvas. Clearly, they were thinking about the lon-
gevity of the works (unfortunately her *The Madonna of Foligno* was dam-
aged by water en route back to America). The first two works Church
copied were *Madonna and Child* (after Carlo Dolci (1616–1686)), com-
pleted in 1862 and *The Unbelief of Doubting Thomas* (after
Giovanni Guercino (1591–1666)), which she completed in 1863.[13] Her
third was Raphael's *The Madonna of Foligno*, which she worked on during
1863. The original painting is large, measuring 320 × 194 cm, and
Church's copy is life-sized. Very Catholic in taste, these three works are
indicative of the educational climate at the time and the seriousness of
copying as an art form and occupation. Church made a fourth work, but
its details and location are unknown.

Church's story highlights what a godsend copying could be; it was an
opportunity for artists of both genders to attract clientele, hone their
skills, showcase their prowess at painting and have their travel expenses
covered. For some female artists, copying was as good as it got. Their male
counterparts used copying as a stepping-stone to their own original prac-
tice. Tourists during the nineteenth century were keen on purchasing
mementoes of their travels; art was in high demand in Rome for the
nineteenth-century tourist. Their requests generally were either images of
the Italian countryside or copies of Old Masters. Raphael was exceedingly
popular to copy and great examples of his work were to be found in Rome,
as Church made use of. Itinerant artists filled churches and museums,
copying works to fulfil commissions and pay their living costs. As art his-
torian Jacqueline Marie Musacchio notes:

> Just like in Paris, the copyists, rather than art, became the main attraction.[14]

Reputations had to be guarded, especially when a female artist copied in
situ unaccompanied. Although demand grew for copies and keepsakes in
the nineteenth century, the female artist was still a minority group.
Musacchio notes that of the 34 artists listed in the 1858 *Guide to the*

Studios in Rome, only four were women. Having a studio was an indication of how seriously you took your chosen occupation, but you had to be able to afford it. Church had a studio in Rome but perhaps many other women artists were painting at home, in their rooms, rather than a specific studio space. Having a studio meant tourists could come and view your work with the intention of purchasing it. And Church opened her studio to visitors.

Church's story is also interesting in terms of value for money. For her copy of *The Madonna of Foligno* she invoiced Vassar College the sum of USD 1200. In 1864 this was a sizeable amount of money for her. Church should be commended for her courage and confidence in asking for that sum. However, it met with resistance. Back at Vassar College, some argued that the money would have been better spent on acquiring original artwork and later in the century that is exactly what happened. In 1870 *The Madonna of Foligno* was moved from the Chapel at Vassar College to the gallery in Avery Hall. Church's three copies, in their original frames, remain in the Vassar College collection today and in no way have a lesser role because they are copies. Church's work was included in the 2021 exhibition at Vassar College titled 'Women Picturing Women: From Personal Spaces to Public Ventures'.[15]

On a more humorous note, Béroud painted a self-portrait *The Joys of the Flooding (in the Medici Gallery)* (1910) in which he balances precariously before Rubens' painting *The Disembarkation of Marie de' Medici* as a water gushes imaginatively into the gallery.[16] Béroud is aware that he is about to get very wet as he watches as the three female figures burst out of his painting. A spoof, Béroud's painting perhaps highlights the perils of the copyist in situ! Using his artistic license, Béroud used his copying skills and specialty genre to the extreme in this visual work of his imagination.

THE PAINTER'S PAINTING IN THE PAINTING

There is also a tradition of the artist including copies of their own works within another work, whether in a domestic setting, their studio or gallery. What they choose to replicate and include is interesting in terms of their contemporaneous choices and how posthumously we read these choices. In other words, their selections can give us windows into their private lives as well as the wider social and historical context within which they are painted.

New Zealand artist Annie Elizabeth Kelly (1877–1946) painted *My dining room* in c.1936 (see Fig. 4.4).[17] To the uninitiated, it looks like a typical middle-class dining room of its time but if you focus on the

Fig. 4.4 Annie Elizabeth Kelly, *My dining room* (c.1936). Collection of Museum of New Zealand Te Papa Tongarewa, New Zealand. (Photo: Museum of New Zealand Te Papa Tongarewa)

paintings it has more gravitas. This is a case of 'size matters'; the larger works, the portraits, are the work of the artist. The smaller, and less significant (and this is my reading of the selection decades on) landscapes are by her husband Cecil Kelly (1879–1954). Proportionally, the scale is correct. Cecil Kelly did not achieve the accolades his wife did. In 1934 Kelly won a Silver Medal at the Paris Salon and in 1938 she was the first New Zealand woman artist to receive an OBE.

My dining room – with its personalised title – represents more than a room where one eats. The room was the centre, the hub, of their upstairs flat in Christchurch. It was also the couple's lounge and painting studio, mainly for Kelly. This was where her models and subjects came and sat for many portraits. Specifically, they sat near the window, facing south towards the city's main river, the Avon. The dining room was also a place to showcase the portraitist's work; Kelly made her living from painting and it was to her advantage to have on show good examples of her work. To the left of the fireplace is an unknown work, possibly a self-portrait as it has a close resemblance to another self-portrait from c.1940 that is held in the Hocken Collection, University of Otago.[18] The image pairs nicely with Kelly's *Portrait of Cecil F Kelly* (c.1925) on the right-hand side.[19] Husband and wife look at each other and both portraits are representative of Kelly's strong and formal approach to the genre, in which she excelled. Centre stage, above the mantelpiece, is Kelly's *Arabesque* (1921).[20] Though exhibited, Kelly did not offer this portrait for sale.[21] She kept it for her own collection, appearing the following decade in *My dining room*.

Below each of the Kelly portraits is a much smaller landscape painting. One possibly depicts New Brighton beach and the other one St Ives, Cornwall – both seaside towns in which the artist couple had formerly lived. It is more than likely they were the work of Cecil Kelly; smaller perhaps as they could have been painted in situ, but also I think because they are less significant when compared with the portraits in the room. Each of the portraits is recognisable; the two landscapes are beach scenes but have been copied in such a way – size and style – that their specific locations can only be guessed at. That Kelly titles her work *My dining room*, gives her work a certain proprietorial pride; ultimately, she used a room in their rented flat as a gallery for her own work. Her copies are the making of the painting; without them it would be just an ordinary dining room. Kelly actually saw the painting as a portrait for she included it in her exhibition

'Portraits by A. Elizabeth Kelly', held at London's Walker Galleries in October 1936. And perhaps she was right in giving her works prominence. Her sense of pride is commendable given the social mores at the time. Even Cecil Kelly allegedly considered his wife the superior painter. Of her generation, Kelly gained the most recognition abroad, which was the aspiration of many artists of her era in New Zealand.[22]

A work with a similar theme is *Interior* (1946), painted by another New Zealander, Ida H. Carey (1891–1982).[23] The image is a typical sitting room scene from the artist's own home. Like many female artists of her generation, the domestic environment was a readily available source for subject matter. Sitting on the sofa, the artist's mother reads. Above her hangs a miniature copy of Carey's *Portrait of My Father* (1932).[24] The other large painting, in the upper right of the composition, is a miniature copy of Carey's *The Inherited Dress* (c.1931), an image of the artist in a formal dress, though somewhat outdated for the time (an earlier title for the work on the verso is *An old-fashioned dress*).[25] Several other works cover the walls, some of which confirm Carey's penchant for posies of flowers. Significantly, Carey has chosen to paint this angle of the room to include copies of two large works in order to create a family portrait. As a spinster, Carey cared for her parents up to their deaths; that Carey never sold the two portraits, or *Interior*, is testament to the value she bestowed upon them.[26] Like Kelly's painting *My dining room*, Carey's work provides clues to an artist's output and domestic circumstances, including what she chose to hang on her walls. Carey had many to choose from; when she vacated her home two years prior to her own death, in excess of 1300 paintings were catalogued. Both *Interior* and *My dining room* were exhibited in 2018 in an exhibition I curated; next to the two works hung the paintings the artists had included as copies within them.[27]

THE ARTIST'S STUDIO

Copies of paintings within paintings are found in abundance when the subject is an artist's studio. Prior to the advent of readily available photography, the studio was a popular and acceptable subject for professional and amateur artists. There were traditionally two kinds of spaces: the atelier, a working studio, and the studio-salon, a show room. In some instances, there was little or no demarcation between the two, though it is the studio-salon that is of greater interest here for that is more often where we find copies of works. Some within this genre are truer, more accurate,

renderings of the studio than others. On that note, any discussion about the artist's studio cannot go past the inclusion of realist artist Courbet's major work painted during 1854–5, with the lengthy and descriptive title of, *The Painter's Studio: Real Allegory Determining a Phase of Seven Years of My Life as an Artist*.[28]

Enigmatic, Courbet's colossal work (at 361 × 598 cm) has intrigued, and frustrated, audiences and scholars for close to 130 years. Its long-winded title is an indication of the work's complexity. Of interest within the context of copying are two areas: firstly, Courbet sits centre stage, the main character in a piece of performance art, and paints (or pretends to) a landscape. Instinctively one would think this to be a copy of one of his known landscapes but Courbet painted a scene specifically of the Loué River Valley as a defiant act against provincialism.[29] But it is a canvas-within-a-canvas, albeit not a copy. Much has been made of the significance of Courbet painting a landscape indoors given it was the age of *en plein-air* painting. Yet *The Painter's Studio* is a folly, a set-up, depicting aspects of his life – from models to patrons – as well as commenting on the state of art.

Secondly, the figures on the composition's right-hand side are referred to as:

> ... a collage of copies of portraits Courbet had painted earlier and of studies of individual figures done especially for the painting.[30]

This is true; for instance, Courbet's patron Alfred Bruyas – tall with a red-dish beard at the back – is appropriated from earlier works, including his chequered coat collar from *Bonjour, Monsieur Courbet* (1854).[31]

Interestingly, there are no copies of Courbet's own work to be found in the studio scene and yet contemporary sources noted that his Parisian studio at 32, rue Hautefeuille was strewn with canvases. The structure of *The Painter's Studio* is best described as fake; not only the combination of characters makes it an impossibility, or the awkward angle at which the artist tries to paint, but so too is its title, explicitly the oxymoron of 'real' and 'allegory'. More romantic than realist, Courbet's masterpiece perhaps gains its fame from not including copies like so many of those who went before and after him, as well as his contemporaries. He turned the notion of the depiction of the artist's studio – with their wares on show – completely on its head.

The great British artist J. M. W. Turner (1775–1851) was innovative not only in terms of what and how he painted, but also in that he showcased his works in his own private gallery. At his London residence, on the corner of Queen Anne and Harley Streets, Turner had a bespoke gallery space built adjacent to his studio, which he opened in 1822. It became infamous for its dishevelled appearance over time, as did his unkempt housekeeper, Hannah Danby. That aside, we know how it looked, including the 'hang', with the aid of George Jones' painting, *Interior of Turner's Gallery* (1851–1861) (see Fig. 4.5).[32] Painted after Turner's death, this small (14 × 23 cm) painting is full to bursting with information about the gallery – from the colour of walls (Indian red) to the skylight covers (herring net and tissue paper), but also, more importantly, the line-up of paintings.

George Jones (1786–1869) recorded from memory Turner's gallery with sketch-like painterly manner. As if taking a photograph, he managed to frame a wide-angled appearance capturing a myriad of paintings as well as Turner – all 1.65 metres (5′5″) of him – and two women visiting the gallery. The threesome give an accurate sense of scale reminding the viewer

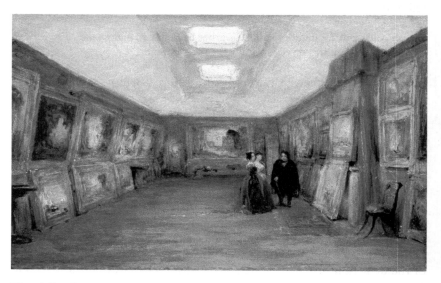

Fig. 4.5 George Jones, *Interior of Turner's Gallery* (1852). Collection of The Ashmolean Museum, Oxford. (Photo: Heritage Image Partnership Ltd/Alamy Stock Photo)

the impressively large scale of some of Turner's works. Turner was renowned for not actually selling many works from here, yet he spent much time engaging with visiting potential buyers. Key to Jones' painting is that several of the works are identifiable. These tiny copies – not much more than a few square centimetres each – confirm which works Turner kept on display, too fond of them to sell. His studio cum showroom was at odds with Turner's attitude about selling. As biographer Peter Ackroyd notes:

> He did not want to sell much of his work, and in fact continually raised his prices to deter bidders ... he simply could not bear to part with them.[33]

On the back wall is Turner's monumental *Dido building Carthage* of 1815 and second from the left in the bottom row is *Hannibal Crossing the Alps* (1812). Both are hugely significant works in terms of Turner's legacy.

Jones visited Turner's studio on two occasions after the artist's death. The other work he completed, a more sombre scene, is *Turner's Body Lying in State, 29 December 1851*.[34] Jones calls on the same compositional format, the gallery dressed floor to ceiling with Turner's works; the deceased artist lies in his coffin, surrounded by mourners (Turner died in his cottage at Chelsea and his body was taken to London where it was placed in the centre of his gallery). The selection of paintings is different in this work but again is a myriad of tiny copies of what was there around the time of the artist's death. It is a credit to Jones' skill when you consider the overall painting is just 14 × 23 cm in size. Jones worked from memory, as Turner refused to have his friend paint his gallery during his lifetime. That Turner's body was placed in his gallery demonstrates the significance of the gallery to him as an artist. Like its companion piece, works are recognisable including on the back wall, flanking the large work, are pendants known as 'Watteau Study' and 'Lord Percy'.[35]

For future generations, Jones' works have provided a valuable and accurate visual resource about Turner's gallery and work. In 2001, the Tate Britain, which has approximately 20,000 works by Turner recreated the artist's gallery as part of an exhibition to showcase Turner's legacy to the nation. Jones' two paintings are the only contemporary images of Turner's gallery and therefore were the source of vital information.[36] Furthermore, Jones bore witness, at the end of the artist's life, as to what the artist had in stock and his last installation. This in itself was no mean feat given that at the time of Turner's death he left behind 100 finished works and 262 unfinished works at Queen Anne Street.[37]

The Tate's anniversary exhibition, marking 150 years since Turner's death, collected together only the pictures, many imposing but rather conventional history paintings, which the artist kept for himself.[38] As the exhibition's curator noted, by exhibiting these works the Tate presented what Turner saw as his own lasting memorial.[39] And there you have it: the tiny copies as seen in Jones' two paintings became the core of the 2001 exhibition.

In 2014 the multi-award winning movie *Mr Turner* graced the big screen. The director Mike Leigh and his team went to extreme lengths to accurately recreate the studio and gallery spaces used by Turner, right down to the bluebottle flies! Given Turner's prolificacy, the props team had to make copies of approximately 200 paintings. Some were printed and over-painted, but others were painted from scratch, including three unfinished at the time of Turner's death (see Chap. 5 for more about paintings in movies). It is hard to imagine the movie being as successful as it was without the aid of Jones' paintings of paintings within paintings.

Jean Frédéric Bazille's (1841–1871) *Studio in Rue de la Condamine* (1870) brings together both the artist's studio and gallery (see Fig. 4.6).[40] A group of his fellow contemporaries, including artists Renoir, Manet, possibly Monet, and Bazille, mingle informally in Bazille's Parisian studio. The walls of Bazille's studio are home to several paintings, including Renoir's *Landscape with Two Figures* (1865) – the large, framed work to the right of the window. Significantly Bazille's copy here is the only surviving image of Renoir's painting in its entirety. The two artists shared a studio at the time of its execution. Apparently a fragment of Renoir's painting survives, but with is present location unknown, Bazille's record is visually valuable.

Bazille's choice of paintings here is far from random. His paintings *The Toilette* (1869–70)[41] – the unfinished work above the sofa – and *Fisherman with a Net* (1868)[42] – situated on the stairwell wall – were both rejected by the Salon. His choice can be read as Bazille's dig at the Salon; this is his artistic and social commentary on what was selected, or not, to hang in the prized Salon exhibition. In this context, with his friends, the works are accepted and enjoyed.

One other work painted by Bazille which features in his *Studio* is the smaller still life above Edmond Maitre, who plays the piano. Regularly referred to as a work by Monet, it is simply given the generic title of 'still life'. Its inclusion alludes to Bazille's ongoing support of Monet as he acquired the work, thus financially helping his artist friend. After a bit of

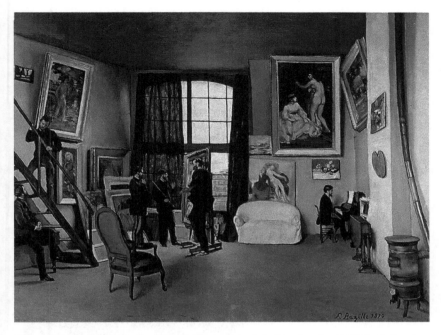

Fig. 4.6 Jean Frédéric Bazille, *Studio in Rue de la Condamine* (1870). Collection of Musée d'Orsay, Paris. (Photo: Musée d'Orsay, Paris)

sleuthing, I found the still life in Wildenstein's catalogue raisonné of Monet. Its correct title is *Still Life with Birds and Fruit* of 1867; dating back half a century, it was last recorded as being in a private collection. Given Wildenstein only provides a black and white image, this makes Bazille's coloured copy, painted contemporaneously, all the more important including for those making copies and selling them online today (see Fig. 4.7).

Killed in his prime during the Franco-German War aged 28 years, Bazille occupied six studios from 1863–70, of which he painted three – each containing smaller versions of his works and those of his contemporaries, who would become known as the Impressionists. Each studio painting is an important record of an artistically exciting time. The Salon rejection of artworks paved the way for modernism; Bazille's *Studio* depicts the very core of this new movement. His work is informal when compared with Courbet's posed and contrived performance piece painted just 15 years earlier, and yet both offer insights into the artist's life and work.

Fig. 4.7 Monochromatic image of Monet's *Still Life with Birds and Fruit* as seen in 'Monet: Catalogue Raisonné', [Volume II, Nos. 1–968], Paris: Wildenstein, 1996, p. 102. (Photo: Penelope Jackson)

The copies of paintings-within-paintings give context to the studio setting and gravitas to artistic discourses about how artists worked and the paintings they wished to hang in their private spaces. Turner was so fond of his gallery that he laid in state there, which is an indication of its significance to him. Identifying Monet's *Still Life with Birds and Fruit* and knowing that Renoir's *Landscape with Two Figures* no longer exists highlights how the studio gallery painting can be a useful tool in recovering records about art that has been lost, or of unknown location, over time.

LOST AND FOUND

Paintings-within-paintings have proven useful in providing evidence of lost artworks. In addition, they can be a significant resource in showing how art was originally exhibited; the artist's intent, or the collectors, is often lost – quite often due to changing fashions and taste – over generations. In some cases, the existence of missing artworks is only known about because of a written reference. Having visual evidence can be superior in providing information, of which even the best of writers cannot give credit. As is the nature of their occupation, art historians have a tendency be obsessive about locating and cataloguing each and every work made by an artist. One of their tasks is to fully contextualise an artist's oeuvre but also to understand their full body of work. Finding a 'missing' painting within another painting is a major coup.

The work of Netherlandish artist, Jan van Eyck (active 1422–died 1441) has long frustrated scholars and audiences alike. His *Arnolfini Portrait* (1434) hangs in London's National Gallery, where hordes of visitors make a beeline for it.[43] The painting is famed amongst many traits for its ambiguous subject and the perfectly polished oil-painted technique. Van Eyck's pièce de résistance, in my opinion, is the *Ghent Altarpiece*, for not only is it a stunning piece of fifteenth-century church art (and architecture) but additionally it wears the badge of honour for being the most stolen artwork of all time. It is worth digressing briefly for the *Ghent Altarpiece* entered a new phase in its illustrious lifecycle in early 2021; after an extensive period of conservation, at a cost of €2.2 million, the altarpiece was returned to St Bavo's Cathedral in Ghent.[44] It is now displayed inside a glass case. The 12 panels that make up the altarpiece have not only been supposedly returned to their former glory, but they are safe and secure from thieves and the harsh environmental conditions that affect the nearly 500-year-old cathedral. What is relevant here is that one of the panels – *Righteous Judges* – is a copy of a copy. This panel, positioned at the lower left of the altarpiece, was stolen in 1934. Five years later, Jeft van der Veken (1872–1964) decided to make a copy. He relied on photographs and another copy made in the mid-sixteenth century by Michiel Coxcie (1499–1592) to render his copy.[45] It would take until 1957 for a purchase price for the panel to be agreed upon between van der Veken and the authorities. The copy of a copy, with some artistic tweaking in the portraits of the Judges, remains in place today and will do so until the stolen original panel is recovered, if it ever is. Interestingly, in 1974,

another controversy erupted about the beleaguered *Ghent Altarpiece*. Conservators Jos Trotteyn and Hugo de Putter questioned van der Veken's copy; on close examination, it was thought that van der Veken had painted over the original missing panel to literally cover up its theft.[46] Although it was decided not to be the case the aspersion of doubt is still there. Noah Charney wrote an entire book about the *Ghent Altarpiece's* chequered past. His last sentence leaves the reader questioning the authenticity of van der Veken's copy (of a copy):

> Perhaps one day the truth will come to light, the Judges panel will be found, and *The Ghent Altarpiece* may be whole once more – if it is not already.[47]

There are only approximately 20 works attributed to van Eyck; one work from his oeuvre is only known today through two copies of it, for the original is lost. The two copies date from the sixteenth and seventeenth centuries; with the former being a painting within another painting. The work, *Woman at Her Toilet* (c.1430), depicting a naked woman and her possible assistant, has for unknown reasons long disappeared. One copy is in the Fogg Collection at Harvard Art Museum, and the other, from the seventeenth century, depicts a copy of the painting as part of a collection in an interior by Willem van Haecht (1593–1637). The significance of having access to these two works is grounded in the knowledge that the female nude, as a subject, lacked popularity during van Eyck's time in the Netherlands. In addition, they are also valuable in capturing a greater understanding about van Eyck's oeuvre and the context in which he practiced.

Van Haecht's 1628 painting, *The Gallery of Cornelius van der Geest*, is an early example of what was a new genre – the picture gallery or kunstkammer. It is a very busy painting; the private gallery is crammed with paintings and sculptures.[48] People are dwarfed as they pore over the works. The painting is a celebration of the collector's wealth and collection; a friend of Rubens, van der Geest was a prominent collector of his time. But there is one work that stands out within the context of this book – the inclusion of van Eyck's *Woman Bathing* or *Woman at her Toilet* or *Bathsheba at her Toilet* or *Judith at Her Toilet*. The painting's title, as does the specifics of its iconography, remains a mystery and has created much speculation among scholars. It is believed that van Hecht copied *Woman at Her Toilet* directly in 1628.[49]

Positioned just to the right of the corner of the room, above a group of sculptures, van Haecht presents us with a slightly angular view of the now-lost van Eyck painting, but it is enough to glean valuable information about the work. Not only is the copy significant with the original lost; it is also significant given van Eyck was not exactly prolific – perhaps his detailed technique and early pioneering of using oil paint was a contributing cause of this, as well as his short working life. Thus, having another work added to his oeuvre is significant. More relevant is that his painting is of a nude woman with the question flagged here as to whether the work was a secular, a religious or a bridal subject. If *The Gallery of Cornelius van der Geest* is accurate in terms of scale, and there is no evidence to believe it is not, then van Haecht gives us the scale of van Eyck's painting. The size of *Woman at Her Toilet* has been challenged; Van Hecht's version is approximately 90 × 60 cm whereas the Fogg's one measures 27.5 × 16.5 cm.[50]

It is believed that van Haecht copied van Eyck's work in 1628, which was likely to be the property of van der Geest. The copy also provides us with a comparative painting to the *Arnolfini Portrait*. The two works are close in terms of their compositions; two figures in a room bathed in light from a window on the left-hand side. Other elements are also repeated; for example, the convex mirror and their reflections. Additionally, the naked woman is a dead ringer for Giovanna Cenami, or should that be the other way around for the *Woman at Her Toilet's* date is only an approximate one? There has also been a suggestion that *Woman at Her Toilet* depicts the ritual bath of Giovanna Cenami with a friend, possibly van Eyck's wife, Margaret.[51]

The original has been at large now for possibly centuries, making the two copies even more important. The painting's unknown location has not gone unnoticed. In 1907 van Gaecht's *The Picture Gallery* was hung at the Royal Academy as part of the winter Exhibition. At the time, *The Burlington Magazine* reported the significance of the painting only in terms of its ability to showcase the missing van Eyck. Curiously, the article's author, Archibald G. B. Russell, referred to the other works in *The Picture Gallery* as 'counterfeited upon the walls'. He goes on to say that '... the copyist has evidently given us a faithful reproduction of a similar unknown work by the same hand', further endorsing its inclusion and the significance of the find or rediscovery.[52]

In 1969 the Fogg Art Museum acquired their copy of van Eyck's *Woman at Her Toilet*.[53] It has subtle differences when compared with van

Haecht's copy, albeit the latter is harder to view being within another painting and situated in the corner, making the foreshortening quite pronounced. Van Hecht's *Woman at Her Toilet* has provided valuable information for curators and conservators. As Harvard University conservator Teri Hensick explains:

> The detail from Van Hecht's painting provided the visual guide necessary to weave together remnants of the missing details. Using this image, nearly indecipherable vestiges of the dog, the blue pillow, the flask on the chair, and the clothed woman's chain and carafe in the Fogg picture were reconstructed.[54]

The two copies have technical and stylistic differences due to being copied a century apart but nevertheless this proves how useful a copy can be in reconstructing another in lieu of the missing original.

Oil on oak panel, the Fogg's copy is old. Hensick suggests, with the results of dendrochronological testing (tree-ring dating), the earliest date for its execution is 1511.[55] Van Eyck's original was clearly still around at this stage. Van Haecht's work dates from 1628, so it is possible that he worked from either the original or the Fogg copy. This infers that van der Geest could have owned either one – the original or the copy. The advantage of having two copies endorses the importance of the artist and the painting's context; that the painting only exists, through copies to our knowledge, confirms the important role copies can play.

As records of lost art, copies are valuable. Fortuitously, New Zealand artist John Nelson Knight (1913–1984) painted a study in the 1930s of a corner of Christchurch's newly opened public art gallery (see Fig. 4.8). At the time, the gallery only exhibited their permanent collection, numbering 160 works. A decade later, one of the paintings captured by Knight mysteriously disappeared, never to be seen again.

Knight, a conservative artist, was known for his technical ability. The painting he recorded was Adolphe Jourdan's (1825–1889) *Leda and the Swan*, dating from the 1870s. This large work (205 × 150 cm) by the French artist was exhibited in London and Melbourne prior to making its way to New Zealand and into the collection of the Robert McDougall Art Gallery, which opened in 1932 in its purpose-built gallery located in the grounds of the botanic gardens.

In 1948 an honorary curator completed an inventory of the collection. *Leda and the Swan* was not on the list. In a period of less than 20 years,

Fig. 4.8 John Nelson Knight, *Study of the South Gallery of the Robert McDougall Art Gallery* (1935). Collection unknown. (Photo: Bulletin 118, Robert McDougall Art Gallery, Christchurch, Spring 1999, p. 28)

the painting had vanished. During that time a custodian managed the gallery; various theories abound about the painting's disappearance. One is that the painting was taken down because it was either damaged (in 1944 schoolboys slashed around half-a-dozen works) or that it was in a poor condition, as was noted in a report from 1890 that observed that the paint layer was cracked and deteriorating. If this were the cause, it would have ended up in the storeroom located in the gallery's basement. The custodian later commented to a friend and former colleague of mine that the painting got in the way of his buckets and mops![56] So perhaps the work was disposed of in the gallery's furnace!

Knight's study not only confirms where *Leda and the Swan* hung in the South Gallery, but also the company it kept. *Leda and the Swan* was No. 141 of the permanent collection and was flanked on the left by C. F. Goldie's (1870–1947) *A Maori Chieftain* (1900) (No. 140) and on the right by Alfred O'Keeffe's (1858–1941) *The drift of many winters* (1914) (No. 142). In fact, all the works in Knight's painting are identifiable, again showing the relevance of such a work, though the artist's objective was

likely to be simply a technical exercise. Although etchings of *Leda and the Swan* exist, these are only black and white images and would have a different texture from Jourdan's oil painting. A photograph taken at the 1880 Melbourne International Exhibition gives a tiny glimpse of Jourdan's painting but it is Knight's study, made as an art student that presents the most informative visual experience of the work in situ.

How works of art are displayed has shifted over time; often dictated by taste and personality, artists and collectors have set ideas about where and how a work is installed. Knight's study is a good example of how less than a century ago a group of works was permanently displayed in a public art gallery context, making it a unique work of the Robert McDougall Art Gallery. By contrast, J. M. W. Turner painted numerous images of the interior of the large and imposing Petworth House and Garden, West Sussex, England.

Turner was a regular guest from 1808 onwards at Petworth House. The Grade I listed National Trust house was a great source of subject matter to Turner. The house has a rich and vast art collection; a series of serious art collectors over the centuries amassed works by Titian, Holbein, Reynolds and van Dyck to name a few. Some of Turner's most stunning pieces are located at Petworth. The third Earl of Egremont was a patron of Turner's and particularly hospitable to painters and writers. Egremont provided Petworth to Turner as a 'living studio'.[57] For me, it is the small interior studies that are both fascinating and useful to the contemporary viewer. In total, Turner made approximately 100 sketches of the house and surrounding grounds. In particular, one caught my eye: *The Red Room* (1827) (see Fig. 4.9).[58]

The Red Room is a small and vibrant sketch measuring 14 × 19 cm; although painted in a loose manner, Turner captured a level of detail that shows his amazing powers of observation and attention to recording information when working in watercolour and on a small scale. *The Red Room* depicts a quarter-share of the ground floor stateroom at Petworth. The main wall contains six visible paintings. The three main ones are: on the left-hand side, *Robert Shirley* (1622) by Anthony van Dyck;[59] on the right-hand side *Teresia Shirley* (1622) also by van Dyck;[60] and over the doorway, *Hans Moritz, Count Bruhl* (1796)[61] by James Northcote (1746–1831). The opulence of the room is reflected in the objets d'art and furniture. The shade of red of the walls has a luminous fresh look.

Fig. 4.9 J.M.W. Turner, *The Red Room* (c.1827). Collection of Tate Britain. (Photo: Tate Britain)

Turner's sketch has proven valuable in returning the Red Room to its former glory. In 1952 art historian Anthony Blunt had the room re-decorated in yellow and re-hung. Petworth had at this time been acquired by the National Trust and turned into a museum. Overall, Petworth has now been returned to how it looked when the third Earl occupied it. His philosophy was to let visiting artists take down paintings they were copying; often the works were not returned to their original places, but that did not faze the Earl.[62] Fundamentally, Blunt re-arranged the collection by artist and era in a manner that overlooked the personal aesthetic when the house was a haven and inspiration for artists. The Earl's ad hoc approach to installation has been reinstated thanks to Turner's sketches of the home's interior. As an aside, red has traditionally been used as a wall colour because it sets off Old Masters particularly well, much as in the same way the 'white cube' is part and parcel of exhibiting and installing contemporary art nowadays. Blunt's switch to yellow (which he did with much authority and declared it should never be changed) was quite radical and

arguably not in keeping with the Earl's choice. In 2002, the National Trust returned the Red Room back to red.[63] The vibrant red so clearly depicted in Turner's sketch was the Earl's idea in 1806. Not only was red reinstated at this time, but so too was the picture hang dating from this period. Today's visitors truly step back in time and Petworth's website acknowledges the aid of Turner's sketch in returning the room to reflect its original self and former glory.

* * *

Copies of paintings as seen within other paintings have proven themselves as useful tools over and over; finding or rediscovering works can provide art historical context for the work and the artist. The passage of time can allow them even greater significance. Paintings-within-paintings are a genre in their own right and one that continues to this day. English artist Susan Wilson's (b.1951) *Painting as an Art by Wollheim* is testimony to this legacy.[64] Painted in 2019, and entered into the 2020 Royal Academy Summer Exhibition (that ended up being in winter due to the global pandemic), Wilson included within her still-life painting a small version of Nicolas Poussin's (1594–1665) painting *Rinaldo and Armida* (c.1628–30).[65] Wilson's motivation for its inclusion was simply that it is the first Poussin painting she really loved. She told me:

> ... the characterisation of Armida is sensational. Just as she is about to stab Rinaldo you detect a glow of affection.[66]

Wilson worked up a colour drawing in situ at the Dulwich Picture Gallery, copying the Poussin. Though more painterly than the original, there is no doubting about which Poussin's work it is. Copying as an art form stands out within the genre of paintings-within-paintings, legitimising the copying of art.

NOTES

1. Collection of Nora Heysen Foundation Collection, oil on canvas on composition board, 88 × 78 cm. The work still hangs at The Cedars.
2. Hans Heysen Foundation Collection, oil on canvas, 60 × 71 cm.
3. This term was coined by Giles Waterfield in *Palaces of Art: Art Galleries in Britain 1790–1990* (eds: Giles Waterfield and Timothy Clifford). London: Dulwich Art Gallery, 1991, p. 129.

4. 'Hans and Nora Heysen: Two Generations of Australian Art', National Gallery of Victoria, Melbourne, 8 March–28 July 2019.
5. Collection of the Terra Foundation for American Art [1992.51].
6. www.reynoldahouse.org
7. Collection of the Louvre, Paris [RF3734], oil on canvas, 69 × 103 cm.
8. Collection of Musuem of Fine Arts, Boston [RES.12.2], oil on paper-board, 40.64 × 30.48 cm, gift of Hollis French in 1912.
9. Collection of Musuem of Fine Arts, Boston [18.620], *The Quarry* (*La Curée*) (1856) was exhibited at the Paris Salon in 1857.
10. Letter from Hollis French to Arthur Fairbanks, February 1912, Museum of Fine Arts archive, Boston.
11. Current whereabouts unknown. *Copyists in the Musée du Louvre*, oil on canvas, 72.3 × 91.4 cm, was sold for USD 20,000 at Sotheby's New York, Art Treasures of America: The John F. Eulich Collection (Lot 101), 21 November 2017.
12. Aviva Briefel, *The Deceivers: Art Forgery and Identity in the Nineteenth Century*, USA: Cornell University Press, 2006, p. 37.
13. Collection of The Frances Lehman Loeb Art Center, Vassar College, New York [1864.1.13 and 1864.1.14], both oil on canvas, 143.51 × 121.92 cm and 302.74 × 194.31 cm (unframed).
14. Musacchio, Jacqueline Marie, 'Infesting the Galleries of Europe: The Copyist Emma Conant Church in Paris and Rome', *Nineteenth-Century Art Worldwide* 10, no. 2 (Autumn 2011), http://www.19thc-artworldwide.org/autumn11/infesting-the-galleries-of-europe-the-copyist-emma-conant-church-in-paris-and-rome (accessed June 2, 2021).
15. 'Women Picturing Women: From Personal Spaces to Public Ventures', 6 February to 13 June 2021, The Frances Lehman Loeb Art Center, Vassar College, New York.
16. Private Collection.
17. Collection of Museum of New Zealand Te Papa Tongarewa [1943-0001-2], oil on canvas, 63.5 × 76.2 cm.
18. Collection of the Hocken Collections, University of Otago, Dunedin [A921], oil on canvas, 66.6 × 51.1 cm.
19. Christchurch Art Gallery Te Puna o Waiwhetū Trust Collection [L86/99], oil on canvas, 76.7 × 63 cm.
20. Collection of the Hocken Collections, University of Otago, Dunedin [73/40], oil on canvas, 61.5 × 51 cm.
21. *Arabesque* was exhibited at the Canterbury Society of Artists in 1922 and illustrated on page 72 of the exhibition catalogue (not for sale).
22. Roberts, Neil. 'Annie Elizabeth Kelly', *The Encyclopaedia of New Zealand*, https://teara.govt.nz/en/biographies/3k5/kelly-annie-elizabeth/print

23. Collection of Waikato Museum, Hamilton, New Zealand [1980/42/5], oil on board, 36.5 × 46.4 cm.

24. Collection of Waikato Museum, Hamilton, New Zealand [1980/42/26], oil on canvas, 59.5 × 75.2 cm.

25. Collection of Waikato Museum, Hamilton, New Zealand [1980/42/31], oil on canvas, 100.4 × 75 cm.

26. All three works were gifted by Ida H. Carey to the Waikato Museum, New Zealand, in 1980, two years prior to the artist's death. *The Inherited Dress* was exhibited in 1931 at the Canterbury Society of Artists (No. 201) for £50-0-0. It was not sold.

27. 'Ida Carey: A Contemporary Viewing', Waikato Museum, New Zealand. Exhibition dates: 23 June–7 October 2018.

28. Collection of the Musée d'Orsay, Paris [RF2257], oil on canvas, 361 × 598 cm.

29. Nicholson, Benedict. *Courbet: The Studio of the Painter.* London: Allen Lane, 1973, p. 20.

30. Chu, Petra Ten-Doesschate, 'Showing Making in *Courbet's The Painter's Studio in Hiding Making – Showing Creation* (eds. Rachel Esner, Sandra Kisters, Ann-Sophie Lehman), Holland: Amsterdam University Press, p. 65

31. Collection of Musée Fabre, Montpellier [868.1.23], oil on canvas, 132 × 150.5 cm.

32. Collection of the Ashmolean Museum of Art and Archaeology, University of Oxford, Oxford [WA1881.348], oil on millboard, 14 × 23 cm.

33. Ackroyd, Peter. *J.M.W. Turner.* London: Vintage, 2006, p. 80.

34. Collection of the Ashmolean Museum of Art and Archaeology, University of Oxford [WA1881.349], oil on millboard, 14 × 23 cm.

35. Roach, Catherine. *Pictures-within-Pictures in Nineteenth-Century Britain.* New York: Routledge, 2016, p. 91.

36. Zanetti, Anna. 'Interior of Turner's Gallery by George Jones', Ashmolean Museum Blog, *Talking Objects,* https://blogs.ashmolean.org/talkingobjects/interior-of-turners-gallery-the-artist-showing-his-works-by-anna-zanetti/

37. Sam Smiles, 'Unfinished? Repulsive? Or the work of a prophet? Late Turner'. *Tate Etc,* Issue 15, 1 January 2009, https://www.tate.org.uk/tate-etc/issue-15-spring-2009/unfinished-repulsive-or-work-prophet

38. Kennedy, Maev, 'Home from home with Turner … more or less', *The Guardian,* 5 March 2001.

39. Dr Blayney Brown quoted in Maev Kennedy, 'Home from home with Turner … more or less', *The Guardian,* 5 March 2001.

40. Collection of the Musée d'Orsay, Paris [RF2449, LUX1439], oil on canvas, 118 × 149 cm framed.

41. Collection of Musée Fabre, Montpellier, France [18.1.2], oil on canvas, 153 × 148 cm.
42. Collection of Rau Foundation for the Third World, Zurich, oil on canvas, 134 × 83 cm.
43. Collection of the National Gallery, London [NG186], oil on oak, 82.2 × 60 cm.
44. Elbaor, Caroline. 'A $2.4 Million Restoration of the Ghent Altarpiece Has Yielded Shocking Revelations – Like the Mystical Lamb's Humanoid Face.' *Artnet*, 20 December 2019.
45. Collection of the Museum of Fine Arts Belgium [Inv.6697], oil on wood panel, 147 × 51 cm.
46. Charney, Noah. *Stealing The Mystic Lamb: The True Story of The World's Most Coveted Masterpiece*, New York: Public Affair Books, 2010, pp. 385–6.
47. Ibid., p. 288.
48. Full title is: *Visit of Archduke Albert and Archduchess Isabella to the Collection of Willem van der Geest*. Collection of Rubenshuis, Amsterdam [RH.S. 171], oil on panel, 100 × 300 cm.
49. Hensick, Teri. 'The Fogg's Copy after a Lost Van Eyck: Conservation History, Recent Treatment, and Technical Examination of the Woman at Her Toilet', *Recent Developments in the Technical Examination of Early Netherlandish Painting: Methodology, Limitations and Perspectives*, Turnhout: Brepols, January 2003, p. 89.
50. Ibid., p. 84.
51. Hensick, Teri. 'The Fogg's Copy after a Lost Van Eyck: Conservation History, Recent Treatment, and Technical Examination of the Woman at Her Toilet', *Recent Developments in the Technical Examination of Early Netherlandish Painting: Methodology, Limitations and Perspectives*, Turnhout: Brepols, January 2003, p. 85.
52. Russell, Archibald G. B. 'A Lost Van Eyck', *The Burlington Magazine for Connoisseurs*, Vol.10, No.47 (Feb 1907), p. 325.
53. Collection of Harvard Art Museums/Fogg Museum [1969.83], oil on oak panel, 27.2 × 16.3 × 7 cm.
54. Hensick, Teri. 'The Fogg's Copy after a Lost Van Eyck: Conservation History, Recent Treatment, and Technical Examination of the Woman at Her Toilet', *Recent Developments in the Technical Examination of Early Netherlandish Painting: Methodology, Limitations and Perspectives*, Turnhout: Brepols, January 2003, p. 89.
55. Hanley S.J, 'The Optical Concerns of Jan van Eyck's Painting Practice', unpublished PhD thesis, The University of York, 2007, Vol. 1, p. 122.
56. See Chap. 5: The loss of Psyche in *Art Thieves, Fakers & Fraudsters: The New Zealand Story*, Wellington: Awa, 2016, pp. 69–80.
57. Ackroyd, Peter. *J.M.W. Turner*. London: Vintage, 2006, p. 49.

58. Collection of the Tate, [D22683], gouache and watercolour on paper, 14 × 19 cm.
59. Collection of the National Trust [486169], oil on canvas, 214 × 129 cm.
60. Collection of the National Trust [486170], oil on canvas, 214 × 129 cm.
61. Collection of the National Trust [486299], oil on canvas, 127 × 100 cm.
62. Gillie, Oliver, 'Trust restores 'personal aesthetic' to Petworth: A Turner Sketch is being used to rehang pictures at a historic country house', *The Independent*, 31 March 1994.
63. Kennedy, Maev, 'Simply Red', *The Guardian*, 4 May 2002.
64. Collection of the artist, oil on linen, 91 × 71 cm.
65. Collection of the Dulwich Picture Gallery, London [DOG238], oil on canvas, 82.2 × 109.2 cm.
66. Email correspondence from Susan Wilson, 16 February 2020.

Education and Entertainment

When James Bond enters his underwater lair in the 1962 movie *Dr. No*, he pauses momentarily and glances at a portrait sitting on an easel (see Fig. 5.1). It is none other than Francisco Goya's (1746–1828) *Duke of Wellington*, a formal portrait dating from 1812–14.[1] Its presence in the movie was an inside joke, for the portrait was actually missing from London's National Gallery at the time the film was made and first screened. What you see in the movie is actually Kenneth Adams' copy of the portrait. The copy's role and inclusion in *Dr. No* was both pure and clever entertainment; however, over time it has taken on a more important role in how we stereotype art thieves. Known as the 'Dr. No. Theory', it has become a staple of art crime studies.

Kenneth Adams (1921–2016) was the artist and designer for many iconic James Bond movie sets. Adams acquired a colour 35 mm slide of the portrait from the National Gallery on a Friday and spent his weekend painting a copy. Filming began on Monday. By all accounts, it was a good copy. The movie's audience would have picked up on the joke for the theft of the real portrait was very well publicised at the time. The copy was used for publicity purposes too. Unfortunately, like the original, the copy was also stolen.

The backstory to the theft of the Goya's *Duke of Wellington* began in 1961, 50 years to the day that the *Mona Lisa* had been stolen from the Louvre. The Goya thief demanded £140,000 in ransom to be paid to a charity. The thief, Kempton Bunton (1904–1976), who was at the time a

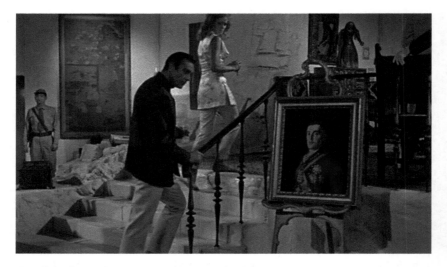

Fig. 5.1 Scene from *Dr No* (1962) movie showing a copy of Goya's *The Duke of Wellington* on easel. (Photo: paintingsinthemovies.com)

57-year-old retired bus driver, claimed that he was trying to raise money for people who deserved it; specifically, he asked that the money be used to pay television licenses for the elderly and the poor. He did not threaten to destroy the painting if his demand was rejected.[2]

The portrait was eventually left in a train station and returned to the National Gallery. Four years later, Bunton handed himself in. He was found guilty of stealing the painting's frame – as it was never found – but not guilty of the four other charges relating to the theft of the painting. Bunton was handed down a three-month prison sentence. The case captured the public's imagination and was followed with great interest, especially since the portrait was a new acquisition having been acquired in 1961 from Sotheby's for the sum of £140,000, the same amount as the original ransom request.

In *Dr No*, the Goya has supposedly been stolen to order. As lawyer A. J. G. Tijhuis writes in 'Art and Crime':

... one of the most popular explanations for prominent art thefts is as follows: mysterious, superrich collectors commission thefts to add unique works of art to their secret collections.[3]

And this is where James Bond fits in. Tijhuis sums up:

> ... the Dr. No figure has a lot more appeal to the media than the many clumsy, unromantic thieves who comprise the largest part of art thefts.[4]

Without a doubt, Bond and Bunton had very little in common! Adams' copy highlights the significant role a copy can play in demonstrating that entertainment and education – with regard to copies – are not mutually exclusive and often work in tandem. This chapter looks at how copies are used to entertain and educate about art and artists.

MR TURNER (2014)

Staying at the movies, Mike Leigh's film *Mr Turner* was an amazing cinematic achievement, both entertaining and educative. Timothy Spall, as artist J.M.W. Turner, was very convincing and the set, which included numerous copies of the artist's works, made this movie memorable. In preparation for the role, Spall spent two years learning to paint under the tutelage of artist Tim Wright (b.1959). Twice a week, Spall would spend time at Wright's Clerkenwell studio learning the rudiments of painting. They began at the beginning, with drawing and, just as in Turner's time, they worked up to drawing 'from the cast', imitating how Turner himself would have copied classical sculptures while studying at the Royal Academy.[5] Spall and Wright also made drawings at various landmarks as well as spending time at the Turner archives held at the Tate Britain. All in all, this was a thorough grounding for the actor who clearly did not want to 'fake' painting on the big screen. His hard work and patience paid off. Great attention to detail was taken with the famous Royal Academy varnishing day of 1832, which was a bit of theatre in itself; the painting *Holvoetsluys*, on which Turner famously painted a red dot (and then returned to the chagrin of his fellow painters to fashion it further into a buoy), had to be re-set 20 times. In other words, the scene was acted out until they reached perfection. To do this, the red dot was applied with a special mixture of soap, glycerine and pigment that looked and behaved just like oil paint.[6] Obviously, to do this, the film set's version of *Holvoetsluys* was a copy.[7]

Turner left a large number of his works to the nation, cementing his importance in Britain's art history. They are highly valuable and desirable; when one is offered for sale there is much interest. In the year that *Mr Turner* first screened, his picture *Rome, from Mount Aventinue* (1835)

was auctioned at Sotheby's. It sold for £30.3 million. As the *LA Times* reported, there was renewed interest in Turner's work since the movie's screening.[8] For this reason, and their vulnerability, copies had to be used in filming *Mr Turner*. This in itself was a huge logistical exercise.

Not only did the film require finished works; more importantly, it also required works at various stages of being painted. As production designer Suzie Davies explained to me:

> During the preparation of the film Mike and I discussed at what stages these paintings maybe at – 1 for a blank canvas – 10 for fully finished painting – we then employed a fine artist Charlie Cobb to recreate these stages – and then used washable paint for Tim Spall to interact with on the canvas so we could wipe between takes.[9]

Turner's unfinished works were a valuable source, especially to Cobb. Wright notes that Cobb was required:

> ... to make several versions of each work. So we might require a 'just started' *Fighting Temeraire* or a 'half finished' *Rain, Steam and Speed*.[10]

As is most often the case with using artworks in films, clearances had to be sought, fees paid and, more importantly, the copies had to be destroyed at the end of filming. This is necessary to avoid questions and confusion about authenticity at a later date. Though Cobb made the paintings at various stages of their creation, the majority of the finished pieces were high-resolution images printed onto lightweight foam board or card, with a clear thick varnish hand-painted over the prints to give an illusion of oil paint. They were finished off with lightweight plastic frames that were glued or stapled on. As Davies says, if you saw the 300 or so copies in real life you'd spot them for what they were but in the film, they worked convincingly well.[11]

From *Mr Turner*, we can learn so much about the artist's life and practice. Attention to detail was paramount; for instance, Turner's revolving table was deemed essential for his studio.[12] Most significantly, Spall painted. He did not pretend. As his tutor notes:

> We wanted the painting activity to come naturally ... Tim needed to be painting without thinking.[13]

Further evidence of Spall's newly acquired painting ability was seen the following year, in 2015, in an exhibition of his work at Petworth House, in the library where Turner once painted.

Spall went on to act as another great British artist, L. S. Lowry (1887–1976) in the 2019 movie, *Mrs Lowry & Son*. Again, the combination of copies and Spall's own artistic ability provided the artworks for the movie. A movie more perhaps about his (toxic) relationship with his mother than his artistic career, it did not require the same number of works or gallery scenes as *Mr Turner* had. The making of the film became the subject of an exhibition at The Lowry Galleries, Salford in 2019. Not only were there props, film clips, photographs and ephemera; there were also a selection of Spall's own paintings. As noted in *The Spectator* magazine:

> There are landscapes from Catalonia and New Mexico and copies of Lowry paintings, one – 'Winter in Pendlebury' – hanging alongside the master's original.[14]

The deliberate bringing together of authentic paintings and copies in a public art museum helps to educate about copies and, in this case, validates the use of copies for film productions. On the back of the success of his Salford exhibition, Spall was offered an inaugural solo exhibition in London at the Pontone Gallery.[15] Spall wrote of this twist in his career:

> Life has imitated art: having played J. M. W. Turner and L. S. Lowry on screen, I took up the pigments and brushes myself and began painting like an artist called T. L. Spall.[16]

And so, like those who have gone before him, Spall trained in a very traditional manner by copying originals before he could call himself a fully-fledged artist.

GIRL WITH A PEARL EARRING (2003)

The making of the award-winning movie, *Girl With a Pearl Earring*, spared no detail. Based on Tracy Chevalier's 1999 novel of the same title, it tells the story of the painting of Vermeer's most famed work; curious servant girl Griet, becomes Vermeer's model.[17] The movie provides a wonderful picture into how the seventeenth-century artist (and the other

members of his large household) lived and worked. In a household full of children, a jealous pregnant wife, an over-bearing mother-in-law and servants, Vermeer tries to eke out a living. Added to this, the dealer–artist relationship is ever-present, being paramount to the family's livelihood. The dénouement of the novel and movie is the execution of Vermeer's c.1665 painting, *Girl With a Pearl Earring*, measuring just 44 × 39 cm.[18] Although both the novel and movie showcase Griet as the subject of the portrait, in reality it is a *tronie*, a portrait painting of an unidentified sitter. Usually sold on the open market, *tronies* were not commissioned and therefore did not have a patron. There are at least three *tronies* in Vermeer's oeuvre, a total that is generally considered small for an artist of his standing. However, Vermeer was not known for his prolificacy; to date there are just 34 authenticated Vermeer paintings. He worked on one painting at a time unlike his contemporaries, who often would have several paintings on the go at once. Today, Vermeer's *Girl With a Pearl Earring* is often described as the Dutch *Mona Lisa*.

Amongst the daily domestic bustle of Vermeer's home and studio, the movie's audience is witness to in excess of 60 paintings. We are constantly reminded that this is an artist's house in the Dutch Golden Age of painting. Producer Andy Paterson, who sourced licences for reproducing all of the works, noted that it was fundamental to the success of the movie to have permission, and buy-in, from the Mauritshuis, The Hague, who own the *Girl With the Pearl Earring*. In addition, permission was sought from five other major art museums and libraries. Without endorsement from the Mauritshuis, the movie could not have been made in Paterson's opinion. In fact, the Mauritshuis were extremely generous and engaged in the movie (their staff watched the filming when the crew was based in Delft). The authentic painting was used for the movie's publicity so as to capture the original beauty and detail.

The copies of paintings used in the film fall into three broad areas depending on where they were hung in the house or studio, their importance and relationship to the script, and how close up they were going to be filmed. These factors determined how they were made and the quality of copy required. Again, as Paterson suggested, the copies had to be of a quality that made them look authentic and in no way ridiculous. It was a great responsibility. The finished copies were hung in a replica of Vermeer's house, built entirely inside a studio.

The first category of copies is in the 'deep background'. Because the viewer sees them only fleetingly and/or from a distance, the copies were

made by printing onto different textures to create the idea of wood panels or the weave of canvas. Often these works appear hazy, or just slightly out of focus. The real significance of these works is to show the cross-section of works that possibly hung in Vermeer's home, as well as the quantity. Furthermore, some of Vermeer's own works are amongst his collection, including *The Little Street* (c.1657–8), an everyday scene depicting an example of domestic architecture in Delft and four women at work, oblivious to the painter and audience.[19]

The 'mid-range' copies were made by artists who over-painted prints or copies of the originals. Some were made at the Dafen painting village in China. Unfortunately, on seeing the images required for copying for the movie, the Chinese copyists took it upon themselves to make some adjustments. They brightened the dark sombre palettes typical of Dutch painting and added cheesy smiles to the portraits. However, these were soon tweaked back to look like their originals. One work from the 'mid-range' is *The Goldfinch*. This is a small painting of a goldfinch sitting on its feeder box. It is possible Carel Fabritius (1622–1654), who painted *The Goldfinch* in 1654, taught Vermeer, hence the reason for it being seen here in Vermeer's home.[20] In the finished movie we see it a couple of times as characters dash past it. At the time not many viewers would have recognised it but it now has a different status since the publication of Donna Tartt's 2013 Pulitzer Prize-winning novel *The Goldfinch* and the 2019 movie of the same name, which was based on her novel. (As an aside, *The Goldfinch* was loaned to The Frick Collection in New York in 2014, attracting 230,000 visitors over the three months it was on show, demonstrating its newfound fame.) *The Goldfinch* copy seen in Vermeer's replica home on the movie set of *Girl With a Pearl Earring* was printed on paper and then burnished into a heavy canvas, as were many of the other copies in the 'mid-range' catalogue of works. On the whole, over-painting was done with acrylic paint. Though not authentic for the art historical period, oil paint takes too long to dry for the purposes of filming. Most of the paintings made from scratch were filmed at intermediate stages and therefore did not require the glazes that were traditionally applied to finished pieces.

Digressing slightly, in the movie *The Goldfinch*, *The Goldfinch* painting was obviously integral to its overall success. Therefore, the painting had to look like the real one. All up, 80 paintings were printed onto photographic paper, which allowed for texture, were used in *The Goldfinch*. In addition, because there is an explosion at the Metropolitan Museum of Art in the

book and movie, the real building could not be used for filming. Instead, perfect replicas of the gallery spaces were built in a warehouse at Yonkers, New York. *The Goldfinch* painting is small – 34 × 23 cm – and the copy was made by scanning the original (fortuitously it was in New York at the time) with a three-dimensional scanner and then the painting was built up with painting layers to scale. Scenic artists were employed to over-paint enlarged digital images to provide exact texture and brush marks.[21]

Returning to the *Girl With a Pearl Earring*, the last category of paintings was the most important one to get correct. There was no margin for error. The works consist of the major ones we see up close as well as the various stages of them being painted by Vermeer. Often the viewer only gets a quick glimpse of the painting during the process of making on the easel, but seeing it progress through the various stages adds to the dramatic tension, anticipation of the finished result, as well as illustrating how labour-intensive Vermeer's works were to execute. His works are generally small and very detailed so seeing them at an early stage with blocked-out areas of flat colour, especially for non-painters, adds another dimension for the audience. *Woman with a Water Jug* (1660–2) is one such work.[22] We see it in its early stages of being painted. The film's set designer, Todd van Hulzen, made this copy. He told me:

> ... instead of gessoing the canvas I glued a paper copy of the original to heavy linen, and then painted over that. We reverse engineered about five versions of that painting in various stages. ... Depending on which stage the painting portrayed, I either used just acrylics tempered with retarder, or a combination of acrylic and then oil.[23]

As the movie draws to a close, the camera zooms in on the *Girl With a Pearl Earring*. The painting's surface craquelure is very pronounced for this is not a copy. This is Vermeer's own work and again an example of the relationship between film crew and the Mauritshuis Museum. Copies served an integral role in the movie, but nothing could replace the original up close on the big screen for the finale.

THE RETURN OF *THE WEDDING AT CANA*

Documentaries are another form of the moving image that uses copies. The work of Factum Arte provides useful and easily accessible information about the making of legitimate copies for a series about lost

paintings – *Mystery of the Lost Paintings* – where paintings such as Graham Sutherland's *Portrait of Winston Churchill* (1954), which was 'disposed' of soon after it was gifted to the sitter on the occasion of this 80th birthday, was replicated. A Spanish company, Factum Arte also makes copies to hang in place of original artworks. The long and involved process of making such copies makes for interesting viewing. As the work is made, Factum Arte films the process every step of the way. One example of such a project is the recreation of *The Wedding at Cana* in 2006–7 (see Fig. 5.2).

The Wedding of Cana (*Le Nozze de Cana*) of 1563 hangs in Room 711 at the Louvre.[24] The majority of visitors to the Louvre file past it without taking in the 7 × 10-metre painting for it hangs on the opposite wall to the *Mona Lisa*. Paolo Veronese's (1528–1588) masterpiece has been in Paris since 1797. The Louvre's website explains how the painting got to Paris, with the last sentence of its catalogue entry noting:

> Despite its exceptional dimensions the painting was confiscated, rolled up, and shipped to Paris by Napoleon's troops in 1797.[25]

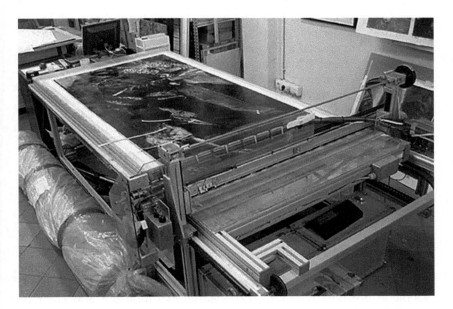

Fig. 5.2 The making of a copy of *The Wedding of Cana* in 2006–7 by Factum Arte for The Refectory at San Giorgio Maggiore, Venice. (Photo: Factum Arte)

Commissioned in 1562 by the Benedictines of the San Giorgio Maggiore, Venice, it took Veronese 15 months, with the help of his brother, to complete the painting. The subject matter is well suited for the refectory, designed by the great Renaissance architect Andrea Palladio (1508–1580). It depicts Christ performing his first miracle; at a wedding feast, he turns water into wine.

The original painting was a mammoth undertaking and it is a Venetian painting through and through. Not only was Veronese a major Venetian artist; stylistically it is characteristic of the city. The subject was site-specific with pigments acquired in the Orient and brought back to Venice. But still it remains in the Louvre over two centuries later. This is where Factum Arte arrived on the scene.

In 2006 permission was granted for the Factum Arte team to scan *The Wedding at Cana* in the Louvre at night in order to make a copy – when I say a copy, I mean an exact facsimile copy. The process – which can be viewed on various film clips on the Internet – was carried out under strict conditions: the scanner could not touch the canvas' surface, external lighting could not be used, nor scaffolding and all work to be carried out after hours. Compliance was crucial both for the project to go ahead and for the production of a perfect copy.

Factum Arte created a 1:1 copy. No detail was left out, including the joins in the canvas. When Napoleon's troops helped themselves to the painting they cut it up to make transportation easier. Once in Paris, it was rejoined. Factum Arte mimicked the seams exactly. Interestingly, it took Factum Arte the same amount of time to make their copy as it took Veronese to paint the original work, giving a clear indication to both their accuracy and attention to detail.

The making of the copy of *The Wedding at Cana* was filmed. The footage is an excellent record of the epic task and it also shows how newly developed technology made it all possible. What is important here is that the works made by Factum Arte are always acknowledged as copies. Their intent was to provide a copy to put in place of the original at the Refectory in Venice; the reception, and conversations had, since its installation are significant in terms of cultural repatriation. Understandably for some, it re-opened old wounds about the return of the original painting. The island of San Giorgio Maggiore remained a military garrison until 1951; Napoleon not only removed *The Wedding at Cana*, but also commissioned the building of a warehouse to store artillery and the construction of two docks with towers. In other words, his presence is still felt there.

Others argued that a copy – albeit an exact one – could never replace the original and thus right an historical wrong.[26] Some thought it immoral to replace the original with a digital re-creation and Italian literary critic, Cesare De Michelis, likened it to cloning human life.[27] Factum Arte maintained that their copy was never meant to replace the original for that is simply impossible. Rather, they have provided an in-depth and detailed study. The footage of the preparation, making and installation of *The Wedding at Cana* during 2006–7 is fascinating, entertaining and educational. The Refectory is open to the public and once again it looks complete having been returned to its former glory, albeit without the original Veronese but with the next best thing.

When Factum Arte made *The Wedding at Cana* it had the advantages of working from the original painting. In another commission, when they made a facsimile of Michelangelo Merisi da Caravaggio's (1571–1610) *Nativity with Saints Lawrence and Francis* for the Church of San Lorenzo at Palermo, Italy, they had very little to go on; just a black and white photograph taken in 1951 when the altarpiece was undergoing restoration and a colour photograph dating from 1968. The colour photograph was perfect in terms of size and quality for a bookplate but, as art historian Alastair Sooke noted, it was 'a milky reproduction ... a sickly, ghost of a lost masterpiece'.[28] He was right. Even when reproduced in relatively contemporary books, the colour photograph has a bloom to it. Factum Arte's task was huge. Not only did they lack an image of good quality to work from but also there was immense pressure and expectation around their work filling a significant void in the Oratory.

Painted in 1609 for the Oratory of the Compagnia de San Lorenzo, the *Nativity with Saints Lawrence and Francis* measures approximately 3 × 2 metres. For all his faults (he had a long criminal record which included murder), this work, painted during Caravaggio's heyday, was magnificent. To walk down the aisle towards the *Nativity*, which hangs above the Oratory, must have been spiritually uplifting. For 361 years parishioners feasted upon Caravaggio's masterpiece; on 18 October 1969, however, two thieves linked to the Sicilian mafia removed it by slicing the canvas out of its frame.[29] It has not been seen since. Though it is academic, in 2006 it was attributed a value of USD 20 million by the FBI in their Top Ten Art Crimes.[30] Factum Arte's facsimile is not the first copy destined to 'fill in' for Caravaggio's painting. For many years, a colour photograph – in itself a form of copying – filled the empty space. In 1986, after a two-year dialogue, the American artist Noel Baron (1952–2006) was granted

permission from the Archdiocese to paint a copy. She gifted it to the people of Palermo for their church. In a cruel twist of fate, her version was lost. According to her family, the painting made its way, at her expense, to Palermo but was never installed. The work was never recovered. Believed to be misplaced, misappropriated or stolen; an extensive search has never recovered the work. Its whereabouts remain a mystery.[31]

Factum Arte tidied up the 1968 photograph by removing the grainy and blurry features. One of their major challenges was to reproduce Caravaggio's textural nuance in which he under painted in a way that optically blended his colours from a distance rather than physically mixing them. They went to great lengths to replicate and capture every detail of Caravaggio's process, including the canvas with the same materials he originally used.[32] Finally the day arrived, nicely timed for Christmas (especially given the subject matter) on 12 December 2015, for the facsimile to be unveiled. Reading the accounts of this event, the unveiling was nothing short of miraculous. Once again, the Church looks complete with the addition of the facsimile. But should the original ever be found – and there are numerous theories of its whereabouts including that rats and hogs ate it – it will be re-installed. In the meantime, the replica plays a significant role spiritually, artistically and architecturally.

MONET AND MATISSE AT HOME

To visit Henri Matisse's (1869–1954) home and studio nestled on the hillside of Nice on a hot summer's day is a rich and unforgettable experience. Everything about the Musée Matisse is as you might imagine; a red-faced three-storey villa complete with a terracotta-tiled roof, Matisse's home, where the artist lived and worked from 1917 to 1954, is as quintessentially French Riviera as it gets. Perhaps what is even more stunning is the permanent collection of Matisse's work: 68 paintings, 236 drawings, 218 prints, 95 photographs, 57 sculptures, 14 books he illustrated and 187 objects, such as tapestries and ceramics. This is an extensive line-up that has continued to grow since the museum opened in 1963. That the works are authentic, many made in Nice, makes the experience resoundingly complete and satisfying.

Further north, at Giverny, Monet's home and garden is visited en masse, especially during the summer months when the garden is at its best, annually by half a million visitors. This is a different kind of experience. Far more commercial in order to deal with the crowds, the key difference is that a visit inevitably includes the viewing of copies of Monet's work. It is

set up to feel like the artist and his family are still in residence. The bright yellow dining room, the kitchen with its blue Rouen tiles, the Japanese bridge and the studio full of paintings provides a window into the artist's life and work. The only original artworks that visitors see are the collection of Japanese prints. A major influence on Monet's work, prints from Japan were highly collectable, especially amongst the Impressionists. At Giverny, there are close to 250 original prints in the collection, many of them on display in the house. The 'three greats' of eighteenth- and nineteenth-century Japanese printmaking – Utamaro (d.1806), Hokusai (1760–1849) and Hiroshige (1797–1858) – are well represented in Monet's collection.

Monet's own paintings were split up over time and now reside in public and private collections worldwide. Yet today's visitors to Giverny still get a sense of Monet's life's work; in the ground floor salon-studio, there is a dense hang of his paintings. In 1899 Monet converted his studio – one of three he had at Giverny – into a salon. Paintings from each stage of his career are exhibited. Some works are framed, others not. Each of these works is a copy, as are the works by fellow artists Cézanne, Renoir, Signac and Caillebotte installed elsewhere in the house. Unlike Matisse's collection, Monet's was broken up over time; the most comprehensive collection of his work, with a staggering 100 oil paintings, is at Musée Marmottan-Monet, Paris.

For the purist visitor, the Monet experience is very different from the Matisse one. There are few historic homes that can boast retaining a full complement of original art and objects. One excellent example is New Zealand's Olveston built in Dunedin in 1904–7 for the Theomin Family, in a Jacobean style.[33] The 35-room house has a lavish collection of objects and art – including ceramics from the Orient, carpets from Turkey, and artworks by leading artists of the day. The rooms are full to bursting with both contemporary and antique art and objects. In true colonial fashion, there are copies amongst this catalogue, including a large painting titled *The Family of Darius at the Feet of Alexander*. It is a copy after Veronese. Curiously, it is labelled 'probably a copy'. It is a copy because the original work, painted between 1565 and 1570, has been in the collection of the National Gallery, London, since 1857.[34] The original, described by art critic John Ruskin as the most precious Veronese in the world, is four times the size of Olveston's copy.

In 1966, the surviving family member, Dorothy Theomin gave the house and its contents, in its entirety, to the people of Dunedin. Open to the public, this is a unique attraction. I visited the house as a nine-year-old

and remember being overawed by the beauty of Olveston. In particular, I recall a vase of sweet peas in Dorothy Theomin's bedroom for they were her flower of preference. There has always been a focus on keeping the house in its original authentic state where possible and with the exception of some of the floor coverings, everything is still original today. The floor coverings that are art works in their own right include hand-knotted Turkish rugs and an Arts & Crafts Donegal piece. Conservators tried various ways of preserving the rugs and carpets over time. Finally, beginning in the late 1990s, copies of the original floor coverings were made and are described on Olveston's website as 'authentically made reproductions'.[35] The advantages of the replica carpets are that you still get to walk on what looks like the original choice of floor coverings while the originals are kept in storage for safekeeping.

AT HOME WITH ALBRECHT DÜRER

Museums dedicated to single artists also contain copies. In the German town of Nürnberg, you can visit the house where the great artist and printmaker Dürer lived from 1509 to 1528.[36] The house includes his workshop, with printing press, and museum. The five-storied Tudor-style home, built in 1420, is the only fifteenth-century artist's house in Northern Europe in existence.[37] To contextualise Dürer's life and work, the museum provides a digital display and exhibition of copies of his work, of which many have interesting backstories. A good case for exhibiting copies is a lack of accessibility to the originals and this is the reasoning here, for the entire hang in the Dürer Hall, which opened in 2012, consists of copies.

Audiences are familiar with Dürer's life and work through his unique self-portraits. One made in 1500, titled *Self-Portrait with Fur-Trimmed Robe*, faces us head-on, his long golden locks framing his face. It has often been likened to a Christ-like image, or rather what some imagine Christ to have looked like. It is dark and endearing. Oil on lime wood panel, the original painting is in Munich.[38] The work stayed in Nürnberg and was on public display from shortly before the artist's death up to 1805, when it was purchased for the Bavarian royal collection. The work exhibited today in the Dürer Hall is an 1880 copy, possibly made by Carl Jäger (1833–1887).[39] Like each of the other copies that make up the permanent hang, it is the same size as the original. The exhibition labels give details,

if known, about the origin of the copies as well as where the original Dürer works are located.

In 1507, having just returned from his second trip to Italy where he experienced Venetian art first-hand, Dürer painted two panels, *Adam and Eve*. Life-size, these two oil paintings were a revelation; not only were they stylistically different from what was happening in German art at the time but they were also very realistic and nude; this latter aspect created some issues after Dürer's death. The provenance is chequered: *Adam and Eve*'s first home being the Prague Castle, the property of collector Rudolf II. During the Thirty Years' War, armies plundered the castle and the panels came into the possession of Queen Christina of Sweden. Christina, in turn, gave the works to Philip IV of Spain in 1654. Later, in 1777, King Charles III ordered that *Adam and Eve* be hidden in the Real Academia de Bellas Artes de San Fernando, and the panels only avoided destruction, due to the King's view that it was obscene, by the intervention of his court painter. *Adam and Eve* arrived at its current home, Madrid's Museo del Prado, in 1827, but was not publicly displayed until 1833.[40] In 2010 the Prado proudly re-hung the *Adam and Eve* panels after they underwent a two-year extensive programme of conservation.

At the Dürer Hall, the *Adam and Eve* on show is a copy made by German artist, Hans Otto Poppelreuther (1885–1965) in 1930.[41] He spent most of his working life in Spain and was known for landscapes and contemporary scenes, including a painting of the interior of the Siemens factory. Though catalogued as painted in 1930, the exhibition label for Poppelreuther's copy, notes that it was made for an exhibition, 'The Early Dürer', in 1928.

In close proximity to both the *Self Portrait* and *Adam and Eve*, hangs *The Four Apostles*. Originally painted in 1523–6, the copy is a 1627 copy made by Johannes Vischer (c.1595–c.1637).[42] Vischer was accepted as a master by the Munich Guild of St Luke in 1621 and was then appointed as the court painter to Elector Maximilian. Vischer was a key player in what is termed the Dürer Renaissance. This movement, dating from approximately 1570 to 1630, saw a keen interest in preserving and cataloguing Dürer's works. In addition, various artists paid homage to Dürer working in his style.

The Four Apostles was the last of Dürer's major works and he painted it specifically to gift to his hometown of Nürnberg. Gratefully accepted, *The Four Apostles* was hung in the upper chamber of the city hall. Painted in oil on linden wood, the two panels each measure 215 × 76 cm (as do the

copies). The work is held in Munich's Alte Pinakothek collection. Vischer was sent to Nürnberg in 1627 to make copies of both panels; they were painted before witnesses who included Maximilian's Kammerkunstler (chamber artist), Augustin Hammel Haimbl. The finishing touch to the copy – a request made by Maximilian – was to remove with a saw the text panels from the lower portion of the original paintings and attach them to Vischer's copies. This was done. It was not until 1922 that the text inscriptions were re-united with the originals in Munich.

The Dürer Hall exhibition is completely made up of copies as discussed above. In other museums, copies are deliberately included (and many more unbeknownst) in exhibitions alongside originals as learning tools. Such inclusions can really engage the visitor to seek out the authentic from the copy. They can make viewers look more closely at artworks. Additionally, they can encourage debate about the 'value' of art and its copies. A good example was at the Dulwich Picture Gallery in 2015. The conceptual artist Doug Fishbone (b.1969) organised to have a copy of Jean-Honoré Fragonard's (1732–1806) *Young Woman* of c.1769, from his famous 'Figures de Fantaisie' series, made in China for £100.[43] Visitors were encouraged to find the Chinese copy. In fact, they did not need too much encouragement. Visitor numbers doubled for the duration of the exhibition; nearly 3000 people voted using iPads in the gallery. Only 10 per cent guessed that the imposter painting was *Young Woman*. Afterwards, the copy and the original were hung side by side to enable visitors to make a close-up visual comparison. Visitors specifically visited the gallery to see the 'Fragonards', thus proving the motivation for the exhibition:

> The project explores the nature and importance of the original versus the copy and the role of art as a commodity, a subject of increasing importance in our age of global mass production.[44]

The Dulwich Picture Gallery created even more interest when they invited notorious art forger John Myatt to spot the copy. He did spot it and suggested to me that it was not a good copy![45] Today the copy is kept in the gallery's storeroom.[46]

In a similar vein, an exhibition I curated, 'The Empty Frame: Art Crimes of New Zealand', included copies of two works from the Waikato Museum's collection (see Fig. 5.3).[47] Visitors were asked to identify the authentic from the copies. Like the Dulwich Picture Gallery's copy, these two were also made in China. Organising the copies to be made online

Fig. 5.3 Originals and copies of Adele Younghusband's *Floral Still Life* (1958 and 2016) and Ida H Carey's *Interior* (1946 and 2016) in 'An Empty Frame: Art Crime in New Zealand' exhibition (2016–7). (Photo: Waikato Museum Te Whare Taonga o Waikato)

was scaringly easy and the results were exceptionally good. For my part, I supplied a couple of digital images and the museum paid USD 186.50 for the paintings and freight. Visitors were enthralled at being involved and for me as the curator, listening in on their conversations was an added bonus. There were a few aspects, however, about exhibiting the newly made copies that were important to me. Firstly, given the works were both still in copyright, permission had to be sought from the estates of the two deceased artists – Ida H Carey (1891–1982) and Adele Younghusband (1878–1969). It was only respectful to explain the objective for exhibiting copies and ask permission to use the images. Secondly, the extended label explained the process, as well as stating that at the end of the exhibition the copies would be destroyed. And lastly, the copies were destroyed so as not to cause any confusion in the future. Both the Dulwich and Waikato Museum's use of copies was not only legitimate but also ticked both the entertainment and educational boxes.

This was not the case with German woman Petra Kujau (b.1962), who used Chinese copies to profit herself. She was following on a trade after the death of Konrad Kujau (1938–2000), the infamous forger of the Hitler Diaries. Having completed his prison sentence he made copies of paintings and signed them with his own signature. He was completely open about the works and numerous collectors acquired a 'Konrad Kujau'. Petra Kujau, who was allegedly related to him, continued on Konrad Kujau's but instead of painting the copies herself she had hundreds made in China. She then added Konrad Kujau's signature and sold them

deceitfully as his work. In essence, they became forgeries of copies.[48] At the time of Kujau's conviction of fraud in 2010, Judge Joachim Kubista commented:

> Art forgeries are nothing unusual, but the further fabrication of the forger is really rather unusual.[49]

CLYFFORD STILL'S 'REPLICAS'

In the exhibitions discussed above, the copies have been made by artists other than the original one and often in a different era. In this next example the original artist made the copies, or 'replicas', as he referred to them. Clyfford Still (1904–1980) is known for his Abstract Expressionist works evolving from the early 1940s, having spent his formative years working in a more representational style. A museum dedicated to Still, located in Denver Colorado, opened in 2011. In the exhibition 'Repeat/Recreate: Clyfford Still's Replicas', more than 70 works, across a variety of media and size, were hung in duplicates and triplicates. This was a first, and ultimately challenged, popular perceptions about Abstract Expressionism and how the works were executed. As one of the curators, Dean Sobel, noted:

> This exhibition illustrates how paintings by Still, Pollock, Rothko, and Motherwell were not the outpourings of unbridled and fleeting creative impulses but were, in fact, the result of slow, methodical deliberations that could – and would – be recreated in marvellous variations.[50]

Still's practice of making copies was not exclusively new or original; others such as Monet or Rembrandt to name just two, made multiples of works. The key difference here is that Still's painting style did not naturally lend itself to copying. There are only very subtle differences – and purposefully – between the original and the copy and vice versa. So why did Still make copies throughout his painting career? Firstly, to recreate a work that had sold of which he wanted to retain an image and secondly, to improve or refine the original painting. Thirdly, to experiment with scale and/or palette which was very evident when viewing the installation of the exhibition. Lastly, in 1972, Still noted that he made replicas ' ... in homage to a concept worthy of more than one stretch of the canvas'.[51] Still recognised and acknowledged that though he was making replicas, each one had ' ... its special and particular life and is not intended to be

just a copy'.[52] In essence, they were replicas and unique at the same time. This nuance of being individual could also be read as Still's personal reinterpretation of his work.

Still's replicas have given him more kudos as an artist of copying – or recreating – non-representational images as this is no mean feat on both conceptual and practical levels. Ultimately, Still gazumped the idea that abstraction was not just about action but was considered and, as reviewer Michael Paglia noted, a contemplative practice and one that could be repeated.[53] The works in the exhibition were more than 'just copies'. They were new creations. Reviewer Susan Tallman aptly describes Still's practice for making replicas as:

> ... unsettling, like discovering that an impassioned speech has been carefully rehearsed and delivered to multiple beloveds.[54]

Banksy Does Monet

In late 2020, interest was hyped when Banksy's (b.1974) *Show Me the Monet* sold for £7.6 million at auction (see Fig. 5.4).[55] Painted in 2005, it depicts Monet's iconic water lily pond and garden with its Japanese bridge. As perhaps to be expected, Banksy's one has additions; two abandoned supermarket trolleys and a fluorescent road cone have been biffed into the pond. The beauty and serenity of Monet's pond and bridge are stripped; that we live in a throwaway society is the clear message here. Fly tipping is a global issue and the Banksy pond could be almost anywhere. The carefully selected objects are international symbols of progress and consumerism.

Show Me the Monet was shown originally in Banksy's 2005 exhibition titled 'Crude Oils: A Gallery of Re-mixed Masterpieces, Vandalism and Vermin', in which the artist reinterpreted the works of 'famous' artists – Van Gogh, Warhol, Vettriano and Monet.[56] The enclosed gallery space was filled with 164 live rats that represented humans and, in Banksy's own words, he saw them as ' ... the triumph of the little people, the undesirables, and the unloved'.[57] *Show Me the Monet* is signed by Banksy and, in keeping with Monet's oeuvre, executed in oils on canvas.

Show Me the Monet is not an exact copy. Banksy blended three of Monet's works: *Le Bassin aux nymphéas*, *Water Lilies and Japanese Bridge* and *The Water-Lily Pond*, all dating from 1899. Banksy's Monet is slightly larger than the originals, at 140 × 140 cm. Unframed, Monet's are approximately 90 × 90 cm. Banksy labels the works from his 'Crude Oils' series

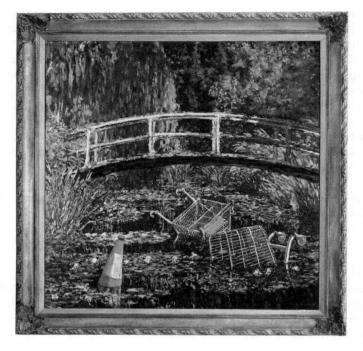

Fig. 5.4 Banksy, *Show me the Monet* (2005). Private collection. (Photo: Sotheby's)

as 're-mixes'; without the originals his re-mixes would not exist. In true Banksy fashion, when *Show Me the Monet* was offered up at auction the catalogue entry noted: 'This work is accompanied by a Pest Control Certificate of Authenticity.'[58]

As entertaining as viewers found Banksy's 2005 exhibition, albeit with rats (no wonder the two-week exhibition had free entry!), he makes works and uses them as vehicles to make a stand. Commenting on aspects of contemporary life, whether it is social, political or economic, Banksy is an activist artist. Through his imagery, he educates and affects change. About *Show Me the Monet* he stated:

> The real damage to our environment is not done by graffiti writers and drunken teenagers, but by big business. ... exactly the people who put gold-

framed pictures of landscapes on their walls and try to tell the rest of us how to behave.[59]

The rationale behind Banksy's use of iconic paintings is, the more famous it is the bigger the audience for sending a message. His quasi-copy of Monet's water lily pond at Giverny makes you consider whether it would be worth visiting full of rubbish (and we know approximately half a million visit annually to see it rubbish-free).[60] Banksy contrasts the beautiful with the ugly, the imagined with reality. Selling for what it did, Banksy's *Show Me the Monet* has been taken to a whole new level for copying or remixing or however you want to label it. Indeed, the irony of his title *Show Me the Monet/Show Me the Money* came into its own given the price paid for it at the 2020 auction.

* * *

Clearly incorporating copies are essential to the successes of exhibitions, displays and movies. In many instances, the original authentic artwork is too vulnerable, too valuable, or not available for the purposes of educating and entertaining. Artists have also used copying as an extension of their own practice, as shown by the actions of Still and Banksy. When copies infiltrate exhibitions of authentic works they have the ability of posing questions around authenticity and just how closely the average viewer looks (and if they know what they should be looking for in a fake or a copy). This enriches visitor experience.

For the producers of movies there are challenges that change as technology improves (the ability of producing an exact copy improves with 3-D scanning and printing, but so too does the technology of cinematography which can pick up on any imperfections). One challenge is time. For instance, Gustav Klimt (1862–1918) spent three years painting the *Portrait of Adele Bloch-Bauer I* (1907).[61] Steve Mitchell (b.1954), the scenic artist who painted the copy for the movie *Woman in Gold* (2015), had just five weeks to fashion a copy from scratch. His second challenge was achieving the same surface texture as Klimt's original. To not achieve this is a dead giveaway to the trained eye. Also, given the time restraints, the materials used to make a copy often cannot be the same as the original. Acrylic paint replaces oil for it dries faster and is far easier to manipulate. Detail, however, remains important: for example, Rembrandt and his contemporaries used quite coarse linen to paint onto, often with visible slubs. The canvas

available in more recent times is finer and more evenly woven which is due, in part, to its being made industrially rather than being hand-woven as in Rembrandt's time. Such coarseness has to be replicated in a copy to make it as close to the original as possible. The *Portrait of Adele Bloch-Bauer I* contains a large proportion of gold leaf, which had to be replicated for the big screen. Mitchell not only made the completed portrait for the movie but also a half-made version, as well as a close-up of the central section of the painting. To add to the complexity, Klimt made many alterations to his painting, making the surface even more complicated. These too, had to be convincingly copied.[62]

I will end this chapter where it began – with the story of Kempton Bunton's theft of the *Duke of Wellington*. It's possibly the theft that appeals to audiences more than the actual portrait, which is somewhat underwhelming when you see it up close. I was reminded of this when it was on exhibition in Canberra, Australia, in 2021. A small portrait given the enormity of subject, yet easy to sling under your arm, Goya's painting shows an almost vulnerable Duke. You get the impression that his chest won't support any more medals; Goya's handling of paint gives the portrait an immediacy and warmth. But perhaps there was something more than the price the National Gallery had paid for the portrait that attracted Bunton to it. Was it that the Duke was a hero and that if Bunton got his way, he too would be a hero amongst those not well off financially. Whatever the answer, the theft continues to entertain. A play, *The Duke in the Cupboard*, written by Susan Wear was staged in 2015 and a musical called *Kempton Bunton* rolled out in 2020.[63] No doubt copies of Goya's work were made for both. With a stellar cast, the movie *The Duke* (2020) relived the story of Bunton and his protest against the poor and elderly having to pay television licenses when the government of the day had enough funds to acquire the £140,000 portrait. In it, Bunton, played by Jim Broadbent, handles the Goya several times. Artist Paul Driver (b.1959) made two copies of *The Duke* for the movie. Both were oil on mahogany, just like the original. Driver was supplied with a high-quality print of the portrait to work from, but also made a few trips to the National Gallery to study the painting up close (though he admits to the security staff watching him closely after he'd been there for quite some time studying just the one painting). Today the original portrait remains seemingly safe and secure at the National Gallery. Since 1961, it had been believed that Bunton was the thief but the latest film adaptation of the story saw the revelation of a new twist. Allegedly, in 1969 Bunton's son John (known as Jackie) confessed to the painting's theft; however, the lack of evidence meant he wasn't prosecuted.[64]

The theft of the Goya is the art crime that just keeps on giving. At the end of the most recent movie Bunton and his wife, Dorothy, are seen sitting at the movies watching *Dr. No*. As Bond pauses as he walks past the easel, Bunton nudges Dolly and says, 'It's that bloody painting again.'

NOTES

1. Collection of the National Gallery, London [6322], oil on mahogany, 64.3 × 52.4 cm.
2. Conklin, John E. *Art Crime*. Westport CT: Praeger, 1994, p. 151.
3. Charney, Noah (ed). *Art and Crime: Exploring the Dark Side of the Art World*. California: Praeger, 2009, p. 42.
4. Ibid., p. 49.
5. https://timwright.com
6. Ibid.
7. The original painting, *Helvoetsluys; the City of Utrecht, 64, Going to Sea*, is in the collection of the Fuji Art Museum, Tokyo, oil on canvas, 91.4 × 122 cm.
8. Ng, David. 'J.M.W. Turner painting goes for record $475 million at auction', *Los Angeles Times*, 4 December 2014.
9. Email correspondence from Suzie Davies, 15 April 2020.
10. https://timwright.com
11. Email correspondence from Suzie Davies, 15 April 2020.
12. https://timwright.com
13. Ibid.
14. Gascoigne, Laura. 'Mummy Dearest', *The Spectator*, 31 August 2019, p. 30.
15. Exhibition dates: 18 June to 18 July 2021.
16. Spall, Timothy. 'Artist's Notebook', *The Spectator*, 5 June 2021, p. 19.
17. Chevalier, Tracy. *Girl With a Pearl Earring*. London: Harper Collins, 1999.
18. Collection of Mauritsshuis, The Hague [670], oil on canvas, 44.5 × 39 cm.
19. Collection of the Rijksmuseum, Amsterdam [A2860], c.1657–61, oil on canvas, 54 × 44 cm.
20. Collection of the Mauritsshuis, The Hague [605], oil on panel, 34 × 23 cm.
21. Cascone, Sarah. 'How the Filmmakers Behind 'The Goldfinch' Built Near-Perfect Replicas of the Met and the Dutch Masterpiece at the Story's Heart', *Artnet News*, 17 September 2019.
22. Collection of the Metropolitan Museum of Art, New York [89.15.21], oil on canvas, 45 × 40 cm. Also known as *Young Woman with a Water Pitcher*.
23. Email correspondence with Todd van Hulzen, 25 November 2020.
24. Collection of the Louvre, France [INV 142/MR 384], oil on canvas, 6.77 × 9.9 m.

25. www.louvre.fr/en/oeuvre-notices/wedding-feast-cana
26. Povoledo, Elisabetta. 'A Painting Comes Home (or at least a Facsimile)', *New York Times* 29 September 2007.
27. Ibid.
28. Sooke, Alistair, 'It is the art crime of the 20th Century. Forty-four years after its theft, what do experts think happened to the Italian painter's masterwork?', https://www.bbc.com/culture/article/20131219-hunting-a-stolen-masterpiece, 23 December 2013.
29. Caravaggio's *Nativity* was loaned on three occasions: Milan in 1951, Palermo in 1952 and Paris in 1965.
30. Simon Houpt, *Museum of the Missing: A History of Art Theft*, New York: Sterling, 2006, p. 176.
31. www.waveourflag.com
32. Visit www.factum-arte.com for a full account of the making of Caravaggio's *Nativity* facsimile.
33. www.olveston.co.nz
34. Collection of the National Gallery, London [NG294], oil on canvas, 236.2 × 474.9 cm.
35. Email correspondence with Erica Atkins, Olveston, 19 January 2021.
36. Albrecht-Dürer-StraBe39, 90403 Nürnberg, Germany.
37. https://museums.neurnberg.de
38. Collection of Alte Pinakothek, Museum [Nr.537], oil on limewood, 67.1 × 48.9 cm.
39. Collection of Albrecht-Dürer-Haus [Gm2865], oil on wood, 67.1 × 48.9 cm.
40. https://en.wikipedia.org/wiki/Adam_and_Eve_(D%C3%BCrer)
41. Collection of Albrecht- Dürer -Haus [Gm1142 and Gm1143], oil on wood, each panel is 212 × 82 cm.
42. Also known as: Johann Georg Vischer, Johannes Fischer, Johann George Fischer and Hans Fischer.
43. Collection of the Dulwich Picture Gallery, London [DPG 074], oil on canvas, 62.9 × 52.7 cm.
44. https://www.dulwichpicturegallery.org.uk/about/press-media/press-releases/fragonards-young-woman-revealed-as-replica-in-made-in-china-project/
45. Email correspondence from John and Rosemary Myatt, 22 December 2020.
46. Email correspondence from Helen Hillyard, Dulwich Picture Gallery, 21 January 2021.
47. 'The Empty Frame: Art Crimes of New Zealand', Waikato Museum Te Whare Taonga o Waikato, New Zealand. Exhibition dates: 24 September 2016–8 January 2017. The two works copied were: Ida H Carey's *Interior* [1980/42/5] of 1946, oil on board, 36.5 × 46.4 cm and Adele Younghusband's *Floral Still Life* [2003/8/6] of 1958, oil on board, 736 × 578 × 40 cm.

48. For a fuller version about this case study see Penelope Jackson, Chapter 5 'The Art of the Con[wo]man', *Females in the Frame: Women, Art, and Crime*. London: Palgrave Macmillan, 2019.
49. Connolly, Kate, 'Art dealer convicted of forging forger's forgeries', *The Guardian*, 10 September 2010.
50. https://clyffordstillmuseum.org/replicas
51. Boyd, Kealey, *Hyperallergic*, 'Clyfford Still's Radical Reputation', Hyperallergic, 4 January 2016.
52. Ibid.
53. Paglia, Michael, 'Clyfford Still's Greatness Bears Repeating in Replicas', *Westword*, 11 November 2015.
54. Tillman, Susan, 'On Copying', *Art in Print*, Vol.5, No.4, (Nov-Dec 2015), p. 2.
55. Lot 106, Contemporary Art Evening Auction, Sotheby's, 21 October 2020.
56. The exhibition was held at 100 Westbourne Grove, London, October 2005.
57. https://www.barrons.com/articles/sothebys-to-sell-banksys-show-me-the-monet-01600432508
58. https://www.sothebys.com/en/buy/auction/2020/contemporary-art-evening-auction-2/banksy-show-me-the-monet
59. Holmes, Helen, 'Banksy Was Trying to Make a Political Statement with 'Show Me the Monet'. No One Cared'. *Observer*, 23 October 2020.
60. www.thefrenchlife.org
61. Collection of the Neue Galerie, New York [No.2006.04], gold and oil paint and silver on canvas, 140 × 140 cm.
62. Gelt, Jessica, 'Scenic artist hit a masterwork mother lode with 'Woman in Gold', *LA Times*, 27 March 2015.
63. BEAM 2020 – the festival of new musical theatre.
64. Hastings, Chris. 'Revealed: Bus driver jailed for stealing Goya's painting of Duke of Wellington from the National Portrait Gallery in 1965 didn't do it, new documents show as Helen Mirren stars in new film', *The Mail on Sunday*, 6 June 2021 [note the painting was stolen in 1961, not 1965 as this article heading suggests].

Copies in Public Collections

Public collections have long been repositories, both intentionally and unintentionally, for copies of artworks. The role of copies in public collections has continued to change over time. For the context of this chapter, public collections refers to collections that can be visited by the public no matter who they are owned, governed or administrated by. Though the practice of actively collecting copies over original artworks for public collections is now minimal, copies can and do still play active roles. These can include, but are not limited to: disseminating information about a significant person; assisting in contextualising a collection when the original is not available (perhaps it is part of a permanent collection elsewhere); offering a window into a historical period, or person or occasion that is revered at the time of making; and providing a cost-effective substitute to originals that are expensive or impossible to acquire. There are many copies in public collections that provide and enhance a visitor's experience.

George Richmond's *Portrait of Charlotte Brontë*

One way of valuing the importance of copies is to think of an example and imagine if it was removed from the context in which it plays an important function. How would this change the venue and lessen the visitor experience if it did not exist? Take, for example, the *Portrait of Charlotte Brontë* in Haworth House, in West Yorkshire, at the Brontë Parsonage Museum (see Fig. 6.1).

P. Jackson, *The Art of Copying Art*, https://doi.org/10.1007/978-3-030-88915-9_6

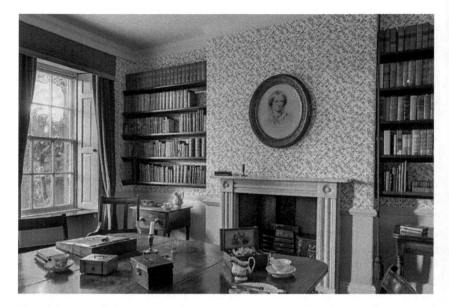

Fig. 6.1 The dining room at Haworth House, West Yorkshire, with a copy of George Richmond's *Portrait of Charlotte Brontë* above the fireplace. (Photo: Justin Paget, *Country Life*)

In the summer of 1850, Charlotte Brontë's (1816–1855) publisher, George Smith, commissioned artist George Richmond (1809–1896) to draw a portrait of the author.[1] Rendered in chalk, the portrait – as remembered by Charlotte Brontë's biographer Elizabeth Gaskell – hung in the parlour at Haworth Parsonage. The head and shoulders portrait is a delicately drawn work, depicting a demure Brontë, in an oval frame. The parlour, also known as the dining room, is perhaps one of the most significant literary dining rooms in the history of English literature for it was here that the novels *Jane Eyre*, *Wuthering Heights* and *Agnes Grey* were penned. Nowadays, the dining room at Haworth House is restored as close as possible to when the Brontë sisters used it as their communal writing room.

At the time of its making, Richmond's portrait caused Brontë much consternation, about which there have been endless discourses. The basis for this is the question of likeness. For Richmond's generation of portraitists, a good likeness to the sitter was the measure of the success of the

finished portrait. Richmond cleverly produced a portrait that emphasised the sitter's large hazel eyes and detracted from her square jaw, prominent nose and mouth. Such was Brontë's dislike of the experience of sitting for her portrait that she was reduced to tears; in Brontë's opinion, her portrait looked more like her sister Anne (1820–1849), who died a year before Charlotte. Thus, this small work has a history of causing pleasure – Mr Brontë was pleased with it – and displeasure. That aside, the work duly hung and remained at the Brontë family home until 1861, six years after Brontë's death. Brontë's widower, Arthur Bell Nicholls, bequeathed the Richmond portrait to the National Portrait Gallery, London, in 1906. His death pre-dates the opening of the Brontë Museum in 1928.

The Richmond portrait that now hangs above the fireplace at Haworth is a photographic copy of his original work; the provenance of the photographic copy is unknown. It dates from the early twentieth century and, although it was located on the wall adjacent to the fireplace during the 1980s, it is now back in its original position above the fireplace. Regardless of whether the portrait is a copy, or not, the Richmond work is significant in terms of providing a true historical experience nearly 170 years since the original one was made. Without the portrait, the dining room would be missing a key object. The Brontë Museum has gone to great lengths to make the room as authentic as possible, including acquiring the original mahogany dining table – with its sunken area for inkpots – which was sold in 1861 when the family vacated the parsonage. The table was purchased for £580,000 in 2015. The dining room is also significant as it is where Emily Brontë died in 1848 and, as Gaskell noted, it was the room where the sisters exercised (they walked laps around the table and talked late into the night).

Today, the portrait is clearly labelled as a copy. Being a copy does not, however, detract from the experience of seeing the dining room as it helps complete the picture of the curate's family of writers. There are multiple copies of the portrait, including a sea of copies that can be viewed on the Internet, and yet we know from contemporary records that the likeness to Brontë is not good. For many, the portrait is a romanticised image of how they possibly think the female Victorian novelist looked. This is further endorsed by the fact that there is only one other portrait of Brontë within a group portrait with her sisters, painted by their brother and aspiring artist, Patrick Branwell Brontë in 1834.[2]

According to those who knew her and her biographers, Brontë was never at ease with the Richmond portrait. In a letter to her publisher, dated 26 February 1853, she thanked him for the gift of a portrait of the writer, W. M. Thackeray Esquire.[3] She also noted that he has two other portraits to keep him company – an engraving of the Duke of Wellington (gifted at the same time in 1850 as her own one) and:

> ... for contrast and foil – Richmond's portrait of an unworthy individual who – in such society – must be nameless.[4]

She is speaking about herself and at the time of her writing in late 1853, Brontë was the published author of *Jane Eyre*, *Shirley* and *Villette* – an impressive line-up and yet she remained humble. Albeit that Brontë didn't agree, Richmond's portrait is certainly of a worthy individual and without its copy at the Brontë Museum the dining room could feel incomplete. Therefore, a copy in this context is both highly valuable and acceptable. Richmond's portrait had an extended life cycle for not only has it been copied ad nauseam; for example, American publisher Evert Augustus Duyckinick presented it as the idealised posthumous portrait in 1873 in his book *Portrait Gallery of Eminent Men and Women of Europe and America*. Duyckinick's portrait of Brontë is a tinted engraving. One can ask if its significance would be any less or different if the portrait was the original one: what is more important here, however, in my mind, is the actual image of the great writer herself rather than its authenticity.

ROSA BONHEUR'S *PLOUGHING IN THE NIVERNAIS* AND *THE HORSE FAIR*

Copies made by artists of their own works have found their way into public collections. One such artist is the nineteenth-century French painter, Rosa Bonheur (1822–1899). Renowned in her own time, Bonheur has attracted much attention, especially since the recognition and writing of women's art history, for her lifestyle. Short haired, chain-smoking and trouser-wearing, Bonheur did not conform to the feminine ideals of her day. In fact, she ignored the rules and conventions in order to establish her professional artist career as a painter of animals, including perhaps her two most famous works, *Ploughing in the Nivernais* and *The Horse Fair*. Writers have dwelled on her sexuality and non-conformist attitudes, but she can

also be remembered for the copies she made of her own work for they have provided awareness about her life and work.

Following in her artist father's footsteps, Bonheur was taught by him. From the age of 14, Bonheur copied Old Masters – Poussin and Rubens being favourites – at the Louvre to sell.[5] By the age of 17 years, Bonheur was making substantial contributions to her family's income (her three younger siblings also became artists). In her late twenties Bonheur painted her epic work *Ploughing in the Nivernais*. The work, depicting Charolais oxen (indigenous to Nivernais) ploughing through the hard earth in preparation for the winter ahead, is an example of nineteenth-century photographic realism and a celebration of rural life. Bonheur adhered to direct observation from nature throughout her artistic career, giving her work that photographic appeal. It was the culmination of years of studying animals – both dead and alive – by the artist. Large by nineteenth-century standards for a woman to paint, the oil on canvas measures 1.34 × 2.60 metres and was presented at the Paris Salon in 1849. In preparation for painting *Ploughing in the Nivernais*, now in the Musée d'Orsay's collection, Bonheur made a smaller preparatory study, measuring 40.64 × 21.59 cm; Bonheur's application of paint is far looser and painterly when compared with the final work. The preparatory work is in the collection of the R. W. Norton Art Gallery, Louisiana. Though a study, the work is signed and infrequently referred to as a preparatory study. An alternative way of viewing, somewhat cheekily, the Musée d'Orsay version is positing it as a copy of the preparatory painting!

On the back of the painting's success (it was the winner of a First Medal at the Salon in 1849), Bonheur went on to paint a copy of her original work in 1850, which is more often described as a 'variant'. Now in the Ringling Collection at the Florida State University, this work was purchased for a mere USD 230 in 1929 and subsequently bequeathed by John Ringling in 1936; the work is the same size as the original.[6] Although a copy, there are slight variations in the sky and vegetation. By the late 1920s, these kinds of paintings were out of vogue in both subject and style, hence the smaller price compared with its sale in 1866 equivalent in today's currency to USD 200,000.[7]

Another *Ploughing the Nivernais* exists, painted by the American artist and close follower of Bonheur, Anna Elizabeth Klumpke (1856–1942). A professional artist in her own right, Klumpke greatly admired *Ploughing in the Nivernais* when she first saw it in 1877 at Paris' contemporary art museum, the Musée du Luxembourg. The size and whereabouts of

Klumpke's copy of *Ploughing in the Nivernais* is unknown; soon after its completion, Klumpke sold it to an American buyer for 1000 francs. She used the proceeds of its sale to further her art education and related the significance of copying Bonheur's painting in her *Memoirs of an Artist*:

> How often I lingered before the picture, was it not, indeed, in copying that picture that there came to me a revelation of my artistic vocation? That picture became to me a talisman.[8]

Bonheur's *Ploughing in the Nivernais* was well received by the public and copyrighted prints of it provided a long-term income stream for Bonheur.

Before leaving *Ploughing in the Nivernais* there is one more copy worth mentioning. Painted in 1868, by Elizabeth Jane Gardner (1837–1922), an American artist of Bonheur's generation, her version was made with specific outcomes in mind.[9] In 1864 Gardner left America and headed to Paris with her artist companion Imogene Robinson (c.1824–1908). Particularly astute, Gardner devised a strategy in place to become a professional artist; supporting herself and gaining a reputation as an artist was key to her trans-Atlantic relocation. She funded her training in Paris by painting and selling both portraits and copies of Old Masters. In a letter home to her mother, Gardner revealed her attitude to copying:

> I do it with good zest because it is an order, but I do not like much to copy.[10]

She might not have enjoyed the process of copying, but her clients enjoyed her results. As Gardner told her brother:

> One gentleman was so satisfied with a copy I did for him that he paid me more than I asked.[11]

Gardner realised early on that she needed to build a patron-base in order to become financially independent. She saw copying as a means to an end; wanting to improve her animal compositions she looked to Bonheur's work to study and copy. Ultimately, her preference was to paint original pieces but copying bridged the gap for her on several levels. Today, we would describe Gardner as a great networker; not only was she an impressive painter (she was the first and only American woman to receive a Salon medal)[12] but she too was good at sales. In fact, some have labelled her an

'artist dealer', or, to use a more contemporary expression, art consultant.[13] Brokering deals for collectors was part of retaining her financial independence.

Gardner's *Ploughing in the Nivernais* is basically half the size of Bonheur's original version. It belongs to the collection of the Dahesh Museum of Art in New York. Interestingly, Gardner gave her copy an alternative title too, *The First Dressing*, perhaps to clearly distinguish it from the original which has alternative titles: *Oxen ploughing in Nevers* or *Plowing in Nivernais*. To allay any confusion over who painted it, Gardner signed it: 'E. J. Gardner/Rosa Bonheur/Paris 1868'.[14] Gardner realised that securing a Salon Medal meant she could increase her prices. In 1868, on her first attempt she had two paintings accepted for the Salon, giving her more exposure as an artist and she could increase her prices.[15] Gardner would go on to exhibit regularly, exhibiting 36 paintings all up between 1868 and 1914. In 1887 she became the first and only American woman to receive a medal (third class) at the Paris Salon.[16] Although Gardner was focussing more on original pieces by the time she won her Gold Medal, the demand for copies remained high; Americans devoured French academic art and, as art historian Tiffany M. Reed noted, the quantities were enormous. The American Register reported that in 1878, Americans spent USD 3 million on French art and by 1882 five times that amount.[17] Copying certainly assisted Gardner in establishing her career as an artist.

Another painting that Bonheur is particularly well known for, and which gave her celebrity status, which was no mean feat for a woman in the mid-nineteenth century, is *The Horse Fair*.[18] Dated 1855, this large work, measuring 244.5 × 506.7 cm, depicts horses from the Paris market that she frequented. Full of energy and life as the horses pound the ground, it too won accolades and harboured much attention. The various copies certainly assisted in it gaining widespread attention. Queen Victoria had a private viewing of *The Horse Fair* and was particularly taken with it; Empress Eugenie of France awarded Bonheur the Legion of Honour, making her the first woman in history to receive it.

The Horse Fair was originally purchased by the Irish American department store magnate Alexander Turney Stewart and later donated to the Metropolitan Museum of Art by Cornelius Vanderbilt II in 1887. Bonheur made a smaller copy of the painting and it is possible that Nathalie Micas (1824–1889), the artist's long-term companion, assisted with painting the copy.[19] A quarter of the original's size, the copy was made for ease of transport to England where her dealer, Ernest Gambart, organised engravings

of it to be made. On 18 February 1863, the engraving was published. The engraver was C. G. Lewis and the engraved copies measured 41 × 83.8 cm. Engravings, especially in the nineteenth century, were a great way of sharing an image. For Victorians – and Bonheur's work was more popular in Britain than in France – collecting engravings of 'famous paintings' was a popular and affordable hobby, as well as being a signal to others that the collector was perhaps familiar with the original. In fact, there would be generations of etchings of *The Horse Fair* in her own time. Print historian Basil Hunnisett noted that Gambart's image was regarded by his contemporaries to have been his best plate. The original plate, by Thomas Landseer of 1856, was, however, destroyed; C. G. Lewis re-engraved it in a smaller size in 1863 and W. H. Simmons made an even smaller one in 1871.[20] These engravers were catering for the domestic market and there is no knowing how many prints were made but, given the number that continue to be offered up for sale on auction sites today, it would seem that the editions were substantial in size. Many engravings made their way into public collections such as the British Museum.[21]

The copies of Bonheur's work, made by herself or the numerous etchings made by others, helped in making her work better known and assisted in cementing her name in art history. As art historian Bridget Quinn noted, reproductions of *The Horse Fair* could be found throughout America, from post offices to schoolhouses to Elks lodges.[22] The artist as copyist, in her time, was acceptable and, in many ways, a practical solution to being self-sufficient. It also meant that her work, original and in copy form, is now represented in public collections.

VELÁZQUEZ AND *THE ROKEBY VENUS*

The great Spanish artist Diego Velázquez (1599–1660) possibly painted *The Toilet of Venus* (1647–1651) in Italy, where he was influenced by both Titian and Giorgione. Spaniards actively collected paintings of the female nude but they did not encourage their own artists to paint them. This is perhaps the painting's first claim to fame – the subject being of a naked woman admiring her reflection in a mirror held by her son, Cupid. As an aside, seeing her reflection is problematic; known as the 'Venus Effect', it would have been impossible for Venus to see herself given her placement in a supine position and the angle of the mirror. The painting's second claim to fame is that it was central to the vandalism deployed in 1914 by the British Suffragettes in a bid to raise awareness and ultimately achieve

the franchise for women. Slashed by Mary Richardson, who decided it was morally superior to attack a painting than a person, the painting had only been in London's National Gallery's collection for eight years at the time of the attack. It was acquired for the sum of £45,000, money raised by the National Art Collections Fund, which included financial support from the King. By this stage, Velázquez's painting, measuring 1.22 × 1.77 metres, was known as *The Rokeby Venus*. The painting left Spain – having hung in the homes of various Spanish courtiers – in 1813 and a year later was acquired by the politician John Bacon Sawrey Morritt for his personal collection at Rokeby Park in Yorkshire, England, where it was installed above the fireplace in the lavish Rokeby Hall. This is when and where the painting acquired its new title. During 1857 the painting proved popular when it was part of the 'Manchester Art Treasures' exhibition, which boasted 16,000 works and attracted 1.3 million visitors over a period of six months.[23] Morritt later sold the painting. But its place at Rokeby Park is not forgotten, as artist William Alan Menzies (1865–1929) made a copy of it; what is unique is that the copy was fitted into the original's frame (see Fig. 6.2). Menzies is known for the numerous copies he made, several of which are held in public collections.[24] He copied artists such as Reynolds, Emil Fuchs and John Singer Sargent. It would appear that Menzies' livelihood was made from copying the work of others. Menzies' copy continues to hang today at Rokeby Park. Many large houses whose owners cannot afford to keep their original artworks or who do not want to for fear of theft, have replaced them with copies. In a bid not to spoil the look of a room, copies are commissioned and, in all probability, the majority of visitors are none the wiser.

The National Gallery acquired Velázquez's painting in 1906, but it retains the title *The Rokeby Venus*. After Richardson's 1914 attack, the painting was restored so it was close to its former glory. At Rokeby Park the copy's role is integral to and in keeping with how the home looked in its heyday in the nineteenth century. By retaining the original frame, the copy is the exact size of the original, meaning it sits well with the other works in the room. Having a copy also allows for a larger audience to see this unique Velázquez work. In other words, the original and the copy fulfil different roles. At Rokeby Park, the copy is clearly labelled as a copy, and arguably the copy does not diminish the viewer's experience, especially since it is high up on the wall above a fireplace. Like the copy of Richmond's *Portrait of Charlotte Brontë*, having a copy provides substance to Rokeby Park, open to the public, that is a window into the past.

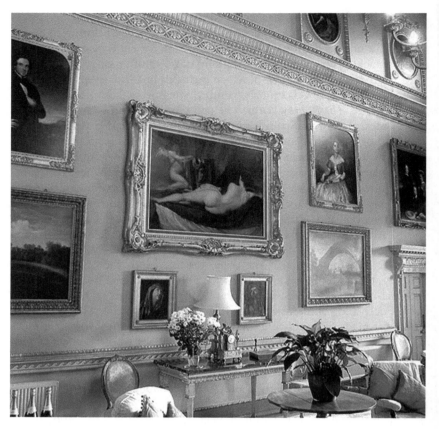

Fig. 6.2 Copy of Velázquez's *The Rokeby Venus* by William Alan Menzies (c.1905) with the painting's original frame in the Saloon, Rokeby Hall, Yorkshire. (Photo: Rokeby Park, Yorkshire)

GEORGE COATES AND THE *MARRIAGE OF ST CATHERINE*

Artworks are added to public collections in different ways fulfilling different objectives. Today, public collectors have a collections policy; historically, these have been looser and have changed over time to better reflect time, place, society and budget. In the next example, artist George James Coates' (1869–1930) works were added to Australia's National Gallery of Victoria's collection quite deliberately. When I say deliberately, I

mean they were added as known copies. Their addition to the collection was legitimate and actively sought. Coates studied fine arts in Melbourne. In 1896 he was awarded a National Gallery of Victoria Travelling Scholarship, which entitled him to a stipend of £150 per year for three years studying abroad. For emerging Australian artists who were students at the National Gallery of Victoria schools, such scholarships were highly prized. In January 1897, Coates set off for London and then to Paris. It was in Paris that he copied Antonio da Correggio's (1489–1534) painting, the *Mystic Marriage of St Catherine with St Sebastian* (mid-1520s).[25] Correggio, an Italian artist from Parma, painted the work in c.1527. Coates studied the painting in the Louvre, where he set about making his copy.[26]

Correggio's original painting is oil on poplar panel, whereas Coates' copy is oil on canvas. The most obvious reason for this – aside from the cost – is ease of handling in terms of transporting the canvas to the Louvre (though they were often left there overnight) to paint in situ and, upon completion, sending it back to Melbourne. Coates' work is only a couple of centimetres different in size from the original, indicating his desire to make an identical copy to fulfil the terms and conditions of his Travelling Scholarship.

The Travelling Scholarship was established to enable Australian artists to become better acquainted with the Old Masters found in European collections. Indeed, Sir George Verdon, the chair of the gallery trust at the time of Coates' award, believed that an artist was not educated until they had seen the Old Masters. By introducing an acquisitive condition to the scholarship, the next generation of emerging Victorian artists could view Old Master copies closer to home. The terms and conditions required recipients, over the three-year period, to paint two copies of Old Masters as well as to complete an original composition, with all three paintings to be presented to the National Gallery of Victoria. This scholarship stipulation is how in 1899 the *Marriage of St Catherine* came into the gallery's collection and joined other Old Master copies of works by Titian, Botticelli and Rembrandt.

Establishing the collection meant that if artists and the general public were unable travel to see Old Masters then they would come to them in the form of copies. And as seen in Chap. 2 there was no shortage of apprentice artists making copies in the most prized art museums in Western Europe. For Melbourne's National Gallery of Victoria, the scholarship was beneficial to all parties. For Coates, Europe would prove very enticing; he married Australian artist Dora Meeson (1869–1955) in 1903 and

they settled in Chelsea, London. Coates duly sent his three paintings back to Melbourne, fulfilling the requirements of his scholarship; the other two works were *Motherhood* (1903) and a copy of Anthony van Dyck's *Portrait of Jean Grusset Richardot and Son* (1899).[27]

Coates' *Marriage of St Catherine* is clearly labelled as a copy on both the verso of the work and in the gallery's catalogue. The work is catalogued as an Australian painting in line with Coates' nationality. Although works such as Coates' undoubtedly had a role to play in the early decades of the National Gallery of Victoria's history, one wonders how significant they are now. Yes, they are very much part of Australian's colonial art history, but are they considered second-rate today, given they are copies from a different time and culture. Perhaps the answer to this in part can be found in the painting's exhibition history. The *Marriage of St Catherine* has not been exhibited during the last four decades. Records prior to 1986 were not kept, so analysing the painting's entire exhibition record is impossible; in short, however, it can be assumed that over time it has been shown less and less. The Old Master copy collection at the National Gallery of Victoria is an interesting nuance, obviously initiated with good intention; however, in an era of such exciting developments in art it is now viewed as somewhat outdated and inhibiting. As art historian John Gregory suggests:

> In retrospect, the Travelling Scholarship probably played a contradictory role in the Australian art world of the late 19th and earlier 20th centuries. In a negative sense, its academic emphasis on copying of Old Master paintings moored it (and the NGV, given the stipulation that the copies should be added to its collection) to an increasingly outmoded notion of what constituted Great Art in the era of early Modernism.[28]

Gregory makes a valid point, but the course of art history cannot be changed. Arguably, the Old Master copies in the National Gallery of Victoria collection provide a window into the past. As an aside, the scholarship provided opportunities for Australian artists to experience old and new art alike. Established in 1861, the National Gallery of Victoria set out to build a collection – and a European one at that – from scratch. By adding Old Master copies to it, the collection had the European look so admired by colonial society.

Coates' *Marriage of St Catherine* has not aged well. In late 2019, I visited the painting at the National Gallery of Victoria's offsite storage

facility in Melbourne. The canvas has areas of bulging and is warped; covering much of the surface there is a light white cloudiness known as efflorescence. This is caused by certain paint components and additives migrating to the painting's surface. The varnish has also discoloured over time, causing dullness and making it close to impossible to distinguish the figures and objects.[29] When you see the enormity of the gallery's collection it is understandable that other works have taken priority in terms of being exhibited and conserved. Having said that, *Marriage of St Catherine* is on the gallery's conservation 'to-do' list.[30] Coates was praised at the time for the quality of his copy: in 1899 *The Age* reported Coates' copy to be the best at the Louvre for years.[31] As subjective as this is, it was high praise for Coates who went on to have a long career as an artist, including completing many portrait commissions for the Australian War Memorial in Canberra. The *Marriage of St Catherine's* relegation to storage is not so much about the image or artist, but rather that it is a copy and very much posited within a colonial context; in its time, Coates' painting had fulfilled an important role for both the artist and its Australian audience.

ARTEMISIA GENTILESCHI AND *SUSANNAH AND THE ELDERS*

The most celebrated female artist of the seventeenth century, Artemisia Gentileschi (1593–1653) is known for painting images of strong female figures. Tortured as a young woman, Gentileschi was highly successful at portraying this characteristic, and the vulnerability of her victims, in her work. In a major exhibition of her work at the National Gallery, London, in 2020, art commentator and reviewer Jonathan Jones likened the experience of seeing Gentileschi's powerful and traumatising works en masse to being hit by a train.[32] Her ability to convey horror, including sexual harassment, is exceptional. Gentileschi painted the subject of Susannah and the Elders, from the Old Testament's 'Apocryha' (Susannah: 15–24) three times over the course of her career (1610, 1622 and 1652). All three versions were included in the National Gallery's exhibition; only one belongs to a British collection. [33]

Over the last few decades, interest in Gentileschi has increased as her life story has emerged and been disseminated; at the age of 17, she was raped by her perspective tutor, Agostino Tassi (c.1580–1644). Gentileschi was tortured in an effort to confirm she was telling the truth at the court trial and Tassi was successfully convicted of her rape. Added to that horrific event is the strength of her oeuvre that makes her work compelling

viewing. Gentileschi's *Self-Portrait as Saint Catherine of Alexandria* (1615–17) was acquired by the National Gallery in 2018; it became the catalyst for a major retrospective exhibition.[34] Gentileschi had a London connection; during 1639–40 she was in London, possibly to help her sick father, Orazio Gentileschi (1563–1639) complete a ceiling painting at Queen's House, Greenwich, for the Court of Charles I (the Gentileschis' nine-panelled *Allegory of Peace and the Arts under the English Crown* was relocated to Marlborough House in 1711). Prior to the National Gallery's acquisition there were only two other works by Gentileschi in British collections, the Burghley House *Susannah and the Elders* (see Fig. 6.3) and her *Self-Portrait as an Allegory to Painting (La Pittura)* of 1639, in the Royal Collection.[35] This made the 2018 acquisition an even more wonderful addition to the nation's public art collection, and in a bid to show the painting to a far wider audience the gallery toured it to Sacred Heart Catholic High School in Newcastle upon Tyne and then to the Pocklington Group Practice doctor's office in Yorkshire. Valued at £3.6M, *Self-Portrait as Saint Catherine of Alexandria* had 24-hour security guards to protect it. Taking the painting to such venues was completely revolutionary, innovative, out of the ordinary and cutting edge in terms of visitor engagement.

The retrospective exhibition, made up of 29 works, included the second of the three versions of the Susannah and the Elders theme; painted in Rome during 1622, it was owned and possibly commissioned by the

Fig. 6.3 Artemisia Gentileschi *Susannah and the Elders* (1622). Collection of Burghley House, England. (Photo: Burghley House, England)

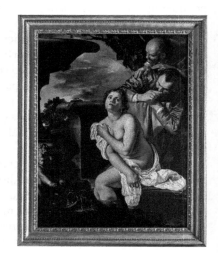

papal nephew Cardinal Ludovico Ludovisi, according to Gentileschi scholar and curator Letizia Treves.[36] The ninth Earl of Exeter later purchased the painting from the Barberini Palace and it was first listed on the Burghley House inventory in 1763.[37] Situated in Peterborough, England, Burghley House boasts one of the finest private collections of Italian seventeenth-century art. In 1993 the painting was cleaned, revealing Gentileschi's signature and date of production: Artemitia Gentileschi lomi faciebat A.D MDCXXII. Since that time the painting has travelled far and wide to be exhibited and viewed by many scholars, and all bar one concur that the painting is indeed by Gentileschi.[38] There is little doubt about the painting's authenticity now, but one cannot help wondering if the Earl of Exeter knew whose work he was acquiring at the time of his purchase sometime between 1768 and 1772 when he was visiting Italy! In fact the painting's authorship was doubted in the past for not only was the work stylistically different from her earlier work, especially the 1610 *Susannah and the Elders*, but it was more closely stylistically aligned with Caravaggio's work hence its earlier attribution to him.[39] Aside from who painted the work there is evidence to prove its originality by way of the under-drawing – *pentimenti* – and the changes Artemisia made to the composition along the way. You don't get this in copies per se.

Just 50 miles from Burghley House, at Nottingham Castle Museum, there is another *Susannah and the Elders* (see Fig. 6.4).[40] Generally

Fig. 6.4 Unknown copyist, *Susannah and the Elders* (undated). Collection of the Nottingham Castle Museum and Art Gallery. (Photo: Nottingham Castle Museum and Art Gallery)

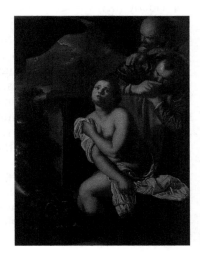

accepted now as a copy of the Burghley House work, Leon H. Willson gifted the painting in 1964; it is highly likely that Willson believed it was the real deal for the Nottingham Art Galleries and Museums Committee's Annual Report of 1963–4 notes that Willson's gift was attributed to Gentileschi. This in itself is both interesting and confusing given the Burghley House work was only authenticated some three decades later. So how did Willson know it was a Gentileschi image – whether authentic or not? Unfortunately, there are no archival records to support the Annual Report. Willson was still alive at this time so it must be assumed that he passed on this information to the committee. In the following decade, Christopher Wright in his *Old Master Paintings in Britain* (1975) catalogues Nottingham's *Susannah and the Elders* as a copy.[41]

For me, the copy should not be judged or dismissed on the grounds of it being a copy – and some say not a very good one at that – but rather it can be an invitation to ask questions such as: why was the copy made? Who made it? Did they think they were copying a Caravaggio (for the copy pre-dates Gentileschi's signature being revealed and it was thought to be by Caravaggio)? And was the copy actually painted at Burghley House or from a photograph? Trying to answer these questions can give greater insight into the motivation for copying. Firstly, in all likelihood, the copy was made because the original is a stunning work. It depicts a coy and nervous-looking Susannah covering her modesty from two leering male elders. As the story goes, wrongly accused of meeting a young man, the elderly men will drop the accusation if she obliges and has sex with them. Gentileschi nails her subject. It is a dramatic and compelling work. When compared with the same subject by others (men) there is something about Gentileschi's work that is unique. She grabs our empathy and attention for this beautiful and wrongly accused young woman; her imploring eyes talk to her viewers. Gentileschi had found herself in a similar situation and was therefore painting from personal experience. And like her other works, compositionally, the painting is superb. By all accounts, Gentileschi's 1622 *Susannah and the Elders* is an extraordinary painting as eloquently confirmed by Letizia Treves in the 2020 exhibition catalogue:

> From the silk effects of the foremost elder's plum-coloured jacket to Susannah's crisp white chemise, whose cuff trails delicately in the water, Artemisia shows herself adept at conveying the varied sentiments required by her subjects through a rich pictorial language.[42]

Clearly, it was worthy of copying.

There is no evidence of who the copyist of the Nottingham *Susannah and the Elders* was. Given the original has always been in a private collection, it is less likely to have been copied by a formal art student. In addition, Burghley House is some distance from any art schools. It is possible that the copyist – or the owner of it – did not know that a female artist painted the original work. Before confirmation that it was Gentileschi's work in 1995, it was believed to be by Caravaggio. Letizia Treves, also a Caravaggio scholar noted:

> ... by 1815, the Susannah was considered to be by Caravaggio. ... The attribution to Caravaggio persisted throughout the nineteenth and well into the twentieth centuries, the signature confirming Artemisia's authorship only becoming apparently after cleaning in 1995.[43]

Caravaggio was one of the most revered Italian artists of the seventeenth century, but I'd like to think that Gentileschi has posthumously joined him in that exclusive club.

Lastly, it is interesting to imagine where the copy was made. Depending on when it was made, the copy could have been painted off-site using a photograph. This could account for the slightly different palette of the copy and the overall quality of the work for which it has been criticised. Interestingly, both the original and copy are identical in size. This indicates a determined effort to make a true and identical copy. The life and times of the copy remain a mystery. Unfortunately, there is nothing on the verso of the painting or in the archives to help solve the puzzle. Only testing the paint could give an approximate idea of its date. At one stage it was thought that Gentileschi made a second version – the Nottingham copy – for her own collection. On viewing a photograph of the copy, art historian E. K. Waterhouse described it as 'a good early copy' and yet it is now accepted that the copy is a far lesser work. When the two works are compared, admittedly only a computer screen, the Burghley work is far brighter; the colours are intense and vibrant, as was the fashion during the Baroque period. The Nottingham painting is dull by comparison; earthy and dark, its top layer of varnish has discoloured over time. Like so many copies in public collections, they are a low priority for conservation. Their art historical value in the majority of instances is viewed as less than authenticated works.

What is known is that the donor gifted the copy in 1964. The donor, Leon H. Willson (1896–1975), was a master printer and lived his adult life in Nottingham. Perhaps the work had been in the family since it was made and he wanted it to stay in the area. Willson held two public offices: as Sheriff in 1949 and Lord Mayor in 1952. His gift to the city remains significant; Nottingham Castle Museum has exhibited their *Susannah and the Elders* regularly including in Yinka Shonibare's (b.1962) exhibition 'Diary of a Victorian Dandy Project'.[44] Shonibare selected works such as *Susannah and the Elders* and Charles Le Brun's (1619–1690) *Hercules Vanquishing Diomedes* (c.1640)[45] to sit alongside his own works in his touring exhibition made up of five photographs that depict a day in the life of a dandy, starring the artist as the dandy.

HANS HOLBEIN AND THE *PORTRAIT OF JANE SEYMOUR*

Sometimes a copy can literally fill a gap in a major institution's collection. A portrait of Jane Seymour, Henry VIII's third wife, is a case in point.[46] In 2016 the National Portrait Gallery, London, acquired an unfinished portrait of Seymour from the auctioneers, Cheffins of Cambridge.[47] By all accounts, it was a lucky find; as curator Charlotte Bolland noted at the time of its acquisition:

> ... previously, the only portrait we had of Jane Seymour was a mid-seventeenth century engraving. We had no painted representations of her.[48]

Although the portrait is unfinished (and 'after' Hans Holbein (1497–1543)) this should not detract from its value as an image. The painting is significant for its subject matter, its sitter, and its age. The original portrait is in the collection of the Kunsthistorisches in Vienna. Dendrochronology puts the National Portrait Gallery's copy as having been completed in the sixteenth century, specifically around 1537, and it has been suggested that the reason for its incomplete state is that the artist ceased work upon the death of Jane Seymour in 1537 (demand for a sovereign's portrait declines after their death). The original in Vienna is dated 1536 and is of a similar size. Another theory for the work's incomplete state is Holbein's own death in 1543. Whatever the reason, there is enough of the copy (an estimated 90 per cent) to show a good likeness to the original. All these unanswered questions give the copy a level of intrigue and provides interesting lines for future engagement and enquiry.

When the portrait was initially offered at auction it was believed to be a nineteenth-century copy. Its provenance only went back that far, which is not at all unusual. After the National Portrait Gallery purchased it for £34,000 the painting underwent technical analysis and conservation, indicating that ' ... the work is not simply a copy but did most likely come from Holbein's studio'.[49] In other words, Holbein knew of its execution and more than likely oversaw the painting of it. This is an excellent example of a legitimate copy and a real coup for the National Portrait Gallery. The portrait now has a new frame; when acquired, it was in an unsuitable frame for its art historical period, made of a very ornate gold, complete with crown centre top, drapery and wings. The gallery had a new frame fashioned more in keeping with how it would have originally been framed. A very similar portrait, a copy after Holbein dated 1536–1599, of Jane Seymour in the Knole Collection, Kent, was used as a model for the new frame.[50]

Portraits of monarchs and prominent courtiers were in high demand during the Tudor era; copies supplied the demand and today they make for interesting comparisons as well as providing context and information about artists and their studio practices. Works such as the *Portrait of Jane Seymour* are not relegated or undervalued but rather celebrated for what they are and how they can teach us more about this period, both historically and art historically. The National Portrait Gallery's 2012 exhibition, 'Double Take: Versions and Copies of Tudor Portraits', was exceptional in showcasing originals with their copies. Being transparent about copies and exhibiting them in this manner adds to the discourse around copying as well as acknowledging and legitimising them.

* * *

The above examples have made their way into public collections legitimately but this is not always the case. In some instances, artworks are acquired and only found later to be copies. A good example of this is Gottfried Lindauer's (1839–1926) *Portrait of Kewene Te Haho* (undated).[51] Lindauer was a Bohemian artist who settled in New Zealand in 1873. He painted formal representational portraits of Māori, including this 90-year-old chief. A very similar *Portrait of Kewene Te Haho* by Lindauer is in the collection of Auckland Art Gallery Toi o Tāmaki.[52] Artists such as Lindauer made copies of their own works, as there was a good market for them. *Portrait of Kewene Te Haho* was purchased in 2001 by the philanthropic

Trust Waikato. In 2012 it was discovered not to be by Lindauer, as first thought, but rather the work of an unknown artist. Not only were there several visual aspects wrong with it, such as the crude painting of the area around his ear, but scientific testing also revealed that the paint used was not in production during the artist's lifetime. The copyist had also added a kind of gritty sand to the surface to try and make it look older than it was. It was proven conclusively that there was no way that Lindauer could have painted the work. When the Auckland and Waikato versions are placed side by side, it is obvious which one is authentic and which one is a later copy, for the former is simply of a better quality in terms of paint finish and over-all technique. The controversy about its provenance played out in the media and though its monetary value plummeted with the discovery, its real value lies in the image of the sitter. Kewene Te Haho died in 1902 and this portrait is one of the few images in existence of this Māori chief.

There is another positive aspect to having copies – or other versions – in collections. For instance, the National Gallery, London, owns a much smaller version of Rembrandt's *The Night Watch*.[53] It contains crucial information about the larger original version, as Rembrandt's original was cut down in size, whereas the London one is the complete picture (see Chap. 7 for more about this). And *The Night Watch* copy is not alone; when searching the National Gallery's online catalogue, 188 works appear when you enter the word 'copy' in their search engine. The huge majority of these works are not on display. Read what you want into this, but essen-tially it reflects a time when collecting copies was more acceptable; it is also a case of having more works than walls to hang them on, as well as original authentic works taking priority over copies.

Sometimes there is a happy ending when copies are discovered to be originals. It does not happen often but when it does it is a huge windfall for a public collection. Re-attributing works is a costly and time-consuming exercise, but sometimes someone has a hunch to put a work through the process in a bid to have a work, that has been relegated to being a mere copy, to being by the hand of an Old Master. In 2014 at Sir Francis Drake's former home, Buckland Abbey in Devon, England, a Rembrandt was given the newfound status of being authentic. Not only is the painting by Rembrandt but it is also a *Self-Portrait*.[54] Signed and dated 1635, Rembrandt painted himself clad in a richly embroidered velvet cloak wear-ing a jewelled beret with plumage referencing his profession as an artist. He looks very much the dashing gentleman artist in his late twenties. The findings included that the poplar/willow wood panel, the pigments

(azurite, smalt and bone black), and the quality of the brushwork helped
to conclusively decide whose hand painted it. In addition, the infrared and
x-ray images showed that while Rembrandt was painting his own image he
changed the composition. A copyist would not do this. Previously, the
Self-Portrait was considered to be a later copy of this image that sold at
auction in 2017 for SEK2.800.000 and was clearly labelled as from the
'Studio of Rembrandt'.[55] In 1968 German-Dutch art historian Horst
Gerson had excluded the work as being original.

After eight months and a myriad of tests, the Rembrandt was re-instated
as being authentic. Though putting a value on the work is academic (apart
from for the purposes of insurance), as the work will supposedly never be
sold, the media reported its newly acquired status gave it a value of
£30 million.

The following year, the Mauritshuis Museum in The Hague had the
fortune of also re-attributing a Rembrandt painting. The status of *Saul
and David* spent eight years in limbo; a popular work, this painting of a
biblical scene was purchased in 1898 by the then director of the Mauritshuis
for his own personal collection.[56] When he died in 1946, he bequeathed it
to the museum. In 1969, Gerson questioned *Saul and David's* authentic-
ity. Unfortunately, the painting's history also includes being cut up with
the pieces sold off separately. The painting also has a complex date too –
c.1651–4 and c.1655–8. The pieces of the oil on canvas were later re-
attached. As such, it was thought to be a studio copy until recently. In
2015, *Saul and David* was proved to be an authentic Rembrandt painting.

2019 can be remembered for being the year of authenticating two
Botticelli paintings in British collections that were previously thought to
be copies. Both works depict the Madonna and child with a pomegranate
(symbolising the Resurrection) and can now claim a new status. Found to
be from the master's workshop, they now have a far higher monetary value
and more significant art historical value. In March 2019 *Madonna of the
Pomegranate* in the collection of English Heritage was confirmed to be
from Botticelli's workshop. Now this is better than it sounds. When a col-
lector purchased a work in the fifteenth century, they knew and expected
that the artist had assistants to help make works whether it was preparing
pigments or actually painting. This was accepted practice. The paintings
were not considered copies, but rather authentic works from the master's
studio. The English Heritage's *Madonna of the Pomegranate* (dated
c.1487) came into their collection from the diamond magnate Julius
Wernher. He purchased the work in 1897 when it joined his vast art

collection at his Georgian villa in Greenwich, London. The painting is a *tondo* measuring 97 cm in diameter, coming in substantially smaller than Botticelli's original work at the Uffizi, which measures 143.5 cm in diameter.[57] The removal of yellow varnish from the oil on panel painting, plus the examination of the painting with both infrared and x-rays and pigment analysis, revealed under-drawing and even a doodle by Botticelli. Cleaning highlighted a much brighter and truer palette. It is now believed that this version is the closest to the Uffizi one. However, as the conservator Rachel Turnbull told me:

> ... its composition is simpler and materials are less expensive – for example the blue drapery is painted in azurite rather than ultramarine.[58]

Ultramarine (lapis lazuli) was more costly and exotic compared with the carbonate of copper (azurite). After much research, this version is believed to be a smaller version of the Uffizi painting and made in Botticelli's workshop, perhaps for speculative sale or a lesser commission.[59]

In November 2019 the National Museum Cardiff in Wales announced that their *Virgin and Child with Pomegranate* had the newly acquired status of being an authentic Botticelli.[60] The philanthropic sisters Gwendoline and Margaret Davies gave the painting to the museum in 1952. At some stage the oil on board painting had been cut down and an archway painted into the background. It is suspected that a dealer or restorer made this change in the early twentieth century. In the 1940s it had been repainted to make it appear in good condition. *Virgin and Child with Pomegranate* was not taken seriously for a couple of reasons; art historian Bendor Grosvenor suggested that because it was in a Welsh museum it was not considered to be a Botticelli.[61] Furthermore, art commentator Javier Pes said that basically the painting had the status of a copy because experts had not seen it.[62] The painting, which was the subject of an episode on the BBC's *Lost Masterpieces*, is now believed by experts to be a genuine Botticelli.[63] Interestingly, both Botticelli paintings went on exhibition soon after their new claims to fame were made public.

Having the resources to research the authorship (and provenance) of an artwork is often a stumbling block for those working with collections, especially those belonging to churches. Technology plays a huge role in research today and even more so when you live a great distance (and during a global pandemic) from where you suspect the work originated. In

2020 I contacted an Auckland church, St Michael's of Remuera, about two copies they have hanging either side of the nave. The church was consecrated in 1933 and since that time two paintings – copies by Joshua Horner (1811–1881), an artist from Halifax, England, who travelled to the Continent on a few occasions – have graced the walls of the brick church. One painting, *The Holy Family*, is very clearly a copy of *The Virgin of Seville* by Spanish artist Bartolomé Esteban Murillo (1618–1682), minus God the Father. But the other one, titled *Mendicants Asking for Alms*, was more problematic in identifying. It depicts two men, carrying the distinctive blue and red cross of Trinitarian Order, giving money to a family. Given the other was a Murillo and they came from the same source, one assumption was that it too was a copy of a Murillo. But Murillo never painted this subject. However, there were some elements, such as the beggar boy, that can be seen as influences from Murillo. The work is dated 1842 and was made in Rome. Eventually, having had an email conversation with Murillo expert Isabelle Kent, I decided to think of the work not as a copy but as a Horner.[64] It didn't take long to discover that in May 1840 Horner exhibited two works at an exhibition in his hometown of Halifax. One was the Murillo *Holy Family* and a second work as described in the *Halifax Express* was:

... a sketch of Charity, or Almsgiving, by Mr. Joshua Horner, who intends, we understand, to make it the subject of a large picture.[65]

Later that year Horner headed to Europe, including Rome, where it is highly likely he painted the work now hanging in St Michael's. For many decades, it was believed that both paintings were copies, but clearly one is an original. Without technology, this puzzle would have been beyond our means to work out.[66]

The above case studies are certainly of the warm fuzzy variety; they make for great and positive publicity for collecting institutions. The exercise to prove a painting is authentic is expensive and so when there is a happy find they more often than not become centre stage of an exhibition. Audiences are always curious about such findings. All four works discussed above went on show almost immediately, a kind of re-launch back into art society. When the cost of maintaining collections is increasingly high, such exhibitions endorse their significance and associated research.

NOTES

1. Collection of the National Portrait Gallery, London [NPG1452], chalk, 60 × 47.6 cm.
2. Collection of the National Portrait Gallery, London [NPG1725], oil on canvas, 90.2 × 74.6 cm.
3. William Makepeace Thackeray by Samuel Lawrence and Francis Holl, 1853, antique steel engraving, published by Smith, Elder, & Co.
4. Smith, Margaret (ed). *The Letters of Charlotte Brontë: With a selection of letters by family and friends, Vol III: 1852–1855*, Oxford: Clarendon, 2004, p. 128.
5. Harris, Ann Sutherland and Linda Nochlin. *Women Artists 1550–1950.* New York: Alfred A. Knopf and Los Angeles County Museum of Art, 1977, p. 223.
6. Collection of The Ringling Museum, Florida [SN433], oil on canvas, 182.2 × 311.8 × 20.3 cm.
7. 'Ploughing in Nivernais, 1850', The Ringling Museum Docents notes: [http://ringlingdocents.org/pages/bonheur.htm].
8. Klumpke, Anna Elizabeth, *Memoirs of an Artist.* Boston: Wright & Potter Printing Company, 1940, p. 28.
9. In 1896 Elizabeth Gardner married fellow artist Adolphe-William Bougereau (1825–1905) after a 17-year engagement becoming Elizabeth Gardner Bouguereau.
10. Elizabeth Gardner to Maria Gardner, 14 April 1866.
11. Elizabeth Gardner to John Gardner, 28 January 1867.
12. http://www.daheshmuseum.org/portfolio/elizabeth-jane-gardner-bouguereau-ploughing-in-the-nivernais/#.YM_RpiGxXx4
13. https://research.frick.org/directory/detail/1567
14. Collection of Dahesh Museum of Art, New York [2014.1-1-1], oil on canvas, 65.4 × 129.5 cm.
15. Reed, Tiffany M. 'Elizabeth Gardner: Passion, Pragmatism, and the Parisian Art Market', *Woman's Art Journal*, Vol. 20, No. 2, Fall 1999/ Winter 2000, p. 8.
16. Pearo, Charles. *Elizabeth Jane Gardner: Her Life, Her Work, Her Letters*, unpublished Master of Arts thesis, Montreal: McGill University, 1997, p. 56.
17. Reed, Tiffany M. 'Elizabeth Gardner: Passion, Pragmatism, and the Parisian Art Market', *Woman's Art Journal*, Vol. 20, No. 2, Fall 1999/ Winter 2000, p. 7.
18. Collection of the Metropolitan Museum of Art, New York [87.25], oil on canvas, 244.5 × 506.cm.
19. Collection of the National Gallery, London [NG621], oil on canvas, 120 × 254.6 cm.

20. Hunnisett, Basil. *Engraved on Steel: History of Picture Production Using Steel Plates.* Oxford: Ashgate, 1998, p. 1846.

21. Collection of the British Museum [1886, 1206.68], etching/engraving, 52.5 × 93.9 cm.

22. Quinn, Bridget. *Broad Strokes: 15 Women Who Made Art and Made History (in that order).* San Francisco: Chronicle Books, 2017, p. 66.

23. Exhibition dates: 5 May to 17 October 1857.

24. See https://artuk.org/discover/artists/menzies-william-alan-18651929 for examples of Menzie's copy in public collections.

25. Collection of the Louvre, Paris [INV41], oil on panel, 105 × 102 cm.

26. Collection of the National Gallery of Victoria, Melbourne [50-2] oil on canvas, 107 × 104 cm.

27. Collection of the National Gallery of Victoria, Melbourne [134-2] oil on canvas, 283.4 × 140 cm and [67-2] oil on canvas, 109.7 × 75.8 cm.

28. https://www.beforefelton.com/ngv-travelling-scholarship/

29. Email correspondence with Beckett Rozentals, National Gallery of Victoria, 24 March 2021.

30. Ibid.

31. 'Australian artists in Paris', *The Age* (Melbourne), 1 July 1899, p. 4.

32. Jones, Jonathan. 'A blood-spattered thrill ride into vengeance', *The Guardian*, 29 September 2020.

33. Exhibition dates: 2 December–24 January 2021.

34. Collection of The National Gallery, London, [NG6671], oil on canvas, 71.4 × 69 cm.

35. Collection of the Royal Collection, Britain [RCIN 405551], oil on canvas, 96.5 × 73.7 cm.

36. Treves, Letizia et al. *Artemisia.* London: The National Gallery, 2020, p. 177.

37. Collection of Burghley House, England, [BH No. 218], oil on canvas, 161.5 × 123 cm.

38. Email correspondence with John Culverhouse, Burghley House, 28 February 2020.

39. Treves, Letizia et al. *Artemisia.* London: The National Gallery, 2020, p. 176.

40. Collection of Nottingham Castle Museum and Art Gallery, England, [64.72], oil on canvas, 161.5 × 123 cm.

41. Wright, Christopher. *Old Master Paintings in Britain.* London: Sotheby Parke Bernet, 1976, p. 73.

42. Treves, Letizia et al. *Artemisia.* London: The National Gallery, 2020, p. 177.

43. Treves, Letizia. *Beyond Caravaggio*, London and New Haven: Yale University Press, 2016 unpaginated.

44. Exhibition dates: 23 December 1999 to 2 April 2000.
45. Collection of Nottingham Castle Museum and Art Gallery, England [NCM 1893-52], oil on canvas, 276.9 × 179 cm.
46. Collection of National Portrait Gallery, London [7025], oil on panel, 64 × 48 cm.
47. Lot 806, 16 June 2016, estimate £20–30 K GBP. Sold for £34 K GBP.
48. Brown, Mark. 'Henry VIII wife Jane Seymour – new acquisition for National Portrait Gallery, *The Guardian*, 23 August 2019.
49. Ibid.
50. Collection of the National Trust, Knole, Kent [129744], oil on panel, 61 × 48 cm.
51. Collection of Trust Waikato Art and Taonga Collection, New Zealand [2001/2/3], oil on canvas, 106.5 × 91.6 × 5.5 cm.
52. Collection of Auckland Art Gallery Toi o Tāmaki [1915/2/17], oil on canvas 98.7 × 84.2 × 5 cm.
53. The full title of *The Nightwatch* is: *The Company of Captain Banning Cocq and Lieutenant Willem van Ruytenburch*.
54. Collection of the National Trust, Buckland Abbey, Devon [NT 810136], oil on poplar panel, 91.2 × 71.9 cm.
55. Lot 1105, Studio of Rembrandt, oil on panel, 77 × 63 cm, sale 7–10 June 2017, Uppsala Auktionskammare, Sweden. Sold for 2.300.000 SEK.
56. Collection of Mauritshuis, The Hague [No. 621], oil on canvas, 130 × 164.5 cm.
57. Collection of the Uffizi Collection, Florence [No. 1607], tempera on wood, 143.5 cm in diameter.
58. Email correspondence with Rachel Turnbull, English Heritage, 21 January 2021.
59. Ibid.
60. Collection of Amgueddfa Cymru Northern Wales Museum [NMW A 242], oil on board, 64.8 × 41.9 cm.
61. John Daley, 'An Unidentified Botticelli Painting Spent Decades Hidden in Welsh Museum's Storeroom', *Smithsonian Magazine*, 18 November 2019.
62. Ibid.
63. BBC, *Lost Masterpieces*, 13 November 2019.
64. Email conversation with Isabelle Kent, University of Cambridge, England, 18 August 2021.
65. 'From the Halifax Express', 16 May 1840, p. 11.
66. With special thanks to John Shaw of St Michael's Church, Remuera, Auckland for being so engaging and sharing his information about the *Mendicants Seeking Alms*.

Protecting the Past

Increasingly, over the last half-century or so there has been greater attention given to caring for heritage and cultural objects, in an effort to protect them for future generations. Technology has played a major role in identifying and measuring damage to cultural objects of significance. Advances in technology have also meant objects can be 'saved' from further deterioration, or at least the process slowed down. It's important to acknowledge too the paradigm shift towards conservation rather than restoration. The former is about preserving as much of the original object as possible and slowing up further deterioration. Restoration, on the other hand, is more about restoring a work to its 'original' condition, whether the restorer has evidence of the artist's intent and original look of the item or not. In some cases changes in taste have also meant restorations have altered the original appearance of an object. History provides plenty of examples of works that have been restored – or over-restored – and contain very little of the original object. This is particularly true in the case of paintings. In some cases, routine conservation has revealed new information about a work; for example, in 2018 a portrait at the Allentown Art Museum in Pennsylvania, was discovered to be an authentic Rembrandt. *Portrait of a Young Woman* (1632) had been labelled as by 'someone from his studio' for decades.[1] Cleaning removed several layers of varnish that were possibly added in the 1930s (when the sitter was also possibly repainted) when it was the fashion for paintings to have very smooth surfaces. Professional conservators nowadays would never contemplate such

P. Jackson, *The Art of Copying Art*, https://doi.org/10.1007/978-3-030-88915-9_7

interventions. *Portrait of a Young Woman* was in New York for conservation when it was reattributed, some 60 years after it was gifted to the museum, as being painted by Rembrandt. At the time, it was suggested that Allentown was too small a place for experts to visit so it was fortuitous that its trip to New York led to this re-discovery.[2] Its authenticity is now well documented and it will be cared for accordingly.

In some instances, an object is so vulnerable and fragile that it cannot be exhibited – or it can only be exhibited for short periods of time before it needs to rest. This is often the case with works on paper where an over-exposure of light and unfavourable atmospheric conditions can speed up the process of deterioration. In this situation, museums and historic buildings have two choices. Firstly, not to display the original work and only show it in digital form. Secondly, a copy/replica can replace the original object on display. This option poses several issues for museums and audiences alike; what is often termed the 'aura of authenticity' is lost when a copy is used. Audiences can feel cheated and short-changed when faced with a copy, especially if their expectation has been for viewing the original, which perhaps goes without saying. Unfortunately, in some instances this information is not shared with visitors who run the gamut of being either nonplussed when they do find out the truth or extremely disappointed and annoyed.

Transparency around a copy as a replacement being exhibited is fundamental, but clearly not mandatory; visitors need and expect to be provided with this information and preferably ahead of their visit if possible. Museums need to use this opportunity to educate visitors about why a copy is replacing the original object. This can be, and should be, a positive educative experience. For museum professionals and visitors it comes down to the quality of experience – in other words, will a viewer's experience be different and/or compromised if they are faced with a copy? Purists might argue that a copy is no replacement for the authentic object and that there is little or no difference between looking at a copy and viewing the merchandise in the museum's shop.

It is important not to lose sight of the original objective of the museum concept; a place to store, collect, care and exhibit original and valuable objects. Replacing items with copies goes against this mandate, and as art historian Noah Charney so succinctly surmises:

> Fakes, forgeries or copies have no place in museums – at least, not knowingly, or without identifying them as such.[3]

And therein lies the essence of this conundrum about original versus copy. 'Knowingly' and 'identifying' are at the very crux here. In recent times, fakes and forgeries have come into their own being the centre of attention for exhibitions, but these are clearly acknowledged as not being the real deal. It is when this information is not shared that we can feel cheated. On the other hand, if we do not protect our cultural and visual heritage we are seen to be selfish and not considerate of looking out for future generations of audiences.

THE LASCAUX CAVES, FRANCE

Art historian E. H. Gombrich wrote an art book that, especially for students, became a core text in the second half of the twentieth century. *The Story of Art* was first published in 1951 and to date has sold in excess of six million copies. His narrative begins 20,000 years ago at the Lascaux Caves in France. It is a good beginning place to revisit in terms of the topic under discussion here.

At the time of writing, Gombrich and his readers could visit the caves. They had been discovered in 1940 by four teenage boys whose dog, Robot, had wandered off from the group. During the dog's rescue, they stumbled across the caves containing paintings of animals. It was believed these were used for ritualistic and spiritual activities. The discovery was mind-blowing and in 1948 the caves opened to the public to view the marvels of art from the Palaeolithic age. The artworks became the starting point for many narratives about the history of Western art. Gombrich noted about the art of this era that it was not about looking good; rather, it was 'something powerful to use'.[4] The enormity and complex labyrinth of caves and their decorations indicated Gombrich's reading of them is entirely justified. Just as centuries later cathedrals – also places for spiritual and ritualistic activities – were decorated, so too were the caves of the Dordogne region.

On most days the caves attracted 1200 visitors; by the early 1960s, however, it was recognised that they were deteriorating. The combination of visitor breath and sweat, which formed carbon dioxide, and increased humidity from body heat, meant the paintings were deteriorating quickly. They were also losing their vibrancy of colour as a consequence of the use of artificial light. The changed environment within the caves also caused the development of microbial and fungal growth. In 1963, the decision

was made to close the caves to the public. The significance of the caves and their artworks was recognised and acknowledged in 1979 by UNESCO, when it was declared a World Heritage Site. When Gombrich wrote his book, the caves could be visited and experienced, as they were thousands of years ago, with a few exceptions, including a ceiling fan for ventilation. For decades, they remained closed until 2016 when the International Centre of Parietal Art (CIAP) opened.

The caves you can visit today are replicas, copies of the original caves, set within a contemporary architectural setting adjacent to the original cave site. Each of the paintings is copied to within 3 mm of their original size. The money and technology invested in this new centre provides visitors with a remarkable experience, albeit not an authentic one. By all accounts, the new 'whiz bang' centre is remarkable; it is cold and dry, the colour pigments are true (or as true as they were when they were re-discovered), the supplementary information superb, and so on. But the caves are fake, and high-quality fake at that. Like other experience-type venues, technology is at the forefront, even before you get there. The website extols the virtues of the new visitor attraction and to their credit they are transparent about the caves being replica copies. However, their terminology tries to invoke a sense of the real. They suggest that visitors will experience the 'authentic atmosphere'. Perhaps they will. But it is not authentic; it is copied, albeit with very good intent.

The question remains: can the replica experience replace an original one? Given we cannot visit the original, do we accept defeat and go with what the harsh critics call a Las Vegas-style theme park? We must not lose sight of why the original caves were closed. They are being preserved by not being visited now with the exception of the occasional scientist to measure their environmental conditions. The attraction offers more than just the caves – technology abounds – and perhaps in this day and age there is an expectation for this. And if you did not know the caves were copies and you visited, would you be disappointed? It is hard to know, but for many the caves have perhaps shifted from an authentic museum-type experience to a visitor attraction of the modern age. In her 2019 book *Genuine Fakes*, Lydia Pyne devotes an entire chapter to the caves. Her analysis in addressing the advantages and disadvantages of the real and the fake caves is superb. For me, it's the subtitle of her book that is fundamental to this conundrum, *How Phony*

Things Teach Us About Real Stuff. This is true and cannot be underval-ued. Both the real and copies have merit. The sceptic might ask: for what are the caves being saved for if no one will ever visit them? Gombrich described the paintings as 'astonishingly vivid and lifelike'.[5] And they are, both then and now.

THE CRUCIFIXION BY PIETER BRUEGHEL THE YOUNGER

In a bid to save a painting for present and future parishioners of a small Italian church, a copy was substituted for the original. Behind a glass case in a side chapel of Santa Maria Maddalena, the Baroque church of the hilltop town Castelnuovo Magra, *The Crucifixion* (c.1617) is displayed. The seventeenth-century painting was gifted to the church in the nine-teenth century, having previously belonged to Italian nobility. But at lunchtime on 13 March 2019 thieves used a hammer to break the glass casing and quickly absconded with the painting in their white Peugeot getaway car. Unbeknownst to the thieves, they had gone to a huge effort to plan and steal a contemporary copy of *The Crucifixion*.

Having got wind of a possible art heist, Italy's national military police, the Carabinieri, cunningly swapped the original painting out with a copy. And then they waited. The heist went like clockwork, partially because only a cluster of people knew about it, with the town's mayor and the church's priest being the only others in on the subterfuge. The heist was timed to co-ordinate with Father Alessandro Chiantaretto's daily visit to his parishioners to offer Communion. Cameras were installed to capture the thieves. Mayor Daniele Montebello kept up the pretence after the theft, which, he subsequently admitted to media, was difficult. Prior to the theft, a few observant parishioners thought some-thing was not quite right about the painting but fortunately they man-aged to keep schtum about it. In the meantime, the original painting was safely stored off-site.

Churches, with their wonderful collections of art and objects, are easy targets for thieves as many lack adequate security. Their dark interiors make it easier for thieves to go about their business, including scoping the place prior to a heist. Furthermore, churches are often open all hours. Brueghel's *Crucifixion* was previously hidden during World War II in order to avoid being looted; it was also stolen in 1981, and later recov-ered. Santa Maria Maddalena has another painting of the Crucifixion by a

follower of Anthony van Dyck (which was stolen in 1979 and recovered). Both thefts illustrate the vulnerability of this small church's art collection. The use of a copy in this case was cunning as it saved a painting, with an estimated value of €3 million from disappearing permanently.

The irony is that the copy was a copy of a copy. Pieter Brueghel the Elder (1525/30–1569) had painted the original *Crucifixion*. His son, the Younger (1564–1637/38), had a large studio in Antwerp and ran a lucrative trade in copies of his father's work (he also painted original pieces). A heavy drinker, the Younger often found himself in financial strife and the copies assisted him to ward off debt. The upshot of all the copies he made meant his father's reputation spread far and wide. Much of what we know about the Elder today is through his son's copies. Not all the copies were exact however, and subtle differences can be found, indicating that the Younger often relied on the etchings of his father's paintings to use as the basis for his own copies. It is thought that the Younger used the copying process called 'pouncing'. A three-stage technique, pouncing was commonly used to transfer and render an image: 1. An original drawing is made; 2. Pinholes are pricked around the's drawing's outline; 3. The drawing is laid onto the panel and charcoal dust is pushed through the holes to provide the outline ready for painting.

Brueghel the Younger also regularly made more than one copy of a work. For instance, *Winter Landscape with Skaters and a Bird-trap* (1565) was copied by the Younger and his workshop staff at least 60 times. This gives a good idea of the scale of his business and the popularity of his father's scenes. What makes *The Crucifixion* even more valuable – both culturally and monetarily – is that the Elder's original work no longer exists. Perhaps the thieves knew this. But what they did not bargain for was being out-smarted. The substitution of the copy for the purposes of the art heist was the best possible scenario to protect the seventeenth-century painting from disappearing permanently or being damaged. The story of the Brueghel substitution copy went viral putting the town, with a population of approximately 8,500 inhabitants, into the spotlight. At the time of writing, the theft was still under investigation so details were scant about the actual type of copy and where it was made. Sadly, what it also highlighted was the enormity of Italy's situation, where it is estimated about half of all art thefts are from churches.[6]

THE HORSES OF ST MARK'S (TRIUMPHAL QUADRIGA)

Artworks are susceptible to damage, depending on the material from which they are made, their location and environmental factors, or age. When the work is of huge and significant cultural value and a public landmark it can, in some cases, be replaced with a copy. *The Horses of St Mark's* commands a prime position atop the Basilica's façade in St Mark's Square, Venice. Venice's ecology ensured that, over time, the sculptural installation deteriorated and, in 1981, a decision was made for the good of the sculptures to replace them with copies.

The history of the *Horses* is complex and well documented. Serving as war booty on at least two occasions, these sculptures date from somewhere between 400 BCE and 400 CE. Unfortunately, an autopsy during the last restoration revealed no elements that might lead to absolute dating. Various theories purport to why the *Horses* were made, for whom and when. What is known is that they are life-sized, weighing in at about 900 kg per horse, and that they were made of copper, lead and tin. The materials used were rare, if not actually unique for statuary of this size.[7] Originally, they were gilded, possibly with a combination of leaf and mercury, making them monumentally a visual feast.

When Constantinople fell in 1204 the *Horses* were taken by ship to Venice. Installed above the main doors of the Basilica of St Mark's, they remained in place until Napoleon helped himself to them in 1797. Back in Paris, they eventually ended up gracing the top of the Arc de Triomphe du Carroussel.[8] Following the Battle of Waterloo, the *Horses* were returned to Venice. During World War I they were safely stored at Rime's Palazzo Venezia and during World War II they were stored not too far from Padua. The catalogue of locations demonstrates not only how political the works have been, but also that all that moving about is not ideal for any artwork, no matter what it is made of. In at least one instance they were not crated up for transportation but paraded in a procession, just like real horses.

Back at the Basilica, the *Horses* wooed crowds up to the early 1970s, when it was acknowledged that the air pollution of Venice was doing them irrevocable damage. In 1974 they were removed for conservation. Though Venice has the luxury of not suffering the effects of pollution from motor vehicles it has other pollutants at play. Built on the sea, Venice's environment makes artworks very volatile to long-term damage. Conclusively, the air is not conducive to a stable clean environment for sculptures of the *Horses'* age and materials.

Once restored, it was decided not to return the *Horses* to their pediment. A new home for the *Horses* was found indoors at the Museo Merciano. For the last three decades, a conservator, Corinna Mattiello, has cared them for. However, not everyone agrees that they are better off indoors. In 2004 Charles Freeman, a biographer of the *Horses*, wrote that the sculptures are exhibited in confined quarters, lit by sharp artificial light, and that the angles they are viewed from are limited.[9] He makes some valid points, but arguably the originals are better off indoors, where they are monitored regularly and far less vulnerable to decay. They are spiritually close to their former resting place and, as Freeman goes on to note, ' ... they are the only team of four horses surviving antiquity'.[10] Surely that is enough reason alone to house them indoors. The advantage of them being in a museum setting is that you can get up close to them; you can see their musculature, pulsating veins and how they 'talk' to one another as they move. This has to be an extraordinary bonus. Art crime writer Arthur Tompkins described the *Horses'* home above the doors as both 'lofty and commanding'.[11] Their new home cannot compete with the pediment, however another set of *Horses* has been tethered to the pediment.

The copies are dated 1978 (on one of the horse's hooves) and were made by the Battaglia Fine Art Foundry in Milan (see Fig. 7.1). Using the traditional lost-wax technique, the process was time-consuming and complex. As described by Venetian guide Luisella Romeo:

> Foundry workers at Battaglia started [by] making a plaster cast. But as they could not start from a mould, they had to pin down fixed points from the ancient work to create the plaster copy. A cage in iron threads and bars was first built and then layers of straw and plaster were applied. With the help of a pantograph, the fixed points were repositioned on the model so to create a geometrically faithful reproduction. Using special liquid gelatine to create a hollow model, wax was then cast making sure the thickness would be the same of the final bronze statue.[12]

Since the copies' installation, many visitors to St Mark's Square would be none the wiser to the *Horses'* lack of authenticity. Freeman describes them as 'uninspiring'.[13] Perhaps a little harsh, when one considers the alternatives. Having the originals indoors makes for closer observation that is advantageous and is protecting them long-term. The façade of the Basilica still looks the same whether or not the *Horses* are genuine. Unfortunately, the moulds no longer exist so if and when another set is required they will be copies of copies.

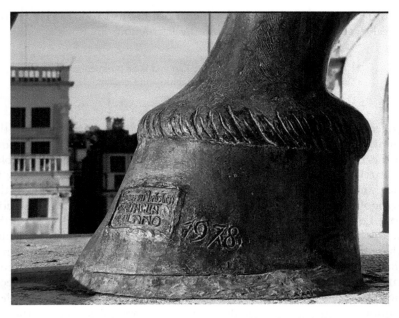

Fig. 7.1 *The Horses of St Marks*, Venice, (detail of hoof with date), copy made in 1978 by Battaglia Fine Art Foundry in Milan. (Photo: Luisella Romeo)

THE PARTHENON MARBLES

On Friday 16 December 1988 I visited the Acropolis of Athens. It was my first time in Europe and the first port of call was Greece. Recording each day's activities, I noted two things that struck me on that particularly cold and wet Friday. One was how polluted Athens was. Coming from a cleaner and greener country, this observation was not at all surprising. The second note in my travel diary was seeing the *original Caryatids* in the Acropolis Museum for they were replaced, in 1979, with *replicas* on the Erechtheion. Now three decades later I am revisiting these two facts in a chapter about preserving the past for the future. Much has happened at the Acropolis since the 1980s, the most significant being the 2009 opening of a state of the art museum, adjacent to the Acropolis. The history of the Parthenon Marbles is chequered and blighted, especially with the early nineteenth-century removal of both a significant proportion of the sculptures and the sculptural frieze by Lord Elgin.

In 1801–5 Scotsman Thomas Bruce, Lord Elgin (1766–1841), secured a deal to acquire the following from the Parthenon:

21 figures from the statuary from the East and West pediments
15 of the original 92 metope panels (Lapiths and Centaurs)
75 metres of the Parthenon Frieze

Collectively, this haul equalled more than half of what now remains of the surviving sculptural decoration of the Parthenon, the largest temple, built in the Doric style, atop the Acropolis. Up until the Parthenon Marbles were relocated into the Duveen Gallery at the British Museum, London, they were added to with casts as each new fragment was found on the Acropolis. British agents would arrange for casts to be made.[14] In addition, Lord Elgin also 'collected' objects from the other buildings on the Acropolis. Today you can view all of the above at the British Museum, where they have been homed since 1817.[15] And herein lies the issue; since 1832 – when Greece regained independence – successive governments have tried valiantly to have the Parthenon Marbles repatriated to Greece, their home of origin where Phidias carved them in c.447–438 BCE. Endless petitioning has fallen upon deaf ears. They are called the Parthenon Marbles for a reason!

Amateurs, professionals and celebrities have weighed into the argument for repatriating the Parthenon Marbles, or not. Concerns for them staying put have often been around their protection; pollution and vandalism have taken their toll on the remaining Parthenon Marbles in situ, as opposed to the British Museum, which can provide a museum environment that can halt deterioration. Allegedly, this has not always been the case though, for in the 1930s the patina of the Parthenon Marbles was damaged when inept staff cleaned them with wire brushes.[16] There is some truth to the argument about the British Museum being able to protect them, especially with the effects of acid rain that bites away at the porous marble. But in 2009 the new Acropolis Museum opened and offers the perfect environment – on several levels – for the Parthenon Marbles to return to Athens.

The Museum, with its fabulous outlook over to the Acropolis bringing the old and the new together, exhibits a combination of original objects and plaster cast copies of the 'missing pieces' that are held in collections across Europe. The plaster cast copies are easily identified – they are much whiter than the aged marble and do not have quite the same texture. The

original sculptures were carved from Petelic marble and have a natural yellowish hue. Plaster casts often fail to have the same depth of detail and are far whiter (unfortunately, some museums have painted plaster casts making them even whiter and glossier). I like that the Acropolis Museum differentiates between the authentic and the plaster casts, however, as it makes for good conversations. I see the plaster casts as stand-ins, waiting for the originals to return, offering a glimmer of hope.

The Acropolis continues to be the victim of damaging forces; in a city of 3.1 million people (in 2020) there is little hope of escape or minimising pollution (car fumes and industrial burn off). Since 2004 conservators have been using laser technology to remove the grime from the structures and sculptures. It is delicate and time-consuming work. This and the new museum demonstrate the efforts being made to protect this wonder of the ancient world for future generations. The role and value that copies have played in the bigger Acropolis picture is very relevant to protecting its future.

Topping the list is the important role copies play in filling the gaps of the missing pieces that now reside in the British Museum. Enabled by the exhibition of copies, the Acropolis Museum delivers two significant messages. One message is highlighting the question of why there are gaps in the displays. And secondly, showcasing as close as possible, given it is in a museum setting and not in situ, an idea to visitors what the original decorative scheme would have looked like.

As mentioned earlier, in 1979 the *Caryatids* were removed from the Erechtheion and replaced with replicas. These sculptures are awe-inspiring; five women act as columns, holding up the small temple. Nearly every art history and classical studies' student has studied the *Caryatids'* drapery and classical forms. They epitomise the best and most beautiful of Greek sculpture. They are now preserved in the Acropolis Museum; their clones brace themselves against the forces of human-made pollution and climate change. Arguably, the copies have saved the originals.

Lord Elgin has certainly taken a hiding for his acquisition of the Marbles, but what few realise is that he inadvertently assisted in preserving them. At the time of taking, Elgin had plaster copies made of those he did not acquire, mainly the West Frieze. These casts have proven very useful in revealing details of how the Frieze looked before the onslaught of Victorian tourism when taking a little marble souvenir from the Acropolis as a memento was quite acceptable, and pollution. Before the advent of photography, Elgin did the next best thing in an effort to record what the

missing sculptures looked like. In 2019, the results of a new study whereby 3-D scans of the plaster casts and the originals were compared revealed how much detail has been lost. Elgin's plaster casts have been described as a time capsule from 1802. Another set of copies made in 1872, reveal the loss of detail during that century.

Cast copies are enjoying a heyday in their own right. Skulpturhalle in Basel, Switzerland, has an extensive collection of more than two thousand plaster casts. That is its role – to collect and exhibit casts. Needless to say, the Parthenon is represented; it has assembled casts of every surviving remnant from the Parthenon exhibiting them to mimic the original scheme. This equates to 160 metres of frieze and 52 metopes. It offers the most complete collection of casts of the Parthenon Marbles. Between 1985 and 2010 the Skulpturhalle's collection trebled, demonstrating a growing interest in this area. In 2018, the Cast Courts re-opened at the V&A in London. Originally opened in 1873, the Cast Courts have been returned to its former glory. The techniques used today include reproducing copies in plaster, electrotypes, photographs and digital media. In a time when it was more complex and expensive to travel, the Cast Courts brought art to the London public. You could see all 35 metres of Trajan's Column and Michelangelo's *David* without setting foot in Italy. As the V&A's website notes:

> The cast collection is a dramatic expression of Victorian ambition, and the strongest embodiment of the Museum's founding mission as a school of art education for both practitioners and the public.[17]

The V&A is a trailblazer for recognising the significance of the copies in their collection and giving them a new lease on life for present and future generations. For a time, though, plaster copies were very much out of vogue yet they do have a role to play; they can be seen as a genre in their own right. The history of plaster cast copies makes for interesting studies, including their benefits, as seen with the Russell Statues and the beginnings of formal art education in Auckland, New Zealand (see Chap. 2). Plus, arguably when copies are exhibited alongside the originals, to fill gaps, they can make a display look more complete.

Lastly, copies of the Parthenon Marbles play a global role. Sent to the far corners of the world, copies of the Parthenon are found not just in museums. In late 2017 the Greek Centre in downtown Melbourne, Australia, unveiled a replica of the frieze gracing the exterior of the

Parthenon building. This new addition to the city was a nod to the city's Greek population – Melbourne has the largest Greek population outside of Greece – and was also politically charged. The replica symbolises the ongoing debate around repatriation of the Parthenon Marbles back to Greece. Copies can also be the catalyst for conversations about other collections; a case in point is in Perth.

The Museum of Western Australia has in its collection a full-sized cast of 60 per cent of the Ionic Frieze from the Parthenon. Perth's copy was made from Lord Elgin's frieze and acquired in the early twentieth century for the purpose-built gallery in the Western Australia Museum. The copy dates from the latter half of the nineteenth century and was collected to offer:

> ... a physical facsimile of the original art, art of major international significance, held in the British Museum.[18]

This objective was certainly not unique to this museum. The Perth frieze resides, as it originally did, in the Beaufort Street building where it was installed in 1908. Originally called the Hellenic Gallery, the cast was made by Brucciani and Co., perhaps the best in the trade at the time. He made moulds and casts for many museums, including the South Kensington Museum (now the V&A), the British Museum and the National Portrait Gallery.

More recently, the role of the plaster copy has shifted; it has initiated conversations around how, why and when it is displayed and its significance in relationship to indigenous collections. Does the copy provide a foil only or does it offer ways of viewing indigenous Australian art? Whatever the answers, the copy is providing food for thought at a museological level. Today the newly opened Western Australian Museum (2020) continues to exhibit their Parthenon Marbles copies; it is the focal point of the 'Innovations' gallery surrounded by objects about innovations and creativity from a range of Western Australians.[19]

The original Parthenon Marbles remain at the British Museum and their stance is:

> The Museum is a unique resource for the world: the breadth and depth of its collection allow a global public to examine cultural identities and explore the complex network of interconnected human cultures.[20]

The global public could undertake their studies in Athens too. The British Museum's website goes on to say that fundamentally by keeping the Parthenon Marbles in London the world audience gets the best of both worlds:

> The Acropolis Museum allows the Parthenon sculptures in Athens to be appreciated against the backdrop of ancient Greek and Athenian history.[21]

This is true too, hence the complexities of the ongoing debate.

Putting aside the moral, ethical and legal arguments for repatriation, Lord Elgin was not protecting the past for the future. His objective, pure and simple, was to collect beautiful objects. Inadvertently, however, he has protected the Marbles from the ravages of war, earthquakes, bombings and pollution. The copies he had made have also advanced knowledge of these prize examples of Hellenic sculpture. The British Museum will continue to be criticised for being 'colonial' in their attitude to keeping the Marbles. One consolation is at least now the sculptures are referred to as the Parthenon Marbles, rather than the Elgin Marbles, as they were labelled for close to two centuries. And the numerous copies of the Parthenon Marbles dotted around the world still allow contemporary audiences marvel at Greek ingenuity and their attention to detail; their beauty is second to none and the basis for the evolution and development of Western art.

A SMALL WATERCOLOUR BY JOHN KINDER

On a much smaller scale, a delicate watercolour by the Reverend John Kinder (1819–1903) is hugely significant to the history of New Zealand's Bay of Plenty and the collection of The Elms Mission Station. *Te Papa, Tauranga*, measuring 197 × 298 cm, was painted in 1858 by Kinder, an amateur artist and photographer. The scene depicts the vista across from the Te Papa peninsula over the harbour to Mt Maunganui.[22] The location was strategically significant to Māori and colonists alike.

The mission station established by the Church Missionary Society consists of a cluster of buildings in a beautiful garden setting. The Mission House was completed in 1847 and built in a faux Georgian style. It is one of the oldest European buildings in New Zealand and is open to the public. The Archdeacon Brown and his family lived in the home and in 1859

his daughter, Marianne Celia Brown, married Kinder. Fast-forward 150 years and the work Kinder painted the year before their marriage became available at auction.[23] The Friends of The Elms raised the funds and acquired the work for the collection.

Te Papa, Tauranga is significant not only for the family connection but also as a historical record of the area at that time. Kinder dated the work – January 1858 – giving the work specificity; his work is an accurate topographical rendering rather than on of artistic expression. The work on paper is very particular to The Elms and its region and, given very few examples exist like it, it was seen as an important acquisition in 2005 when it was purchased by the Friends of The Elms for NZD 6,750.

At the time of acquiring the Kinder painting, the Mission House was challenged in providing a safe environment for the exhibition of objects to full museum standards. With the House's condition in mind, a facsimile of Kinder's watercolour was made when the work was conserved soon after purchase. *Te Papa, Tauranga* is executed in pencil, watercolour and chalk ground on paper. Like other works from this period, it is vulnerable given its delicate nature and age and therefore a copy was seen as a way of protecting the original as well as giving visitors the opportunity to see the image. The copy was framed and displayed in the Mission House, the original put into storage.

In 2020 I was keen to see if the copy was still on display. It wasn't: the intervening years had seen remedial work completed at The Elms, including greater care and knowledge about the collections and making the environment more stable for objects. The original work is now exhibited in the Mission House. The copy still exists; worryingly, however, it had been accessioned in 2006 and carries a catalogue reference number on the verso of the work. However, the original did not carry such a number, though it was catalogued in the collection database. Disaster averted, this mistake has now been rectified but it demonstrates how a simple mistake could have ended in the original being compromised or worse, destroyed at a later date. Fortunately, knowledge of the copy and original existed. Arguably it proves just how good copies can be!

* * *

There is no doubting that every possible effort should be made to protect artworks for the future. It is how we go about this that can be problematic as demonstrated by the above examples. Not protecting artworks in public

collections is considered negligent and unprofessional. When works are removed from display to be conserved in a museum context they are either replaced with another work, or have a text label explaining why the work is missing and, in some cases, provide information about the treatment required of the work, or on rare occasions they are substituted with a copy of the artwork. And it is the latter to which some visitors take exception.

In 2016 art historian Noah Charney wrote an article, 'A fake of art' in a response to his recent visit to Vienna's Albertina Museum that holds approximately 130 Albrecht Dürer drawings in its collection. However, they are rarely exhibited given their vulnerability to excessive light. As art historian Olivia McEwan notes:

> ... its most famous masterpieces by such artists as Dürer, Schiele, and Rembrandt are represented in its Hapsburg State Rooms by high-quality digital lithography facsimiles, with discreet captions notifying visitors.[24]

The captions were so discreet that the very observant Charney missed them! Charney made a beeline for two of Dürer's iconic works – *Tuft of Grass* (1503) and *Young Hare* (1502). He soon recognised, however, that something was not quite right about them. Later that day, one of the museum's curators confirmed that the *Young Hare* was indeed a copy. Both of these watercolours are only ever exhibited for periods of three months every few years.[25] The remaining months are spent resting in their Solander boxes. These works are seminal pieces in the history of the Northern Renaissance and clearly have to be protected. Charney was not critical of the resting period, but he was of the lack of accessible information about the inclusion of copies on exhibition. Eventually, after a bit of detective work, he found the information pertaining to the exhibition copies, but he had to dig for it. This crucial information should be very visible and accessible not just in terms of honesty, but also as part of the museum's educative role. Charney had not expected to see copies and this is at the very core of the argument; we expect to see authentic works in a museum. We can view copies in the museum's gift store.

Works on paper – by their very delicate nature – are more difficult to protect; over-exposure to light can be disastrous. Often far smaller because they are on paper, they are easier to de-install and replace with another work. Oil paintings are less problematic in terms of their exposure to light. Very large works are often difficult to move, store and accommodate in

conservation laboratories. In some cases, a painting might never be moved from the wall to which it is fixed. For example, *Burial in the Winter on the Island of Marken (The Dutch Funeral)* 1872 by Petrus van der Velden (1837–1913) was too large to be easily de-installed from the public art gallery in Christchurch, New Zealand.[26] When it was not required for an exhibition, a false wall, complete with dado railing, was placed in front of it. The public did not know what was hiding behind the wall. More recently, museums have become more imaginative, and open, about conserving works. Amsterdam's Rijksmuseum set about in mid-2019 to complete an extensive programme of conservation on Rembrandt's *The Night Watch* (1642). Instead of relocating the work into a laboratory and thus taking it out of the public's view – or supplementing it with a copy – the museum ingeniously built a glass chamber in which the conservators work on the painting. A bit like a modern-day spectator-full glass squash court, visitors can view the painting and the conservators at work. This is a different kind of visitor experience, and certainly better than none at all. And people do like to see what goes on behind the scenes in art museums. Modern technology has allowed the Rijksmuseum to take this a step further as the conservation process can be viewed via webcams set up especially for the event. Called 'Operation Night Watch', this is a unique and educative experience.

While *The Nightwatch* was being conserved the Rijksmuseum took the opportunity to restore the composition to its former original glory. In 1715 Rembrandt's large painting was trimmed on all four sides, enabling it to fit between two doors at Amsterdam's city hall. The word trimmed perhaps doesn't do justice to how much was actually removed: 60 cm from the left, 22 cm from the top, 12 cm from the bottom and 7 cm from the right. This downsizing changed the composition and dynamics of the group irrevocably, until 2021. Thanks to sophisticated computer software, and the copy made by Gerrit Lundens (1622–1686) before the painting was cut down, the missing panels have been made and attached.[27]

Lundens' copy is about 0.5 square metres to Rembrandt's original at nearly 16 square metres. There are a few subtle differences between the original and Lundens' version, including the reduced number of pikes against the wall and the positioning of the pikeman, Walich Schellingwou (right-hand side of four centred figures in the background). These are minor when you consider how useful the copy is in terms of what was cut from the original masterpiece. Lundens reproduced his copy in six parts and, according to art historian Harriet Stoop-De Meester:

The different sections from which the composition seems to have been made and the slightly distorted heads of some of the members of the company in the copy strongly suggest the use of an optical instrument.[28]

Whether or not Lundens used a camera obscura is not known, but it's a possibility. What is known is that his copy is a very contemporary one, having been made some time between when Rembrandt completed his work in 1642 and 1649.

Scanning the original and the copy, in the collection of the National Gallery, London, provided the information to computer-generate the missing pieces. The additions are designed to overlap, and not touch, the original painting and were temporarily displayed. The Rijksmuseum noted that Rembrandt's hand would have been superior to modern-day add-ons created, but nevertheless they give viewers a truer view of how Rembrandt originally intended *The Nightwatch* to look.[29] Without a doubt, not having a copy would have made this impossible.

By way of comparison, it is interesting to look at other large conservation projects. As *The Night Watch* is to Amsterdam, *The Last Supper* is to Milan. Leonardo da Vinci's (1452–1519) masterpiece is larger than *The Night Watch*, at 4.6 × 8.8 metres, and is permanently attached – painted on – to the wall of the refectory at Santa Maria delle Grazie. Painted between 1495 and 1498, *The Last Supper* was literally flaking off the wall less than two decades after completion. The reason for this has been well documented over time; in short, however, da Vinci, forever the experimenter, used a combination of media; oil, tempera, red chalk and black paint over white lead all together on a dry wall. Unlike fresco, painted onto wet plaster, which requires a certain amount of alacrity, Leonardo took his time and when completed added his final touch – layers of varnish not meant for a fresco. The result of this concoction of paint types has meant that, with the exception of the first two decades, *The Last Supper* has been in a perpetual state of needing restorative treatment.

In 1978 (when only 20 per cent of the original painting was left) a major programme of conservation was embarked upon. It took 21 years to complete and for all that time the painting was unavailable to the public. In 2019, a new air filtration system was installed at the church in a bid to protect the work going forward. Visitors have to pre-book tickets for their allocated 15–20 minute viewing time. It is a shame that the public missed out on the experience of seeing *The Last Supper* for so long. Even seeing it through scaffolding with conservators at work would have been better

than not seeing it. As a visitor you can't get up too close to *The Last Supper*, an alternative for those wishing to hone in on details is now available. In 2020 a copy of the painting, made by his students, Giampietrino and Giovanni Anthonio Boltraffio in c.1515–20, was digitized and made available online.[30] Unlike Leonardo's recipe of varied media, the copy is oil on canvas and has lasted the test of time far better, including bits that have completely disappeared from Leonardo's work but can still be seen in the copy.

There are many instances of an artwork being over-restored, and even over-conserved. For example, American conceptual artist Cady Noland's (b.1956) work *Log Cabin* was the centre of a legal battle in 2019. The sculpture, resembling a log cabin, was loaned to a museum in Aachen, Germany, in 1995. Having been outside and exposed to the elements, conservators discovered and replaced rotten boards on the sculpture with new ones from the original Montana supplier. Noland, angry at the work carried out by conservators, argued '... that the restoration of the work was so extreme that it amounted to the creation of an unauthorised copy of the original..'[31] Unfortunately for Noland, she could not sue under the United States of America Copyright Act on the grounds that the conservation work was carried out in Germany.

Works in private ownership can also suffer from an over-indulgence of restoration. In 1987 auctioneers Christie's sold Egon Schiele's *Youth Kneeling Before God the Father* for a large sum. However in 1995 after the sale, Christie's were directed to reimburse the buyer when the painting was found to have had 94 per cent of its surface repainted during restoration. The judgement declared that it could no longer be considered to be by Schiele. This case highlights the need not only for transparency around information at the time of sale, but also questions of authenticity and judgements as to the stage at which an original becomes a forgery.[32] The Schiele is not an isolated case and raises questions around how a work's status is changed when conserved to what is considered too extreme.

Visitor experience is central to this chapter; our expectations as viewers is for the eternal search for authenticity. The more time we spend in front of screens perhaps the greater our desire is to see authentic art. Alternatives to substitute autograph works with copies is complex, but with creative thinking this can be done successfully. What viewers get miffed about is the lack of transparency when a copy is exhibited. They do not like being duped.

Protecting art for the future is admirable and essential; museums have standards and mandates to ensure the safekeeping, both long- and

short-term, of their collections. Substituting with copies might be done with the best of intentions but without adequate information around the context it is like watching a stand-in for a prima ballerina that you have paid good money to see and *expected* to see perform. There is bound to be disappointment no matter how good the stand-in is. Thinking back to my last year of secondary school in 1979, our art history teacher took our small class of five students to the National Art Gallery in New Zealand's capital city, Wellington. The objective of the trip was to view works by Dürer. One-third of the year's syllabus was dedicated to studying the life and work of Dürer. It was a real treat, and I now realise a privilege given for very good reasons it would never happen today. To have Dürer's original works laid out for us to admire in a private viewing, sowed the seed for me to study art history. Accordingly, I am forever grateful for the National Art Gallery for facilitating this visit.

NOTES

1. Collection of Samuel H. Kress, Allentown Art Museum, Pennsylvania [1961.035.000], oil on panel, 81.28 × 64.77 cm.
2. McGrath, Katherine, 'A Museum Just Discovered It Has Owned a Rembrandt for Over 60 Years', 21 February 2020, www.architectural-digest.com
3. Charney, Noah. 'A fake of art', *Aeon*, 5 February 2016, p. 2.
4. Gombrich, E. H. *The Story of Art*, Oxford: Phaidon, 1978 (13th edition), p. 20.
5. Ibid., p. 23.
6. Magdalena Álamos, www.emol.com, 14 March 2019.
7. www.stmarks.com
8. Prior to this location they were installed at (a) Les Invalides, and (b) at the gate piers at the entrance to the Tuileries.
9. Freeman, Charles. *The Horses of St. Marks: A Story of Triumph in Byzantium, Paris and Venice*. New York: Overlook Press, 2010, p. 9.
10. Ibid., p. 10.
11. Tompkins, Arthur. *Plundering Beauty: A History of Art Crime during War*. London: Lund Humphries, 2019, p. 42.
12. Email correspondence with Luisella Romeo, 25 March 2021. See: https://bestveniceguides.it/en/2020/06/05/the-horses-on-st-marks-basilicas-terrace-replicas-or-art-works/
13. Freeman, Charles. *The Horses of St. Marks: A Story of Triumph in Byzantium, Paris and Venice*. New York: Overlook Press, 2010, p. 9.

14. Jenkins, Ian, 'Acquisition and Supply of Casts of the Parthenon Sculptures by the British Museum 1835–1939', *The Annual of the British School at Athens*, 1990, Vol. 85, p. 89.

15. These sculptures were first seen from 1807 in Lord Elgin's temporary museum. However, Elgin had bankrupted himself transporting the sculptures to Britain. In 1816 Parliament decided to acquire the collection for the British Museum. Since 1817 the sculptures have always been on display to the public in the British Museum, free of charge. https://blog.british-museum.org/an-introduction-to-the-parthenon-and-its-sculptures/

16. https://www.parthenonuk.com/refuting-the-bm-s-statements

17. https://www.vam.ac.uk/collections/cast-collection

18. O'Toole, Keven. 'The Hellenic Gallery at the Museum of Perth – Is it a Story of Contested, or of Complementary, Heritage?', *RAG*, Vol. 2, Issue 4, June 2007, p. 2.

19. Email correspondence from Fiona Brown, Western Australian Museum, Perth, 11 June 2020.

20. https://www.britishmuseum.org/about-us/british-museum-story/objects-news/parthenon-sculptures/parthenon-sculptures-trustees

21. Ibid.

22. Mt Maunganui is a tombolo at the end of a sand spit.

23. Lot 335, Webb's Auction, Auckland, New Zealand, 29 June 2005.

24. McEwan, Olivia, 'A Dürer Retrospective Celebrates His Remarkable Drawings', https://hyperallergic.com/535654/albrecht-durer-drawings-at-the-albertina-museum/, 3 January 2020.

25. Charney, Noah, 'A fake of art', *Aeon*, 5 February 2016, p. 2.

26. Collection of Christchurch Art Gallery, New Zealand [69/125], oil on canvas, 164.5 × 290.0 × 14.5 cm.

27. Collection of The National Gallery, London [NG289], oil on oak, 66.8 × 85.4 cm.

28. Stoop De-Meester, Harriet. 'Gerrit Lundens, His Copy after *The Night Watch* and the Derivatives of His Oeuvre', *The Rijks Museum Bulletin*, Vol. 68, Issue 2, 2020, pp. 146–155.

29. Sterling, Toby. 'Rembrandt's 'Night Watch' on display with missing figures restored by AI', *Reuters*, 24 June 2021.

30. https://artsandculture.google.com/story/explore-the-last-supper/sAKCB2AzvHUmKQ

31. Cascone, Sarah. 'Artist Cady Noland Refuses to Give Up Her Legal Fight Over the Restoration of Her Disavowed Log Cabin Sculpture', *Art and Law*, 15 July 2019.

32. 'Auctioneers Ordered to Compensate Buyer of Disputed Work', www.apnews.com, 13 January 1995.

Cash for Copies

There is a long history of copies being used in transactions for monetary gain, either knowingly or not. Sometimes the status of a work changes – or rather knowledge about its status – after a sale. This chapter scopes the trading of copies for commercial gain. In the twentieth century, it has been easier to categorically say if a work is a copy. Further back in time, say in Rembrandt's time, we know he ran his workshop like a business where his assistants made copies, under his management, to sell. It was acceptable and common practice; this practice blurs the line between original and copy. Or perhaps the copies should be called genuine copies or authentic copies because the original artist oversaw the making and was part of the overall process.

A forger can make a copy of work in order to sell it as an authentic work, choosing what they copy with utmost care. Of great importance is that the buyer cannot access in any way the original image either in the flesh or digitally. So, for instance, a work by a 'famous artist' from an unknown private collection is a safe bet. A forger might feel more comfortable with copying an artist's style and then announcing that they have discovered a hitherto unseen work. This is a great strategy for the forger to supply the demand for an artist's work. Some artists, in particular, have been the victims of such a practice.

Amedeo Modigliani (1884–1920) has been a popular target for the forger. Why? Because his work is well liked, commands high-end prices and he died young aged 35 years without a dealer keeping good records

© The Author(s), under exclusive license to Springer Nature 179
Switzerland AG 2022
P. Jackson, *The Art of Copying Art*,
https://doi.org/10.1007/978-3-030-88915-9_8

or a catalogue of his works and sales. It is also about timing; Modigliani lived and worked in a time when record keeping was not as stringent as it is now or as easy as it is in our digital age. Plus his works, like his contemporaries, were rarely reproduced in catalogues, so again records – both text and visual – are scarce. His early death meant that his 'affairs' weren't put in order. Additionally, Modigliani's work is now out of copyright, giving the forger the green light to press play.

In July 2017 an exhibition of Modigliani's work, on show at the Ducal Palace in Genoa, was dramatically closed down as 20 out of the 21 paintings were discovered to be fake. His style had been copied. Modigliani remains a popular artist with audiences and over 100,000 paying visitors had viewed the fakes, alongside the one original painting, in Genoa before the exhibition was closed prematurely (it had previously been hosted by two other venues before Genoa). The forger, like those before and those still to come, had copied Modigliani's distinctive style. Fortunately, in March 2019 the Carabinieri identified the fraudsters.

The usual process in authenticating a work is in the first instance to check it against the artist's *catalogue raisonné*. Again, with Modigliani this is a cumbersome task for to date there are six such catalogues, which is at odds with the document's objective. In this situation, it's only science that can definitively determine the authenticity of Modigliani's paintings. Copying in the style of an artist is tried and tested and for many a forger, their livelihood.

When an artist directly copies or copies in the style of an artist and then sells that work, either personally or as a fence, as an original, they are committing a crime. As works get passed down through generations, there is even less chance of the work's originality being challenged. Why would you question a work's authenticity, especially if you had always believed, for instance, that the family heirloom was the real thing? We know copies can be made with innocent and legitimate intent but it's when the work is knowingly sold as something it is not that the line is crossed between lawful and unlawful. Aestheticist, Sándor Radnóti, on the question of what is wrong with copying art:

> ... the apparent reason for this is that copying has none, or at least fewer, of the moral connotations associated with forgery.[1]

But again, these lines get blurred on occasion. When a copy is part of a commercial transaction and presented as an original, it is both lawfully and

morally wrong. Historically, copies have been genuinely sold purporting to be an original. This was the case in 1956 when New Zealand's premier public art museum, Auckland Art Gallery, acquired a J. M. W. Turner painting.

J. M. W. Turner's *The Wreck of a transport ship*

Auckland City Art Gallery opened its doors in 1888. The public art museum of New Zealand's largest city collected British art well into the twentieth century. Long before the recognition of art from New Zealand and Pacific came into its own, the collections were very 'colonial'. In many ways, they were mini versions of what you would find on the walls of British and Western European museums. Given this emphasis, it is no surprise that in 1956 the Mackelvie Trust purchased Turner's *The Wreck of a transport ship* for Auckland Art Gallery Toi o Tāmaki (formerly Auckland City Art Gallery) (see Fig. 8.1).[2]

Not overly large, by Turner's standards, *The Wreck* is quintessential Turner. It depicts a dramatic maritime disaster; a convict ship capsizes and as the passengers (convicts and their guards) tread water, local fishing boats try valiantly to rescue the drowning men. Turner chose the moment when it is very much touch-and-go as to who would drown and who would be rescued. As the audience, we expect that the outcome will include loss of lives. It is pure maritime theatre as only Turner could produce. The agitated sea, waves dwarfing humankind and their vessels, make the painting very engaging. Certainly, from a historical perspective, in the 1950s, this was seen as a good addition to the collection. With the exception of works on paper, including etchings, and Dunedin Public Art Gallery's oil on canvas, *Dunstanborough Castle, Northumberland* (c.1799), there are very few Turners in New Zealand public collections, which was another sound reason for Auckland to acquire *The Wreck*.[3]

As with all new acquisitions, the work was formally acknowledged in the gallery's quarterly journal, though it was given the painting's alternative title *The Wreck of the Minotaur*.[4] The *Minotaur* was the name of the ship, which on 22 December 1810 was wrecked off the Dutch coast of Haak Saands. However, Turner had begun sketches for the composition five years earlier, so the *Minotaur*'s fate was not his first inspiration. The painting was purchased by the Mackelvie Trust for the collection on the advice of John Jacob who, at the time of purchase in 1956, was Deputy Director of the Walker Art Gallery in Liverpool. The painting was duly purchased and sent to New Zealand, joining the other Turner in the

Fig. 8.1 James Pyne (attributed), copy of J.M.W. Turner's *The Wreck of a Transport Ship*. Collection of Auckland Art Gallery Toi o Tāmaki. (Photo: Penelope Jackson)

collection; an oil on canvas titled *Yachting at Cowes,* acquired in 1955.[5] The acquisition of *Yachting at Cowes* was recorded in the gallery's *Quarterly* magazine at which stage it was suggested that the:

> ... sketch is clearly connected with Turner's visit to the Isle of Wight in 1827, where he stayed with Nash, the architect, at East Cowes Castle.[6]

And *The Wreck's* date of 1835, was explained as perhaps being signed and dated at the time of its original purchase. Auckland, known as the City of Sails, now had a pair of Turners, both maritime scenes, though very different in content and atmosphere.

Three years later, in 1959 the gallery was advised by Jacob that the original Turner painting, *The Wreck*, had been located. Originally, it had belonged to sailing buff the Earl of Yarborough, who founded the Royal Yacht Squadron. He lived on the Isle of Wight, and died on his yacht. At the time of Jacob's letter to the gallery, the original painting had been in the collection of Portugal's Calouste Gulbenkian Museum since 1920. In short, the work at Auckland Art Gallery Toi o Tāmaki was a copy. It would be several more decades before the gallery discovered more about their copy. In 2008, Andre Zlattinger of Sotheby's, on viewing the work, confirmed *The Wreck* was not by Turner, suggesting that it was highly likely to have been painted by the English artist James Pyne.

James Baker Pyne (1800–1870) is known for his landscapes and seascapes and described as a 'successful follower' of Turner. Self-taught, in the early years of his career Pyne was a member of the Bristol School of Artists. He is represented as an artist in his own right in several public art collections. He was aptly described as a 'successful follower' given his ability to copy Turner's work and in his later years, Pyne made several marine studies that appropriated both Turner's style – especially his treatment of atmospheric elements – and palette.

Zlattinger didn't just have a hunch about the Turner being a Pyne. There were several elements about the work that didn't fit with Turner's oeuvre. Firstly, Turner was habitual about his size of canvas; he favoured two sizes, 61 × 91 cm and 91 × 123 cm (exactly 2 x 3 and 3 x 4 feet respectively). The Auckland work, by contrast, is 87 × 52 cm. Secondly, and this is probably the key to distinguishing the work from Turner's hand, the brushwork is at odds with how he applied paint to canvas. Turner worked quickly and energetically; the confidence of his uninhibited brushwork creates visual energy and tension. It is the whirling, writhing forms of angry sea that draws in the viewer, making it such a vivid experience. At the time of painting *The Wreck*, Turner was literally quite close to his subject matter. He had built himself a boat and spent many hours experiencing the motion of the sea whilst at the same time painting. He had a portable paint box and painted, in oil, *en plein air*. It was this closeness to his subject that gave it spontaneity and immediacy capturing at speed, in the moment, not laboured in any shape or form. In the Auckland work, the focus was on

getting the forms and elements right in the composition rather than the more organic blending of tone. The heavy reliance on impasto, to try and capture Turner's painterly finish, is also at odds with Turner's work.

Thirdly, Pyne had a reputation for making copies of Turner's works. These are easy to find and others can be located in public collections, such as *San Benedetto Looking Toward Fusina (after Turner)* held in the Indianapolis Museum of Art.[7] Though Pyne signed the Indianapolis work 'J.M.W.T', it is clearly labelled as being by Pyne. Interestingly the size is perfect for a Turner (61 × 91 cm). The terminology used for such works differs; in most instances, 'attributed' is used. In much of the literature, Pyne is described as a 'follower of Turner'. Certainly he did appropriate Turner's content and stylistic traits, and in some cases he also copied Turner's signature. Auckland's *The Wreck* is unsigned.

Lastly, the timing for Pyne to execute his copy of *The Wreck* was bang on. In 1849, the painting was exhibited at London's British Institute. Located on Pall Mall, the Institute exhibited annually Old Masters and living artists. Works by the latter were for sale. It so happened that Pyne was in London that year; a year earlier had seen him working in the Lake District and then, in 1851, he set off for three years in Italy. The British Institution was very amenable to having artists set up their easels in the galleries for the purpose of copying. Again, the relatively small size of *The Wreck*'s canvas fits with ease of transporting a canvas to and from the British Institute.

Prior to Zlattinger querying the authenticity of *The Wreck*, leading Turner authority Martin Butlin commented in 1993 of the work:

> Turner almost never painted more than one version of a composition, or did he paint oil sketches in the normal, accepted use of that term.[8]

Butlin knows his Turners. He co-authored the Turner *catalogue raisonné* with Evelyn Joll in which there is a reference note about two versions of *The Wreck*:

> In the compiler's opinion, the sketch at York is certainly not by Turner, and that in the City Art Gallery, Auckland – to judge from a photograph – is very doubtful.[9]

Catalogue raisonnés are integral to authenticating works of art. Auckland's *The Wreck* does not have an individual entry in the 1984 edition,

published three decades after the acquisition was made, apart from doubting its authenticity.

As outlined above, these mitigating factors point the finger to Pyne being the artist or, rather, Turner not being the artist. It would be easy to criticise the vendor for not doing more due diligence. At the time, and the logistics of distance, this was easier said than done. Having said that, in a 1959 catalogue entry the gallery listed the provenance of *The Wreck* dating back to John Henderson (1764–1843), who was an early patron of Turner. On paper, it looked like they had sourced the right information. The time of acquisition also pre-dates scientific testing which can conclusively say when a work was made (the Tate established their conservation department in 1955 and in New Zealand they were even longer in being set up). However, the copy was made within Turner's lifetime so the materials could possibly be the same or similar. The advice given to acquire *The Wreck* was not questioned and Auckland had no reason to express any concerns. Discovering the work was not authentic just three years after its purchase must have been a huge disappointment for the gallery as they had paid a Turner price for it. The Mackelvie Trust paid £4500 in 1956 for *The Wreck*. By way of comparison, the price was reasonable given that in 1951 Sir Kenneth Clark paid £5500 for Turner's *Storm off Foreland*; an oil on canvas and of a very similar size to *The Wreck*.[10] In today's money *The Wreck*'s price tag equates to £96,000; for context, in 1956 a refrigerator cost £98.

Auckland Art Gallery Toi o Tāmaki had just three years with their Turner until its authenticity was thrown out the window. In mid-1959 the gallery hosted an exhibition title 'Old Master Paintings from Private and Public Collections of New Zealand'.[11] In the foreword to the catalogue director Peter Tomory noted that a key objective of the exhibition was to offer paintings of *quality*. Two months later, Jacob, who had just read the exhibition catalogue, realised he had forgotten to notify Tomory that the original *The Wreck* had been located in Paris.[12] Interestingly, Auckland acknowledged that there was more than one version of *The Wreck*; described as a 'reduced replica of the large work'. The entry concludes that their version:

> ... is extremely thinly painted and on analogy ... more likely to have been prepared for a prospective patron than a replica of the more thickly painted full size version.[13]

Whether the author had seen the full-size version is doubtful (it was in Portugal). Certainly when you view the work up close it lacks the spontaneity of an original piece. The flat, even strokes suggest a copyist's work.

There is no doubt other Turner copies exist in collections, unbeknownst to their owners. Auckland has made the best of the situation; clearly labelled in their catalogue, they use the terminology 'now believed to be a copy'. Transparency is the key here, for this painting possibly began its lifecycle as a legitimate copy but was sold more than a century later as an authentic Turner. The work is now attributed to Pyne, but it is not definitive. The gallery's website gives the painting the date of c.1849. Having said all that, *The Wreck* still plays an active role in the collection; since being acquired by Auckland, the painting has been included in eight exhibitions. Interestingly, the biggest gap between exhibitions, of just over two decades, was immediately after its [lowlier] status was confirmed.

L. S. Lowry's *Mill Street Scene*

In hindsight, Auckland's acquisition of *The Wreck* has to be considered as an unfortunate case of mistaken identity. It is just one of those things that museums have historically faced at some time or another. In some instances, however, sellers mislead buyers deliberately. Greed is a major motivation for those sellers who go out of their way to con a buyer and in the process create confusion to an artist's oeuvre and discredit their reputation. Copies of works – or in the style of – play havoc on all kinds of levels. Sometimes, the copyist and/or seller get their just desserts.

As significant as Turner was in nineteenth-century Britain, L. S. Lowry enjoyed a similar reputation in the following century. Although he received accolades in his own time, Lowry was reluctant to accept several honours, including a knighthood. Lowry's work is very collectable and he has enjoyed attention posthumously through many exhibitions and, more recently, a major movie (see Chap. 5). Manchester celebrates Lowry's legacy at The Lowry; opened in 2000 with some 400 works by Lowry as well as his archives, the gallery displays a permanent exhibition of his works. In part, Lowry's story is unique and continues to attract interest.

Lawrence Stephen Lowry (1887–1976) lived his entire life working and painting in the Manchester area. He began art lessons in 1915 at the Salford College of Art; for the next 20 years Lowry studied art. By day, Lowry worked as a rent collector; being out and about on the streets of industrial Manchester was his greatest source of inspiration. A social

recluse, Lowry painted what he knew best – his immediate environment. From the late 1930s, Lowry was acknowledged as a significant artist and enjoyed success in terms of exhibitions and the sale of works. Lowry's big break came in 1939 when the Tate Gallery acquired *Dwellings, Ordsall Lane, Salford* (1927). Monetary success did not, however, equate to a lavish lifestyle; far from it, as Lowry continued to live modestly.

The popularity of Lowry's work means there is a constant demand for his work and this is where the copyist has taken root. The uninitiated might think that Lowry's work is relatively simple to replicate, especially his characteristic stick figures. But underneath this simple-looking veneer is Lowry's great understanding of the human figure that came from 12 years of attending life-classes. In fact, Lowry's process was labour-intensive and time-consuming with some paintings taking him a year to complete. Lowry painted inch by inch; canvases were prepared with a double layer of white paint that deliberately discoloured to a warm yellow over time; additionally, his palette was limited. How Lowry applied his paint was both adventurous (smudging with his fingers and pencil used on oil to form vertical strokes, were just two of his techniques) and consistent. The copyist has to be familiar with these techniques, as well as being able to carry them off.

A search on the Internet at any given time will find a plethora of 'Lowry' paintings. There will be genuine ones that come up for sale at auction or at reputable galleries. But for the most part, many are copies, some labelled as such, others not. Lowry has always had followers; one was Arthur Delaney (1927–1987). A fellow Mancunian, Delaney was clearly influenced by Lowry in capturing the hustle and bustle of Manchester, including the grime and haze synonymous with the industrial city. But Delaney never sold his works painted in Lowry's style as anything but his own work. However, one of Delaney's paintings was the centre of a dodgy and lucrative deal many years after his death.

Mill Street Scene depicts a crowded inner area of Manchester; industrial brick buildings pumping out smoky fumes while the snow-covered streets are full of people moving briskly in the cold (see Fig. 8.2). At first glance, it looks very much like a Lowry. In 2004 Englishman Maurice Taylor purchased *Mill Street Scene* by Delaney (After Lowry). Taylor was a self-styled aristocrat having purchased a title for £1000 and reinventing himself as Lord Maurice Taylor, and, sometimes, Lord Windsor. Taylor decided to doctor the Delaney work; he added the signature 'L S Lowry' and a date of 1964 to the right-hand corner. The same year Taylor sold *Mill Street*

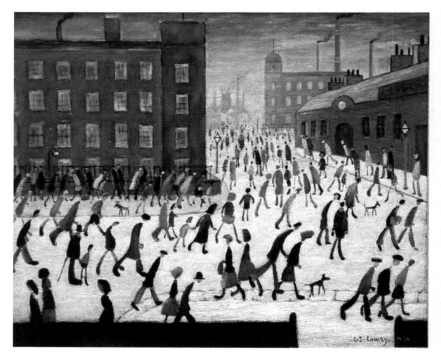

Fig. 8.2 Copy of L.S. Lowry's *Mill Street Scene* by Arthur Delaney. Private collection. (Photo: *Daily Mail*, Australia)

Scene, now proclaiming it to be an authentic Lowry, to antiques dealer David Smith. Apart from the newly added signature and date, he knew he'd have to provide the work's provenance for any serious would-be buyer, especially with an asking price of £330,000. Taylor maintained that industrialist Eddie Rosenfeld, who had conveniently died in 1984, had gifted the Lowry to Taylor. Other reports suggest that Taylor purchased it in the late 1960s from Rosenfeld, who had previously owned the painting. Eventually, it would come out that Taylor had purchased the painting from a dealer, Martin Heaps, in 2004 for £7500 knowing it was not an original.[14] To make the provenance even more robust Taylor had the Chester auctioneers Bonhams provide an insurance valuation. They were convinced that the work was what Taylor professed it was and duly gave the painting an insurance value of £600,000. Taylor decided to sell the painting.

David Smith, owner of Neptune Fine Arts in Hartshorne, Derbyshire, fell for the work and decided to acquire it. The asking price, of £330,000, was well below the insurance valuation and Smith paid a deposit of £230,000. It was at this stage that Smith decided to seek a professional opinion about the Lowry. To his dismay, the painting was soon found to be fraudulent. There were three main problems with the painting that had the experts – from The Lowry – agree that it wasn't genuine. They were: by 1964 Lowry had evolved, making *Mill Street Scene* not a stylistic fit with the date; the red lampposts were not a Lowry characteristic; and, the middle ground area and sky lacked Lowry's fluidity. Smith had been duped. Taylor had convinced Bonhams of the painting's authentic status, and Smith was sure it was the real deal. As auctioneer Adam Partridge noted in late 2010:

> The fake Lowry is a very convincing fake. ... It really does look like an original. ... It may be a copy but it's a very good one.[15]

And there you have it; those in the trade appreciated the quality of the work so it was pure bad luck for Taylor that Smith sought another opinion about *Mill Street Scene*.

In March 2009 Taylor was convicted of fraud at Chester Crown Court, receiving three years' imprisonment and being ordered to pay back £1,157,300 to cover his fraudulent misdemeanours.[16] This was not his first conviction, having been convicted of burglary in 1989. In a funny turn of events, the painting came up for sale in 2010, offered up at auction by Adam Partridge, and Smith purchased it (again). Partridges were selling it on behalf of the police for Proceeds of Crime in one of their regular Antiques & Fine Arts auctions.[17] This time the work was correctly labelled as a Delaney. Smith paid £13,500, well above its estimate of £5000–10,000, and said at the time he had re-acquired it for his own entertainment. As for Lord Taylor, he was aptly given a new moniker by the media, Lord Fraud. It was not reported if Smith received his deposit money back. In a slight change of career, Smith is now a snake breeder.[18]

Mill Street Scene has had an interesting lifecycle in its relatively short existence. Delaney was in awe of Lowry; he made the painting as a kind of homage and certainly not to deceive any future buyers. There is nothing wrong with this. The work Taylor purchased was an original Delaney, in the style of Lowry. But he then presented it as an original Lowry. When Taylor was ousted, the painting was referred to as a fake.[19] Taylor's actions (adding the signature and date and selling it as a Lowry) changed the

status of the work. And now Smith owns a Delaney original. By all accounts, it is hard to imagine that Smith is the only person to have purchased a Delaney masquerading as a Lowry.

Mill Street Scene is just one of numerous supposed Lowry paintings sold fraudulently. Copies, fakes, bogus and forgeries – whatever you label them, they continue to infiltrate the open market. *Fake or Fortune* journalist Fiona Bruce described Lowry, along with being the most popular, as the most faked.[20] Lowry was prolific, as are those who copy his works directly or his style. Given this, and that Lowry didn't keep a record of his work, the open market is a cesspit for works pertaining to be by him. The motivation for trying to sell a fake Lowry is clear; genuine Lowry paintings, with perfect provenance, can make serious money: in late 2018, *A Northern Race Meeting* (1956) sold at Christie's for £5.3 million.[21]

Just sometimes the tables turn and the work being questioned as being authentic is found to be exactly that. In August 1998, Roger Cook, an investigative reporter, purchased a 'Lowry' painting, *The Mill Pond* that had previously been withdrawn from an auction in Nottingham as the Lowry Museum 'expressed doubts about it, and little had been discovered of its provenance'.[22] Eventually, after several experts had looked at the painting, it was given the green light as being an authentic Lowry. In 2005 *The Mill Pond* sold for £18,000.[23]

THE GIFT OF TWO STUBBS PAINTINGS

British artist George Stubbs (1724–1806) is unrivalled when it comes to painting equine subjects. In another case of mistaken identity, one of his works was sold for a song – compared with its true value when it was put up at auction as 'After George Stubbs'. An oil on panel depicting two horses in profile, one with a rider, the painting was very specifically titled *Two Hacks, the property of Henry Ulrick Reay Esq of Burn Hall Co. Durham and their blue-liveried groom in a landscape* (1789) (referred to as *Two Hacks*).[24] However, when it was presented at Christie's 'Living with Art' sale in June 2016, having been de-accessioned by the Huntington Library Art Collections, San Marino, California,[25] it was catalogued with the incorrect title of *Two saddled horses, one ridden by a groom*.

Firstly, some context; the Huntington is an impressive non-profit collection-based research and educational institution catering for both scholars and the general public. Its facilities and collections are impressive,

including 160 British works with a strong focus on the eighteenth and nineteenth centuries. Artists featured include Hogarth, Gainsborough, Raeburn, Constable, and Turner. There is no doubting that theoretically Stubbs fits nicely into this line-up. There are a handful of equine subjects in the collection, including two bequeathed in 1958 by Charles Henry Strub (1881–1958). Strub was a dentist and entrepreneur. He had a serious passion for racehorses and the means to purchase genuine artworks depicting horses as well as building the Santa Anita Park racetrack in Arcadia, California. Strub collected rare and contemporary images of horses, both paintings and etchings, and during his lifetime they were exhibited at the Santa Anita Park. On his death he bequeathed six works from his personal collection to the Huntington Library including, as a 1962 report itemises, two works by Stubbs.[26] But at some stage one of the Stubbs' became known as 'After Stubbs'; in other words, it was now considered not to be an authentic Stubbs.

Two Hacks was de-accessioned by the Huntington and sent to New York in 2016 for auction; the painting was featured not in the pure fine art auction but rather alongside furniture and decorative arts. Christie's catalogue entry notes that the proceeds of the sale would benefit the art acquisitions fund at the Huntington. With no reserve, and an estimate of USD 3000–5000, the painting awaited a new owner. Meanwhile in London, art dealer Archie Parker was attracted to the work; he had good reason to believe that the 'After George Stubbs' work coming up at auction was the real deal. Firstly, he found the painting in the 2007 illustrated *catalogue raisonné*, labelled as *Two Hacks* not *Two Saddled Riders*. Secondly, Parker admits to having a little inside knowledge about the work; during the 1980s, his business partner was involved in the conservation of another version and still had the transparency of it. This version was dated 1790, a year after the one at auction. Dating so closely together usually rules out that the later one is a copy. Parker figured that Stubbs had painted two almost identical paintings, but only one featured in the *catalogue raisonné*.[27] So there are two works – *Two Hacks* and *Two saddled horses, one ridden by a groom*.[28] Both works were conflated into one work by the author of the *catalogue raisonné*.[29]

With this knowledge, Parker hastily made his way to New York to acquire this 'sleeper' – the term given to an artwork that has been mislabelled or undervalued and consequently is undersold at auction. Parker was not the only one with a hunch about the work and ultimately he paid USD 215,000 for it, giving a reasonable boost to the Huntingdon's art

acquisition fund. Once news of the sale hit the headlines, others commented about the situation. The Huntington was criticised for de-accessioning a work and selling it for far less than its true value. Art historian Bendor Grosvenor described the sale as 'one of the biggest de-accessioning blunders of modern times'. He was also critical of there being no reserve on the painting, meaning it could sell for next to nothing.[30] Grosvenor wasn't the only one critical of the Huntington with others quick to condemn with headlines such as 'Experts mistook this masterpiece for a copy – missing out on a small fortune' capturing the mistake/misfortune.[31] However, at the time of de-accessioning and subsequent sale, the Huntington thought the work to be 'After Stubbs' not by Stubbs. So how did this happen?

Given the 1962 article, mentioned earlier, describing Strub's collection and mentioning the two Stubbs it is hard to imagine why one of the Stubbs was relegated in status, in other works to a fake or copy. In the Huntington's defence, the painting was dirty and over-painted in parts.[32] Having said that, perhaps a cleaning of the work prior to making such an irreversible decision would have paid off. Interestingly, one of the telltale signs to Parker that confirmed the painting was authentic was the visible *pentimenti*; the left-hand hind leg of the leading horse has been tweaked by almost one centimetre to the right by the artist. Given the work measures 53.3 × 73.7 cm, this is quite noticeable. The outline of this can be seen under the area of grass. This is evidence of the artist changing things as they painted, and indicates that it is not a copy. Unless the copyist was very amateur, they would not be that far out as to need to change the positioning of a limb.

Parker returned to London and offered his new acquisition for sale at the British Antique Dealers' Association (BADA) in March 2017.[33] His asking price was £750,000. At the time of writing, three years later, the work was still available, though the asking price had been reduced by 20 percent.[34]

The media were very quick to point the finger at the Huntington for is failure to recognise the work's authenticity with headlines such as 'Experts mistook this masterpiece for a copy'.[35] Authenticity aside, the painting's role in the collection was assessed and it was decided that it no longer had a useful place. At the time of the painting's sale the Huntington's Art Museum director, Kevin Salatino, issued the following report:

The painting underwent a rigorous review by staff, with due diligence paid to all available technical and documentary information, as we do for all objects that come under consideration for deaccession. Based on the opinions of a number of international experts going back to the 1990s, as well as recent evaluations by specialists at Christie's, and the fact that its condition had precluded its use in The Huntington collection from the time of its initial gift, we decided in favor of deaccession. Whether or not the painting turns out to be by Stubbs, it would not have been placed on display at The Huntington, considering the outstanding quality of the rest of the collection.[36]

Evidence backs up Salatino's decision about the painting's usefulness; *Two Hacks* was never exhibited at the Huntington. It was last exhibited in 1955 at the Pasadena Art Museum.

The evidence shows that the Huntington's former Stubbs painting is authentic. Clearly, this was a case of mistaken identity by both the Huntington staff and Christie's. The latter, and the Huntington, had more money to make if they had picked up on its authenticity. In addition, according to reports, the work was dirty and had been over-painted, both of which should signal the need for further investigation. There is a chance that the same conclusion is drawn, or not.[37] They retained their other Stubbs painting gifted by Strub, *Baronet With Sam Chifney Up* (1791) and during February to April 2018 they hosted Stubbs' painting *Zebra* (c.1793), on special loan from the Yale Center of British Art. Their annual reports highlight ongoing additions of historical British art, including Edward Burne-Jones' *The Nativity* (1887), accessioned in 2017 with funds raised, including a gift by Charles H. Strub by exchange indicating this was the proceeds of the Stubbs' sale.[38] Christies and the Huntington were upfront about how the funds would be spent; the catalogue entry notes: 'Sold to benefit the art acquisitions fund'.[39] Parker had competition at the auction, pushing the price up, meaning that the Huntington realised a far greater sum than the estimated USD 3000–5000, which is perhaps the one positive to emerge from this oversight. Although *Two Hacks* has been proven to be original, numerous copies, both historical and contemporary, of the image can be acquired online, including etchings made after the original, dating back to 1792.

ROSS BLECKNER'S *SEA AND MIRROR*

For years, actor Alec Baldwin coveted the work of American painter Ross Bleckner (b.1949). In 2010, with one Bleckner already in his collection, Baldwin decided he wanted to acquire the painting *Sea and Mirror* (1996). The large oil on canvas (213 × 182 cm) depicts a myriad of beautiful shimmering shapes, akin to sea anemones, executed in a luminously bright lustre. The work had previously been auctioned in November 2007, at Sotheby's Contemporary Art Day sale in New York. *Sea and Mirror* was estimated to sell for USD 70,000–80,000, and sold for USD 121,000.[40] The painting's provenance was listed as the property of a private Swiss collector who'd acquired it from the Gagosian Gallery, Los Angeles. The painting was exhibited in Hamburg and Zurich the year after it was painted.[41] *Sea and Mirror* had a pedigree provenance. Bleckner is a leading contemporary American artist who, notably, is the youngest artist ever to have the honour of a retrospective at the Guggenheim in New York.[42] Needless to say, Bleckner's work is highly valuable and collectable.

Baldwin approached New York art dealer Mary Boone in his bid to acquire *Sea and Mirror*. Boone was in her mid-twenties in 1977 when she established her gallery in New York and has over the following decades represented major artists such as Barbara Kruger, Jean-Michel Basquiat, Joseph Beuys, and, since 1979, Ross Bleckner. As good as her word, Boone agreed to source *Sea and Mirror* for Baldwin. And she did. The pair agreed on a price tag of USD 190,000 for the painting, including Boone's finder's fee of USD 15,000. *Sea and Mirror* was duly delivered to Baldwin.

Like any new owner should, Baldwin checked the painting over thoroughly; on the canvas' verso the work's inventory number, 7449, was recorded. This matched the 1996 painting to a tee. But for Baldwin, the palette was not quite how he remembered it. Additionally, the painting smelt of new fresh paint (evidence of this came out later in email correspondence about prematurely aging the work and ensuring the paint was dry). Boone offered an explanation for the colour change; allegedly, the previous owner was a heavy smoker, so Bleckner removed the canvas from its stretcher and cleaned it as a courtesy to Baldwin.[43] Baldwin had a hunch that the work still wasn't quite right and although he accepted this explanation at the time – partly due to his fondness for the artist and the work, he continued to have his doubts – some six years later he broached the subject with friends. They too thought it slightly odd and so Baldwin

sought advice from Sotheby's who confirmed, by comparing it against the original in the auction catalogue, that Baldwin did not own the 1996 *Sea and Mirror* painting that he'd commissioned Boone to source on his behalf. So, what painting did Baldwin own?

The truth emerged; Boone had failed to convince *Sea and Mirror*'s owner to sell it. Boone then approached Bleckner and requested him to make another version of the painting and backdate it to 1996. Baldwin subsequently referred to the new painting as a 'copy', but Boone's lawyer Ted Poretz noted that the work was an original by Bleckner. It was; it just wasn't the work that Baldwin had requested to purchase and hand over USD 190,000 for. As an aside, the terminology used throughout the reporting of this case varied. Baldwin referred to his *Sea and Mirror* as a copy. Susan Lehman of *The New Yorker* magazine, by contrast, refers to it as a reproduction.[44] It was in fact an original authentic Bleckner, for the artist had painted it himself, but it was a copy of his earlier work and not the painting Baldwin thought he had purchased or, rather, been sold by Boone. In addition, it was not painted in 1996, even though it was dated 1996, and its inventory number could not have been 7449, given you can't have two paintings with the same inventory number.

Baldwin was conned. Boone clearly saw a window of opportunity to keep her client happy and bank her commission. Unfortunately for Boone, Baldwin called her bluff. Baldwin was later criticised for taking so long to act on his hunch, but perhaps it was his adoration for the artwork – and the artist's oeuvre – that prevented him from pressing for the truth. The time between purchase and discovering the truth doesn't alter Boone's dishonest practice. Baldwin tried to file a criminal case against Boone, but the Manhattan District Attorney's office said this couldn't be done. Boone, perhaps not wanting the case to be dragged through the courts for obvious reasons, offered Baldwin his money back with interest. Finding this unacceptable, on 12 September 2016 Baldwin filed papers with the New York Supreme Court against Boone for selling him a different version of *Sea and Mirror*. The case was settled pre-trial. Baldwin received a seven-figure sum from Boone, of which he planned to donate half to rebuild the Sag Harbor Cinema in the Hamptons that was heavily destroyed by fire in December 2016.[45] Baldwin also got to keep his *Sea and Mirror*, though it is reportedly crated and stored in his basement ready for a lecture tour about art fraud![46] In addition, Baldwin got to commission a new work from Bleckner, who apologised for his part in the scam.

In a bid to please her famous actor client, Boone had let her guard down. Dishonesty and greed cost her. Back in the 1980s Boone was criticised for having some of her artists make works that were inferior in order to supply market demands.[47] Boone continued to represent major contemporary artists as well as selling works on the secondary market, but in 2018 Boone pleaded guilty to two counts of tax evasion and early 2019 saw her sentenced to 30 months imprisonment and 180 hours of community service mentoring New York schoolchildren in a visual arts programme. In March 2019, Boone announced that she would be closing her New York gallery on 27 April 2019. Her plan, once her sentence is served, is to re-launch herself back into the New York art world.[48] In June 2020, during the global Covid-19 pandemic, Boone who was 68 years old, was transferred from prison to a halfway housing office due to the spike in Covid-19 cases at the prison. She had served less than half of her sentence.[49]

What is unusual in the *Sea and Mirror* case, compared with other cases discussed in this chapter, is that Boone involved the artist in the scam, and thus unfairly compromised his reputation. Boone claimed that she had advised Baldwin from the outset that he was receiving a different version of *Sea and Mirror*. He denied this and without a formal written agreement it is difficult to prove either way. As attorney Kate Lucas advises:

> ... careful contracting prior to consummating an art transaction can mitigate the risk of a contentious and costly litigation later.[50]

With the exception of the charity, there were no real winners in this case; Baldwin would have ultimately preferred the original painting he had so admired, for, as journalist Susan Lehman noted, like many lawsuits, this one began as a love story.[51]

Boone is not the only gallerist to dupe a client with a copy made by the original artist. In 2015 art collector Sanjeeva Dissanayake requested the return of his painting by French artist Florent Chopin (b.1958) from London's South Kensington gallery, Envie d'Art. The gallery had been storing it for four years while Dissanayake's home was being renovated. Initially, the gallery had trouble locating the painting but three weeks later made contact to say it had been found at their Paris branch and was available for collection. Dissanayake instantly thought the painting didn't look right. When he got it home he saw the artist had signed and dated it 2014; Dissanayake purchased Chopin's work in 2011, the year it was painted.

Dissanayake was given a copy (with an incorrect date), and not a very good one when compared with the original piece. The differences were far from subtle. A few months later, the gallery manager admitted to having mistakenly sold Dissanayake's painting, for which he'd paid £5000, to another client. When Dissanayake requested its return, the gallery manager panicked and ordered a new one 'in the spirit' to be painted by Chopin. The gallery maintained it was not a copy and went as far as to say it was better than the original.[52] In the end, the gallery compensated Dissanayake but he never saw his original painting again. No doubt someone else purchased the copy, which will complicate matters going forward.

Both dealers put their artists in precarious situations by requesting they copy their own works to fulfil orders. In both examples, the copies were ordered on behalf of a dealer with bad intent. But clients trust dealers and, as Noah Charney noted about the Alec Baldwin case:

> You can argue, of course, that Baldwin should have noticed that he had received the wrong painting much earlier. Even the untrained eye can tell that the two versions of *Sea and Mirror* are different. For someone who carried a copy of the picture in his shoulder bag for years, it is astonishing that he would not have noticed sooner. But such is the faith that collectors have in reputable dealers that such oversights, glaring in retrospect, can happen.[53]

* * *

The cases in this chapter each have a level of deceit or ambiguity around their sales. Underpinning each sale and/or purchase is the amount of money involved in the transaction for an item that was not what it seemed at the point of sale. The Huntington did not know they were selling an authentic Stubbs; Alec Baldwin thought he was purchasing the one and only *Sea and Mirror*; Auckland City Art Gallery though they were acquiring a real Turner; and 'Lord Fraud' earned his moniker. These examples are a drop in the bucket; it is just that they have been unearthed. Money aside, each case highlights our craving and expectations for authenticity. Each purchaser was interested in a work not only for how it looked but also that it was authentic. Discovering that you have purchased a copy (or indeed sold an original that you thought was a copy) doesn't sit well. Having said that, there is nothing wrong with acquiring a copy, if that is your objective.

In recent years, Sotheby's auctions have hosted auctions of Old Master copies. These sales go some way to legitimise copies. They do not pretend to be anything but copies. The transparency is exemplary. Such auctions also acknowledge the role of copies, including specifically how important copying of Old Masters was and that there has always been a market for them. That so many are still about also gives gravitas to the significance of copies. Sotheby's treat the copies they auction with equal respect that they would authentic works; for example, each work has details of its provenance, condition reports and any additional known information about the original work from which it was copied. Interestingly, the copies offered up at auction are made closer to the time of the original Old Masters than, say, nineteenth-century copies. Many are from the 'circle' of an artist. For instance, in the 2017 auction 'Old Master Copies Online: Imitation & Influence', Lot 27 was a copy of *Portrait of Rembrandt's mother* (c.1631). Once thought to be an authentic Rembrandt, the Sotheby's catalogue notes that in 1899 it was exhibited at the Royal Academy, London, in the 'Winter Exhibition: Exhibition of Works by Rembrandt'.[54] The estimated sale price was £8000–12,000. It sold for £9500. Oil paint on oak panel, this work is significant for it is the only copy of a lost Rembrandt.

Separating out the copies in this way has the potential to reduce confusion – and deception – going forward. The sales results show a keen interest for some artists. In a 2018 auction, Lot 71 – a copy of a Canaletto – had an estimate of £6000–8000. It sold for £24,000. The other extreme saw an Angelica Kauffman copy, with an estimate of £2000–3000 sell for the lesser amount of £900.[55] This pales in significance when compared with the 2012 sale of a period copy of *The Concert* by Velázquez, with provenance dating back to the eighteenth century, for £181,250.[56] This was 23 times the auction estimate! Perhaps these two last examples say more about the history of Western art history and gender than the nuances of copying. That aside, there is no shortage of Old Master copies that are auctioned legitimately. Sotheby's 2017 auction was made up of 52 lots and a similar auction in the following year offered 79 lots. By separating the copies from originals, within the context of commercial trading, advances the study of copying giving gravitas to copying as a genre in its own right.

NOTES

1. Radnóti, Sándor, *the Fake: Forgery and Its Place in Art*, Maryland: Rowman & Littlefield, 1999, p. 65.
2. Collection of Mackelvie Trust Collection, Auckland Art Gallery Toi o Tāmaki, New Zealand [M1956/1], oil on canvas, 98.8 × 116.9 × 8 cm.
3. *Dunstanborough Castle, Northhumberland* is in the collection of Dunedin Public Art Gallery, New Zealand [4-1931], oil on canvas, 65.2 × 87.2 × 10 cm.
4. 'Acquisitions', *Auckland City Art Gallery Quarterly*, Number Two, Spring 1956, p. 4.
5. Collection of Auckland Art Gallery Toi o Tāmaki, New Zealand [1955/5], oil on canvas, 33 × 50.8 cm. Inscription: J M W Turner, 1835 (the gallery's website notes the work is undated).
6. 'First Number', *Auckland City Art Gallery Quarterly*, Number One, Winter 1956, p. 2.
7. Collection of the Indinapolas Museum of Art [2000.183], oil on canvas, 61 × 91 cm.
8. Email correspondence with Mary Kisler, Auckland Art Gallery Toi o Tāmaki, New Zealand, 19 July 2019.
9. Butlin, Martin and Evelyn Joll, *The paintings of J.M.W.Turner*, New Haven: Yale UP, 1984, Vol I, p. 129.
10. Purchased from Agnews, London, stock number 0336 on 7 April 1951, 95.2 × 120 cm.
11. Exhibition dates: 14 May to 14 June 1959.
12. John Jacob to P A Tomory, 22 July 1959.
13. '15. The Wreck of a transport ship', *Old Master Paintings from Private and Public Collections of New Zealand*. New Zealand: Auckland City Art Gallery. Exhibition dates: 14 May to 14 June 1959.
14. 'Lord of the manor 'tried to sell fake Lowry for £330,000 at meeting in Ritz hotel', *Daily Mail*, 25 February 2009.
15. 'Art dealer duped by 'aristocrat' conman buys back fake Lowry painting as a souvenir of the scam', *Daily Mail*, 1 November 2010.
16. 'Cheshire Lowry conman ordered to repay more than £1M', BBC, 5 August 2010.
17. Email correspondence with Adam Partridge, 5 August 2019.
18. Ibid.
19. 'Art dealer duped by 'aristocrat' conman buys back fake Lowry painting as a souvenir of the scam', *Daily Mail*, 1 November 2010.
20. Payne, Terry. 'Lowry's paintings are worth a fortune – but can you tell the real ones from the fakes?, *Radio Times*, 5 July 2015.
21. https://www.christies.com/features/LS-Lowrys-A-Northern-Race-Meeting-9534-3.aspx

22. Cook, Roger. *More Dangerous Ground: The inside Story of Britain's Best Known Investigative Journalist.* Sussex: Book Guild, 2007, p. 235. The Mill Pond is signed and dated though the date is difficult to decipher. On the auction listing Bonhams put the date as '19.9'.

23. Lot 00105, Twentieth Century British Art, Bonhams, London, 29 November 2005.

24. This is the painting's full title. On the frame it is titled: *Horses and Groom, G Stubbs R.A., 1789.*

25. Lot 45, 'Living with Art', Christie's, New York, 14–15 June 2016.

26. 'Racing Features For San Marino Ave Planned At Santa Anita', *San Marino Tribune,* 15 November 1962, p. 1.

27. Glass, Nick, 'Experts mistook this masterpiece for a copy – missing out on a small fortune', CNN, 17 March 2017.

28. *Two Hacks* was in 1958 listed as being in the F. Ambrose Clark Collection of Sporting Paintings, New York. Clark was an American heir and equestrian.

29. Egerton, Judy, *George Stubbs, Painter: Catalogue Raisonné,* London: Paul Mellon Centre, 2007.

30. Grosvenor, Bendor. 'Sleeper Alert?', *Art History News,* 16 June 2016.

31. Glass, Nick. 'Experts mistook this masterpiece for a copy – missing out on a small fortune', CNN, 17 March 2017.

32. Grosvenor, Bendor. 'Sleeper Alert?', *Art History News,* 16 June 2016.

33. Brown, Mark. "'Copy' of painting by George Stubbs realed as genuine article", *The Guardian,* 14 March 2017.

34. The Parker Gallery (B12), The Open Art Fair, London, 2020.

35. https://edition.cnn.com/style/article/george-stubbs-two-hacks-painting-found/index.html

36. Email correspondence with Melinda McCurdy, Associate Curator, The Huntington, 30 July 2021.

37. Grosvenor, Bendor. 'Sleeper Alert?', *Art History News,* 16 June 2016.

38. Collection of the Huntington Library, California [2017.20], watercolour and bodycolour on paper, 114 × 58.7 cm.

39. Lot 45, 'Living with Art', Christies, New York, 14 June 2016.

40. Lot 551, 'Contemporary Art Day', Sotheby's, New York 15 November 2007.

41. Illustrated in colour in Bice Curiger (ed), *Birth of the Cool: American painting from Georgia O'Keeffe to Christopher Wool.* Ostfildern: Cantz, 1997, p. 34.

42. Ross Bleckner retrospective was held at the Solomon R Guggenheim Museum, New York, in 1995.

43. Lehman, Susan, 'Alec Baldwin's Legal Tussle Over a Painting', *The New Yorker,* 20 November 2017.

44. Ibid.
45. On 8 November 2017 Alec Baldwin tweeted the news that his foundation would no longer be donating to the Sag Harbor Cinema but rather another East End arts-related charity.
46. Lehman, Susan, 'Alec Baldwin's Legal Tussle Over a Painting', *The New Yorker*, 20 November 2017.
47. Haas, Nancy, 'Stirring Up the Art World Again,' *The New York Times*, 5 March 2000.
48. Sayej, Nadja, 'I feel like a pariah' – how art dealer Mary Boone fell from grace', *The Guardian*, 21 March 2019.
49. Ludel, Wallace, 'Mary Boone released from prison early after facility sees spike in coronavirus cases', *the arts newspaper*, 5 June 2020.
50. Lucas, Kate, 'The Devil's In The Details In Lawsuit Between Alec Baldwin and Mary Boone', Grossman LLP *Art Law Blog*, 2017.
51. Lehman, Susan, 'Alec Baldwin's Legal Tussle Over a Painting', *The New Yorker*, 20 November 2017.
52. Turner, Camilla, 'Gallery sold 'ugly copy' of £5000 painting to fool buyer', *The Telegraph*, 20 March 2015.
53. Charney, Noah. *The Art Thief's Handbook: Essays on Art Crime*, Delaware: ARCA, 2020, p. 35.
54. Exhibition dates: 2 January – 11 March 1899.
55. Lot 73, *The figure of Fame adoring the tomb of William Shakespeare with flowers*, Old Master Copies Online, Sotheby's, London, 13 September 2018.
56. 'Sotheby's annual 'Masters' Week offers replicas of Old Master paintings', *Private Art Investor*, January 28, 2020.

Afterword: Separating the Wheat from the Chaff

A treasured piece of my personal art collection is a large mixed-media work on paper titled *Rooftops, Florence*. Painted in 1959 it depicts, as its title suggests, a view across the higgledy-piggledy terracotta rooftops of Florence. The New Zealand artist Edward Bullmore (1933–1978) lived in Florence for six months during 1959 before heading to London. Bullmore was the subject a major retrospective exhibition I curated in 2008 following years of research and a thesis. So, on many levels, the work is special to me. I was fortunate enough to purchase the painting directly from Jacqueline Bullmore, the artist's widow, in 2007. In 2019, at her funeral, I had a chance conversation with one of Bullmore's daughters. She told me that prior to me acquiring the painting she had a professional photographer come to her house and photograph *Rooftops, Florence*. She had the image printed and it continues to hang on her wall to this day. Clearly, she adores the image (it was her home as a newborn) and having a copy enables her to continue to live with it. I have mixed feelings about this; *my* work has been copied. Yet I have no rights over the work, as the deceased artist's estate retains copyright over his works until 2028. This is the law. Perhaps we are we both winners for this shouldn't be a competition between authenticity and a copy? Or should it? There is no single answer here. One thing, it made me [re]consider how important, and/or valuable, copies are.

When I embarked on this book I was spoilt for choice of copies; there are so many case studies to choose from and different angles to interrogate. I hope I've selected ones that are topical and illustrate the

© The Author(s), under exclusive license to Springer Nature 203
Switzerland AG 2022
P. Jackson, *The Art of Copying Art*,
https://doi.org/10.1007/978-3-030-88915-9_9

motivations for copying, both legitimate and fraudulent. Many of the chapters and themes start out in my homeland of New Zealand. On the edge of what was the British Empire, we certainly have our fair share of copies (still), as do other nations that were once, or still are, tethered to a motherland. New Zealand is as good a place to begin the many conversations around copying.

The motivations for making copies and the roles that they play – which can shift over time – are complex. The quality of copies can vary so much. Measuring quality of art is subjective but when looking at copies – the original next to the copy in particular – they can be measured. Technology enables more accurate copying now but so too does it assist in detecting copies that pose as something else – forgeries. Copying has become more sophisticated, more lucrative and technically more deceptive. Going forward, this will continue to evolve.

From the outset of this project trying to decide which cases to discuss to support the motivations for copying proved tricky; there are many more case studies out there and hopefully in time others will tell them. Just as I reached the end of my research, I found one more copy that I just couldn't leave out. Trailblazing artist Rosa Bonheur's two epic works *The Horse Fair* and *Ploughing in the Nivernais* (discussed in Chap. 6: Copies in Public Collections) have proved popular for copyists. Serendipitously, there is a copy of *The Horse Fair* in the Auckland Art Gallery, just a few hours' drive from my home in the Bay of Plenty, which is a long way from where the painting originated and ended up (see Fig. 9.1).

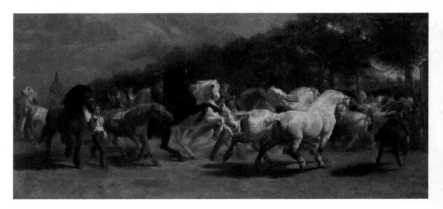

Fig. 9.1 Elizabeth Mary Morton (after Rosa Bonheur), *The Horse Fair*, 1898, Collection Auckland Art Gallery Toi o Tāmaki. (Photo: Auckland Art Gallery Toi o Tāmaki)

Fig. 9.2 Detail of Elizabeth Mary Morton's signature on *The Horse Fair*. Collection of Auckland Art Gallery Toi o Tāmaki. (Photo: Auckland Art Gallery Toi o Tāmaki)

Mary Elizabeth Morton (c.1867–1917) painted Auckland's copy; little is known about Morton apart from she emigrated in 1878 with her family from Northern Ireland and settled with a large Ulster clan at Katikati in the Bay of Plenty. It seems like fate that over a century later I was writing about copies and one of the most revered paintings of the nineteenth century – *The Horse Fair* – was copied by a woman from my neck of the woods. The Auckland Art Gallery's website offered little information about Morton's painting, apart from some physical details and that it was gifted in 1899.[1] Morton clearly signed the painting 'Mary E. Morton after Rosa Bonheur, London 1899' (see Fig. 9.2). Her oil on canvas is just slightly smaller than Bonheur's painting in the National Gallery, London. We know that Morton went to London to study art and, as mentioned in her obituary, she painted a portrait of a famous Australian racehorse called 'Newhaven' while she was there; the racehorse was reported as being in London in February 1898. This places Morton there at the same time. Unfortunately, there are no records or details about copyists at the National Gallery in London where Morton would have made her copy of *The Horse Fair* for those years (registers of copyists are not held for the years 1855 to 1901). Morton returned to New Zealand and continued to paint equine subjects before she died in childbirth. Some might conclude that all these copies brought to the 'colonies' makes us the poor relatives but I disagree; adding to our rich visual culture, they add diversity and depth. In this instance, I don't mind the chaff at all.

As showcased here, there is a huge diversity of copies; the enormity of my study meant narrowing the focus and looking at the motivations behind copying. This was a way of trying to make sense of it all. Though there is an abundance of examples of copies, it doesn't mean there is always an abundance of information about them. My journey was not without

challenges. The main reasons included that some examples were captured under the art crime umbrella and people are not always keen to talk. In addition, especially those copies in public collections are not always the easiest to engage with staff about. Lack of documentation, embarrassment (that 'curatorial burden') and more of a focus on original works can make research about copies slightly fraught.

Copies can hold crucial and essential information for scholars. Classicist Dame Mary Beard (who as an aside has a plaster of Paris copy of a bust of Emperor Vitellius in her study at home)[2] touched on this when she was researching images of Roman emperors.[3] She gave the example of the Ducal Palace at Mantua; Beard visited the 'Room of Caesars', which she described as a shadow of its former self. [4] Arguably, without the copies it would be even further from its original state. The room was designed by Giulio Romano (1499–1546) and contained 11 half-length portraits of Roman emperors painted by Titian (1490–1576) between 1536 and 1540. Commissioned by Federico II Gonzaga, the Duke of Mantua, in 1562 a twelfth portrait by Bernardino Campi (1522–1591) of Domitian was added to the suite. Campi fashioned his from a portrait by Romano. In 1627–8 the suite of portraits was sold to Charles I of England. Then in 1651, after Charles' execution, they were sold to Philip IV of Spain for the sum of £1200. Sadly they met their demise in 1734 when a fire destroyed Madrid's Royal Acazar. Fortunately, beginning in 1561 Campi had made copies of the portraits. Today these hang in the Ducal Palace. Campi made at least four other sets of the portraits to fulfil commissions. And others have copied his work; for example, in 2008 Sotheby's auctioned a set of 11 that were 'After Campi', which, of course, were 'After Titian'. Numerous sixteenth- and seventeenth-century copies in the forms of engravings also exist. Collectively, these copies – in lieu of the burnt originals – provide scholars with a visual record of Renaissance interpretations of 12 Roman Emperors, not to mention Empresses.

Art historian Noah Charney rightly claims a copy may be useful for both scholarship and education. However, he also notes that a copy becomes a forgery when and if it is used to defraud.[5] An excellent example of this dates from 2006 when Tatiana Khan, a West Hollywood art dealer, sold a Picasso pastel drawing titled *The Woman in the Blue Hat* (*La Femme Au Chapeau Bleu*) (1902), to Victor Sands for USD 2 million. At the time, Khan was in her late sixties and owned and operated the Chateau Allegré Gallery in Los Angeles. With the proceeds from the sale she acquired a Willem de Kooning (1904–1997) painting valued at

USD 720,000 and gave Jack Kavanaugh, who had advised Victor Sands to acquire the Picasso pastel drawing, USD 800,000 as a kickback (though he would later to say it was a loan).[6] All was well until 2009 when the owners of the Picasso contacted Enrique Mallen, a Picasso expert and director of the Online Picasso Project and responsible for documenting thousands of Picasso works, for his opinion about their drawing. Mallen categorically came to the conclusion that the drawing was not by the hand of Picasso and he suggested that the FBI investigate it further.

At the time of the sale, Khan told her client that the price tag of USD 2 million was very reasonable and that she was able to let it go for less than its market value as it came from the Malcolm Forbes Estate, who were allegedly keen to keep the sale quiet. Supposedly, the true market value was more in the region of USD 5 million. As art crime writer and director of security for Boston's Isabella Stewart Gardner Museum, Anthony Amore noted, when Khan was subsequently investigated by the FBI she stated that she:

> ... obtained the pastel from a woman named Rusica Sakic Porter around 2005. According to Khan, Porter was an aesthetician she had met when one of her gallery employees visited Porter for a facial across the street from Chateau Allegre. As is the case in many provenance scams, Khan used war to explain the artwork's dicey history, saying that Porter's family purchased the work before the Bosnian War. Khan told [Special Agent Linda] English that Porter borrowed [USD]$40,000 from her and gave her the Picasso as collateral for the loan.[7]

The truth revealed that the pastel drawing was a century newer than Khan led her clients to believe; in 2006 Khan commissioned a duplicate pastel drawing of the original from art restorer and interior decorator, Maria Apelo Cruz (born c.1965) who was very able at duplicating artworks.[8] In one report about the Canadian-born Filipina, Cruz boasted that she could paint almost anything in any style, including Old Master paintings.[9] Cruz duly made the drawing (and was paid USD 1000), thinking that she was assisting Khan's clients who had supposedly had their original Picasso drawing stolen. Khan had ostensibly decided to have a copy made to trick the thief. Cruz would later realise this was a ruse to get her to make the drawing. Khan had the duplicate made under false pretences, falsified the work's provenance, and then went on to sell a copy knowingly as an authentic Picasso.

In 2010, following the investigation, Khan pleaded guilty in the Los Angeles federal court to fraud, making false statements to the FBI and witness tampering. Khan admitted to telling Cruz to lie to the FBI; Cruz was told by Khan to admit to doing the restoration work for Khan, but not to copying art. Khan, aged 70 years by this time, was sentenced to five months' probation, the return of USD 2 million to the purchaser, forfeiture of the de Kooning work and 2500 hours of community service. Arguably, Khan got off lightly given the maximum possible sentence is 25 years (some reports even suggested 45 years) in a federal prison.[10] Khan's web of deceit, and inconsistencies of provenance, came 40 years into her career as an art dealer, a fact that her attorney thought would help her in court. It did not.

The nuance of the original and the authentic was not always significant or part of the bigger conversation about art making. Early in the history of art, contractual arrangements allowed for copies to be made and sold legitimately. It was quite acceptable to acquire copies. Clearly, our attitude towards copies is somewhat prejudiced and has shifted over time. Especially for public art collections; traditionally and contemporaneously there has been an element of snobbery associated with copies. Having the original, the autographed work, of an artist is ultimately the goal for the majority of collectors. I mean that's the point really of art – an individual one-off image or object. But as seen here, it is far from achievable. Private collectors have not been so purist in their attitude towards acquiring copies; King Charles I owned at least 60 copies! Arguably, the justification for copies depends on the intent of the artist, commissioner and the collector.

The seller of a copy also has a role to play in the history of copies. Depending on the seller's intent, they have the ability to 'upgrade' a copy too. Perhaps one of the finest examples of this is the *Hekking Mona Lisa*. In the 1950s art dealer Raymond Hekking based in the south of France, acquired and convinced himself he owned the authentic *Mona Lisa*, and that the one hanging in the Louvre is a copy. His theory was that when the *Mona Lisa* was stolen in 1911 it was swapped out with a copy. Hekking turned his seventeenth-century copy, by an anonymous artist, of the *Mona Lisa* into a career; he built a backstory, including a film about the work, in an effort to convince the art community of his find. So much time and effort went into building the backstory and marketing it that eventually the copy became known as the *Hekking Mona Lisa*. It appears to have changed status; it is now a work in its own right beyond the seventeenth-century copy it started out as. As we know, *Mona Lisa*'s enigmatic smile

has lured copyists en masse over the centuries; in 1952 the exhibition 'Homage to Leonardo da Vinci: exhibition in honour of the fifth centenary of his birth', at the *Mona Lisa*'s home of the Louvre, showed 50 copies of her. In 2021 the *Hekking Mona Lisa* came up for sale at Christie's, who advertised the picture as 'After Leonardo da Vinci, Mona Lisa'. With an estimate of €2–3000 people were blown away when this copy sold for €2.9 million.[11] The descendants of Hekking have now cashed in on his showmanship. Clearly, some copies are collectable. Given Hekking originally paid £3 for the copy, the value has skyrocketed and this has to be attributed to the good job he made of marketing this painting to the world. The *Hekking Mona Lisa* might be chaff, but it's the expensive variety.

How copies are made, collected and viewed is a movable feast. In recent times, within the context of the global pandemic, an example of the inclusion of a copy demonstrated perhaps a slight shift in attitude towards copying. Jonathan Jones, art critic and commentator for *The Guardian*, presented a list of 15 colossal British artworks.[12] The premise was that with the difficulties of travelling overseas during the pandemic, there are huge artworks to be seen closer to home. Somewhat predictably his list included the likes of Damien Hirst's (b.1965) *The Virgin Mother* (2005–6)[13] and Antony Gormley's (b.1950) *Angel of the North* (1998).[14] However, a surprise suggestion was the copy of Michelangelo's *David* at the V&A. He noted that the full-size Victorian plaster cast towers over you just like the marble original; made by Clemente Papi (1803–1875), the plaster copy was gifted to Queen Victoria by the Grand Duke and has been at the V&A since 1856. In a time when travel is limited, making it more complex to see the original easily (and not forgetting the *David* at Florence's Palazzo Vecchio is an 1873 copy by Clemente Papi of the original one sculpted by Michelangelo in 1501–4 on display at the Galleria dell'Academia, Florence), a copy can suffice. The V&A's *David* has his own particular backstory; the V&A's website details the story:

> Our cast of David is perhaps not as famous as the original but is still highly important, as it demonstrates the profound skill and ingenuity of the cast makers and captures the condition of the original marble as it was in 1847, when the mould was taken. X-rays have revealed that the metal rods supporting the legs are arranged similarly to human leg bones and cleverly support the entire figure so that it can stand alone on such a scale. Papi also designed the cast so that it could be dismantled and reassembled, which explains the visible joints.[15]

Although the V&A play down the significance of their *David*, I cannot help but think how interesting the process of art making, and copying is; the complexities of making a plaster cast of this monumental size is fascinating and surely, in my opinion, just as interesting but in a different way from the sculpting of the original marble one.

Transparency is crucial to differentiating the authentic from a copy. In some legitimate cases, there isn't enough information to make such a call. If an artwork is believed to be, and is labelled a copy, is subsequently found to be authentic, then it is a real bonus for the owner, both art historically and monetarily. The opposite can also happen, with the obvious outcomes. However, much to my frustration are the many public institutions that label works by artists, who were clearly not responsible for making them, and yet this information is readily available. Two 'good' examples of this frustration came to my attention during my research. While researching Rosa Bonheur's *Ploughing in the Nivernais* (Chap. 6) I came across a 'version' exhibited in Southport's Atkinson Art Gallery.[16] I say 'version' because it is signed by Bonheur and dated 1842 (or 1849 as the last numeral isn't particularly clear). This then could pre-date the one she painted and exhibited at the Paris Salon in 1849. What a find! Maybe Southport's one was a preparatory sketch for the Salon piece. Its size, 48 × 91.5 cm, could confirm this theory. If the Southport work was 1842, then it would also debunk the long-held theory that Bonheur based her painting on the opening scene of George Sands' novel *La Mare au Diable* published in 1846. But the find was too good to be true; many have researched and written about the Bonheur and to have missed this version is nigh impossible. One email exchange later and it was confirmed that the painting is now catalogued 'after Bonheur'. As is often the case, when J. H. Bell gifted the painting in 1929, it was believed to be an original Bonheur. However, though the attribution has been changed to 'after Bonheur' that information is not available to the public online, at the time of writing, which is my point.[17]

The second example is a J. M. W. Turner painting. When writing about Auckland Art Gallery's copy of *The Wreck* (see Chap. 8) I made the point that its acquisition sat nicely with the other Turner in their collection – *Yachting at Cowes*. This work, as previously mentioned, was acquired the year prior to *The Wreck*. *Yachting at Cowes* is of the same image as Turner's painting in the collection of the V&A titled *East Cowes Castle* of 1827–8 depicting the Royal Yacht Club at the Isle of Wight.[18] What is now evident is that the Auckland painting is a poor copy of Turner's work; it lacks the

finer detail of Turner's work and the application of paint is far looser. However, there is no doubting it is meant to be *East Cowes Castle*. The Auckland painting was made with a pre-primed canvas, indicating a possible date sometime after 1850. A 1979 object report noted an unknown artist painted it, with 'Forged Turner signature' added too. As if this isn't conclusive enough, I think what is interesting is that the gallery paid £75 for *Yachting at Cowes* and yet a year later paid a more realistic market price of £4500 for *The Wreck* (which turned out to be a copy). Surely alarms bells rang in someone's head. But back to my point; *Yachting at Cowes* is perceived as being an authentic Turner for that is what the gallery's online catalogue tells us.[19] Of the four Turners listed in Auckland Art Gallery's catalogue, three are copies (*Child Harold's Pilgrimage* is a copy of Turner's 1832 painting)[20] and an etching/mezzotint *Raglan Castle* (1 January 1816) that was possibly printed by Henry Dawe (1790–1848).[21] The latter is one plate – of which there are numerous copies – from Turner's *Liber Studiorum* (Book of Studies), in which he made the original image with the plates etched by others. This just goes to show that what is presented in online catalogues is not always the most accurate, though admittedly (and rightly so in my opinion) Turner's name is listed second to William Eastwood's (1821–1877) in relation to the production of *Child Harold's Pilgrimage*.

The irony of the Turner copies at the Auckland Art Gallery Toi o Tāmaki is that in the gallery's formative years they had an original Turner in their collection. Listed in the 1885 publication, 'Catalogue of the Mackelvie Collection, for Auckland, New Zealand', is a small work by Turner. Number 27 in the catalogue, the work is titled *View near Plymouth*. Its size is significant for it was an oil sketch on paper made by Turner following his trip to Devon in 1813 where he made oil sketches from nature. Turner made a series of 13 that are now in the Tate's collection; revolutionary at the time, Turner made them in situ as he travelled by foot around the area. His friend, landscape painter Ambrose Bowden Johns (1776–1858) provided Turner with a readymade painting kit so he could paint the instant he saw a vista that took his fancy. What is of even greater significance of the Auckland sketch is the notation in the catalogue entry: 'Accompanied by autograph letter in the pocket at back of frame.'[22] There can be no doubting that this small sketch was by the hand of Turner; the accompanying letter is from Turner to Johns, the original owner of the work. Following his trip to Devon:

... the great painter sent Johns in a letter a small oil sketch, not painted from nature, as a return for his kindness and assistance.[23]

In 1882, James Tannock Mackelvie purchased *View near Plymouth* from Christie's for £39 and subsequently gifted it to the Auckland Art Gallery.[24] I've used the past tense here because the work no longer exists, well not at the Auckland Art Gallery. It hasn't been seen for close to a century and therefore sadly in 2015 was de-accessioned as 'historically missing'.

Researchers rely heavily on institutional websites and expect information to be correct; over the last few decades online catalogues have revolutionised how we research art, artists and collections. And obviously one of the beauties of a digital catalogue is that it can be updated and changed continuously. But some are not always that clear with the information they provide. Take, for instance, the Atkinson Art Gallery's 'Bonheur' as discussed above. I was stripped of a big art historical find when it was revealed to be a copy! More and more we have become reliant on websites for research. There is an expectation that information put online will be correct. In another instance, incorrect online information can cover up a crime. In 2018 Galileo's rare book *Sidereus Nuncius* (*Starry Messenger*) of 1610, an artwork in itself, was reported missing from the National Library of Spain. Four years earlier, book restorers discovered it was a copy. The telltale signs being the book's lack of embossing and that it looked too new. The thief had cunningly swapped out the original, valued at €800,000, for a forged copy.[25] Although armed with this knowledge, the library's website continued to list it as the original until 2018. It took the library four years to file the theft with the police and to date, the book is still missing. Today the catalogue entry lists Galileo's *Sidereus Nuncius* as a reproduction.

Exhibitions are crucial to raising awareness about copying; institutions no longer seem as embarrassed about works in their collections that might not be authentic. Copies can be used, as seen in the many examples in this book, to provide context and educate on many levels. Major galleries and museums have begun to initiate more exhibitions that bring copies, and their foibles, out into the public arena. In the introduction I noted how the small painting *Madonna of the Pinks* was no longer catalogued as a copy, but very much an authentic Raphael. Since its acquisition, *Madonna of the Pinks* has been regularly displayed, including in 'Close Examination: Fakes, Mistakes and Discoveries', an exhibition about artworks in the National Gallery's collection whose status have changed or altered in some way.[26] Art institutions have become better at acknowledging works that

are not authentic; for the most part, exhibitions have tended to focus more on fakes and forgeries than pure copies. One reason for this, especially when celebrity forgers are involved, is that they attract big crowds. If there's a choice between copy and crime, the latter has historically had more pulling power; when art and crime come together, an audience is guaranteed. Such exhibitions are also educative. In 1954 the Salon of Fakes in Paris exhibited no less than eight *Mona Lisas*. Interestingly as early as 1940, the Fogg Museum at Harvard University, had the idea of placing an original artwork next to a fake highlighting, as suggested by art dealer William Casement, who has studied exhibitions of counterfeit art suggested, how originality and creativity are lost in the process of imitation.[27] Exhibitions that demonstrate the confusion between original and others will slowly affect change and bring about hopefully greater acceptance that copies co-exist – both legitimate and fraudulent – in collections. We now have the technology to prevent major acquisition (and de-accession) blunders going forward. Exhibitions will expose more copies and forgeries in collections but each one has a backstory and those are always of interest to visitors.

As discussed, there are copies and there are copies. In some cases a copy is absolutely invaluable, as the original does not exist. One of the greatest female artists ever, Angelica Kauffman's painting *Religion Attended by the Virtues* (c.1799–1801) is now lost and only exists in the form of a contemporary engraving (see Fig. 9.3). The engraved copy of the painting is monochromatic and therefore falls short of replacing the original, but most definitely plays a role in the memory of the image. Kauffman's original painting was a large formal academic work measuring 198.1 × 304.8 cm. It comprises 11 figures painted in the style of the day, Neo-Classicism. It is, in many ways, typical of the artist's oeuvre; as art historian Whitney Chadwick notes of Kauffman's significance:

Kauffman was the first woman painter to challenge the masculine monopoly over history painting by the Academicians.[28]

Described as her most 'complicated of her productions' it depicts Religion seated on a throne holding a cross.[29] Faith, Hope and Charity flank her. The other figures are Devotion, Patience, Joy, Repentance and Peace. This is, or was, a *tour de force*. The finished painting, with others, was sent to England in 1802. Initially, it was part of the National Gallery of British Art that later became the Tate Gallery. James Forbes gifted it in 1835 to the British Museum in anticipation of a National Gallery. By 1913,

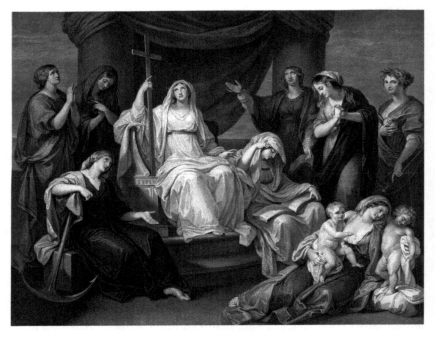

Fig. 9.3 *Fair religion with her lovely train.* Etching/engraving printed in 1812 by William Henry Worthington after Angelica Kauffman's *Religion Attended by the Virtues* (c.1799–1801). Collection of the British Museum. (Photo: British Museum)

Religion Attended by the Virtues was on loan to the Guildhall at Plymouth. It was still there during the firebombing of 1941, but it has not been seen since.

The work, when it existed, was epic in scale, subject and execution. Kauffman was a supreme painter who faced challenges in a male-dominated profession. Kauffman has been revered and studied intensely. But sadly one of her most important works, *Religion Attended by the Virtues*, which has been described as perhaps her final triumph by Tate Britain curator Martin Myrone, is missing.[30] A black and white preparatory 1796 sketch for the painting is held in the Royal Collection Trust.[31] Labelled *Study for Religion Attended by the Virtues*, the drawing is actually of Charity, who was blessed with several children, thought and only did good deeds. In the final painting, and engraving, she holds two infants.

The only visual record of Kauffman's masterpiece, *Religion Attended by the Virtues*, is in the form of an engraved copy.[32] Made by William Henry Worthington (circa 1790 – after 1839), the engraved copy was published in 1812 by Robert Bowyer (1758–1834). It is somewhat smaller at 57.1 × 68.2 cm, but nevertheless has become more significant since the original painting has gone AWOL. In lieu of the painting, the British Museum's etching was borrowed in 1998–9 for a three-venue Kauffman retrospective exhibition. Without it, this ambitious work of Kauffman would not have been represented. The engraved copy cannot replace the original; and much is lost when translating a large colourful oil painting to a monochromatic smaller engraving. At the time of its execution, Kauffman's work met with some criticism, however, as noted in 1924:

The colouring was, however, good, and the actual brushwork careful and satisfactory.[33]

Without the original painting we have no way of commenting on this critique.

In 2018 the Tate Britain made a public appeal in an endeavour to locate the original painting or any knowledge of its whereabouts; though assumed destroyed by a bomb, there is no definitive evidence for this. All records have been lost. Without the engraving, making such an appeal would lack the most vital piece of information, an image. Having the engraving copy has to be a prime example of how significant a role a copy can play.

This book has showcased many examples of copies and discussed the reasons for their existence. Motivations for making copies vary though from a contemporary perspective the most poignant ones for me are those that have political ramifications or will be seen in future as signposts about our time. For instance, copies can be instructional tools with a political message too. John Beard's (b.1943) copies of *The Raft of Medusa* are examples of using the past to try and make sense, or bring about an awareness, of the present and perhaps the future. Many will be familiar with Théodore Géricault's (1791–1824) epic *The Raft of the Medusa*; measuring 4.91 × 7.16 m, it depicted the last of the survivors, arranged in a human pyramidal form, from a shipwreck of 1816.[34] Painted in 1818–19, the work was political at the time for the captain, who had close ties with the Bourbon Restoration government and had not been at sea for twenty years, fought for his own survival and his senior officers as the French Royal Navy frigate *Medusa* sank. Of the original 147 set adrift on

the raft, 15 survivors were eventually rescued by the ship *Argus*, seen on the horizon, but not before resorting to cannibalism. Beard made two copies to scale: one is painted in black and white oils and wax and the other is a mirrored image etched onto a black aluminium sheet to suggest the dark and inky depths of the sea. In 2017, they were hung in The Shed, a gallery space in Galway, Ireland, facing each other with 30 metres in between to give viewers enough space to take them in. Beard refers to his *After The Raft of the Medusa* as reflections and interpretations. Their function is to encourage conversations and debate about how painting has developed over the last two centuries, but you also cannot help but consider the plight of current-day refugees making their way at sea on overloaded rafts and unseaworthy vessels. The addition of 'after' is also loaded. A nod to the two centuries since Géricault put paint to canvas and perhaps questioning how much things have changed, or not.

Géricault didn't make any copies of his own work, though he did have others make at least three in smaller versions. Other copies ended up around the world, including American artist George Cooke's (1793–1849) full-size copy. Too large for the ship's hold, Cooke's version was transported on the deck back to America.[35] Many copies made were scaled down, a technical feat in itself. Géricault's work is recognised for how it changed the course of painting; he took a contemporary incident as his subject, albeit he treated it in a romantic way. No longer did he feel the need to look back in time for subject matter for it was right there on his doorstep. Beard has referenced history with his *After The Raft of the Medusa* and in doing so the iconic image has come full cycle. Banksy also appropriated Géricault's painting; in 2015 on a wall of a building in Calais – not far from the immigration office – he stencilled *The Raft of the Medusa*. On the horizon a modern-day super yacht sails past oblivious to the plight of the refugees heading for Britain in hope of a better life, but who often ended up in the Calais refugee camp known as the 'Jungle'. I've used the term appropriated for Banksy's borrowing of Géricault's famous image but the term 're-purpose' applies equally, especially in the spirit of disseminating a new message. Unfortunately, two years after Banksy made his wall statement, house painters painted over it (the owner decided the building needed a facelift). For the three different artists – Géricault, Beard and Banksy – 'hope' was at the core of their work demonstrating another way of using copies to disseminate a message.

Writing in 1986, British art historian Paul Duro commented about the state of nineteenth-century copying as:

The copy, when viewed as a form of art, is generally considered inauthentic, noncreative, unoriginal, and derivative.[36]

He makes a valid point and certainly what he says is still relevant today; however, I have tried to argue here that copies can and do have other qualities. On the one hand, we should rejoice about some of the copies that have been made over time for they assist us to complete, or make inroads at least, into artist's oeuvres and fill gaps in our visual cultural histories. Much of this book was written during the Covid-19 pandemic. And who would think that copies and pandemics would have any common ground? In 2020 British artist Banksy made an image of a child playing with a toy nurse sporting the International Red Cross, who took on the form of a super hero. Banksy donated the work to the Southampton General Hospital (see Fig. 9.4). Like the pandemic, the image, titled *Game Changer*, went viral. In early 2021, *Game Changer* was auctioned netting a record £16.7 million. The proceeds of the sale were donated to the National Health Service. In hindsight, the sale of the original was an astute move given just two days after the original

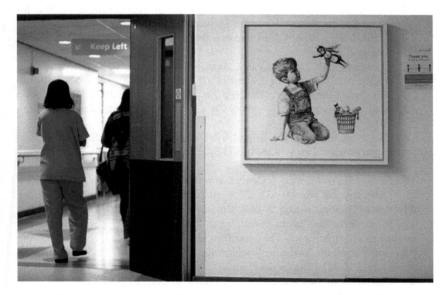

Fig. 9.4 Banksy's original *Game Changer* (2020) painting at Southampton General Hospital. Collection unknown. (Photo: Andrew Matthews/PA Images via Getty Images)

was installed it was 'almost' stolen; a man wearing a hazardous materials suit and carrying a cordless drill was seen loitering near *Game Changer* was fortunately spotted by the hospital's security system.[37] Neither hospital staff, or its visitors, will miss out on seeing the famous image for a copy was made of *Game Changer* for all to enjoy. Categorically, copies made and used with good and legitimate intent play a significant and important role. I can't help but think that perhaps the great Neo-Classical artist Jean-Auguste-Dominique Ingres (1780–1867) was onto something when he stated, 'a good copy is better than a bad original'.[38] Copy that!

NOTES

1. Collection of Auckland Art Gallery Toi o Tāmaki, New Zealand [1899/4], oil on canvas, 101.5 × 216 cm.
2. Some now dispute the identity of the Roman emperor, Vitellius. The plaster copy is of the marble bust (Louvre MR684) made of grey marble dating from the first half of the sixteenth century, which is, was a modern copy of the antique bust dating from the Hadriatic era.
3. Beard, Mary, *Twelve Caesars: Images of Power from the Ancient World to the Modern*. New Jersey: Princeton University Press, 2021.
4. Beard, Mary, 'Where does research time go?', *Times Literary Supplement*, 9 August 2018.
5. Charney, Noah, 'A fake of art', *Aeon*, 5 February 2016, p. 2.
6. Cieply, Michael, 'Media Executive's Father Ordered to Pay $250,000 in Suit Over Fake Picasso', *The New York Times*, 25 May 2012.
7. Amore, Anthony M, *The Art of The Con*. New York: St. Martin's Griffin, 2015, p. 169.
8. To see an image of the forged work visit: https://www.flickr.com/photos/artimageslibrary/4267045785/in/photostream/
9. www.positivelyfilipino.com
10. United States Attorney's Office Central District of California, Press Release Index Release No. 10-078, 27 April 2010.
11. Lot 1, Online Auction 20348, Christie's Paris, 11 June – 18 June 2021.
12. Jones, Jonathan. 'Giant horses' heads and 10-metre sculptures: the massive art to see right now', *The Guardian*, 26 June 2021.
13. Collection of Yorkshire Sculpture Park, England, painted bronze, 1023.2 × 462 × 206.5 cm.
14. Collection of Gateshead Council, England, steel, 20 × 55 m.
15. https://www.vam.ac.uk/articles/the-story-of-michelangelos-david
16. Collection of Atkinson Art Gallery, Southport, England [SOPAG:370], oil on canvas, 48 × 91.5 cm.

17. See: https://artuk.org/discover/artworks/view_as/grid/search/ collectionx:atkinson-art-gallery-collection-1221%2D%2Dmakers:rosa-bonheur-18221899
18. See: https://collections.vam.ac.uk/item/O80862/east-cowes-castle-oil-painting-turner-joseph-mallord/
19. See: https://www.aucklandartgallery.com/explore-art-and-ideas/art-work/2402/yachting-at-cowes
20. See: https://www.aucklandartgallery.com/explore-art-and-ideas/art-work/7929/childe-harolds-pilgrimage
21. See: https://www.aucklandartgallery.com/explore-art-and-ideas/art-work/4426/raglan-castle
22. *Catalogue of the Mackelvie Collection, for Auckland, New Zealand.* Auckland, 1885. https://kura.aucklandlibraries.govt.nz/digital/collec-tion/rarebooks/id/11238, p. 6.
23. Walter Thornbury, *The Life of J.M.W. Turner: Founded on Letters and Papers Furnished by His Friends and Fellow Academicians.* New York: Cambridge University Press, 1862, p. 220.
24. 'Famous Artist's Letter Found In Art Gallery: The History of a Turner', *New Zealand Herald*, 22 April 1913, p. 8.
25. Burgen, Stephen. 'Spain's national library director in bad books over sto-len Galileo treatise.' *The Guardian*, 15 March 2021.
26. Exhibition dates: 30 June–12 September 2010.
27. Casement, William. 'Fakes on Display: Special Exhibitions of Counterfeit Art', *Curator: The Museum Journal*, Volume 58, Number 3, July 2015, p. 336.
28. Chadwick, Whitney, *Women, Art, and Society*, London: Thames and Hudson, 1990, p. 142.
29. 'Memoir of Maria Angelica Kauffman, with a Notice of Her Works', *The Belfast Monthly Magazine*, 30 June 1814, Vol. 12, No. 71, p. 467.
30. Myrone, Martin. Lives of the Artists – Angelica Kauffman, *Tate Etc*, 18 June 2018.
31. See: https://www.rct.uk/collection/917996/study-fornbspreligion-attended-by-the-virtues
32. Collection of the British Museum, London [1872, 0511.195], etching with engraving, 57.1 × 68.2 cm.
33. Manners, Lady Victoria and Dr. G. C. Williamson, *Angelica Kauffman R.A., Her Life and Works.* New York: Brentano's, 1924.
34. Collection of the Louvre, Paris [RF 2229], oil on canvas, 4.91 × 7.16 m.
35. Athanassoglou-Kallmyer, Nina. 'An American Copy of Géricault's *Raft of the Medusa?*,' *Nineteenth-Century Art Worldwide* 6, no. 1 (Spring 2007), http://www.19thc-artworldwide.org/spring07/140-new-discoveries-an-american-copy-of-gericaults-raft-of-the-medusa (accessed June 15, 2021).

36. Duro, Paul. 'The "Demoiselles à Copier" in the Second Empire, *Woman's Art Journal*, Vol. 7, No. 1, Spring–Summer 1986, p. 1.

37. Holmes, Helen. 'Banksy's 'Game Changer' Painting Was Almost Stolen From a UK Hospital', *Observer*, 27 May 2020.

38. Koval, Anne with Jane Tisdale and Adam Karpowicz. *The Art of the Copy*. Canada: Owens Art Gallery, 2009, unpaginated. Exhibition dates: October–December 2009.

GLOSSARY

After A copy of an artwork that is painted after the original authentic work.

Appropriation Re-using a pre-existing image by one artist with little or no transformation applied to them by another artist. An iconic example is Andy Warhol's use of the Campbell's soup can design.

Attribution To suggest an artwork is by a specific artist.

Authenticity Authenticity is a term used by philosopher and critic Walter Benjamin to describe the qualities of an original work of art as opposed to a reproduction.[1]

Autograph An artwork signed by the artist and described as being by the artist.

Bloom A coating that appears on the varnished surface of a painting that has been exposed to damp conditions. Bloom gives a painting a cloudy and dull appearance. It can be removed by a conservator.

Camera obscura A darkened room with a small hole or lens at one side through which an image is projected onto a wall. With a lens in the opening, camera obscuras have been used since the second half of the sixteenth century and became popular as aids for drawing and painting.

Catalogue raisonné A catalogue with every known work by a specific artist. They usually include details about the physical qualities of the work, ownership, exhibition history and provenance.

P. Jackson, *The Art of Copying Art*,
https://doi.org/10.1007/978-3-030-88915-9

Circle of An artwork created by someone associated with the artist, during or in the years immediately following the artist's own lifetime. Sometimes described as a 'follower of'.

Copy A copy is another version of an artwork or object (replica/facsimile). Its subject matter is not original. In some instances, these are used deceitfully; in others, they replace works that are not accessible or too vulnerable to exhibit.

Connoisseur Someone who is very knowledgeable about a particular artist. Prior to scientific and technological advancements a connoisseur could be relied on to authentic artworks. They were seen as an authority of an artist's oeuvre.

Counterproof A counterproof print is made from taking an impression off a wet print; to do this you have to have an etched plate, which is usually made after the original.

Craquelure A network of fine cracks that appear with age in the painted or varnished surface of a painting. Forgers can mimic craquelure by covering an oil painting with shortening and baking it.

Dendrochronology The scientific dating of wood by studying the growth rings of a tree's trunk. Can specifically aid in dating paintings painted on wooden panels.

Edition An edition is a copy or replica of a work of art made from a master. It commonly refers to a series of identical impressions or prints made from the same printing surface, but can also be applied to series of other media, such as sculpture, photography and video.[2]

Electrotype A form of copying using a chemical method for forming metal parts that exactly reproduce a model. Examples of electrotype copies include silverware in the Cast Courts of the V&A.

En plein air The French term *en plein air* means 'out of doors' and refers to the practice of painting entire finished pictures out of doors as opposed to completing a work in the studio. Became popular in the mid-nineteenth century with the invention of tubes for paints and the advent of the railway, particularly in France, meant artists were able to travel and paint more freely.

Facsimile A copy of an artwork that is as close to the original as possible. The use of digital scanning is used today to make facsimile copies.

Fake A fake is something pretending to be what it is not. Fake lawn (looks like the real thing but is not). It is not deliberately made to deceive (though it has the ability to).

Fence Often referred to as a 'middleman', a fence is an individual who knowingly buys stolen goods in order to later resell them for profit.

Forgery A forgery is an object falsely purporting to have both the history of production as well as the entire subsequent historical fate requisite for the original work.

Formatore Someone who makes moulds or models from plaster or wax.

Fraud Fraud is the deliberate false representation of the artist, age, origins, or provenance of an artwork in order to reap financial gain.

Frieze A continuous band that rests on top of the architrave in classically designed buildings, namely temples. They were decorated with relief sculptures.

Hung on the line When the Royal Academy opened in late eighteenth-century paintings were crammed on the walls floor to ceiling. The positioning of a painting was crucial to its, and the artist's, success. The largest paintings, and those considered the most significant, were hung in the most prestigious position along what came to be known as 'the line', about .5 to 1 metre above head height. These works could be easily visible even when the room was crowded. Paintings placed higher up the walls were harder to see and were described as having been 'skyed'.[3] Other art museums followed suit.

Impasto The use of thick paint to create surface texture.

Mahlstick A mahlstick, or maulstick, is a stick with a soft leather or padded head used by painters to support the hand holding the paintbrush.

Metope Stone or terracotta panels inserted between pairs of triglyphs (the vertically grooved member of the Doric frieze) on a Doric temple.

Multiple Refers to a series of identical artworks, usually a signed limited edition made specifically for selling.[4]

Lost-Wax Technique The method of metal casting in which molten metal is poured into a mould that has been created using a wax model. Once the metal is set, the wax model is melted and drained away.

Oeuvre An artist's body of work made over their lifetime.

Painterly The loose application of paint where the brushwork is intentionally visible.

Pastiche The imitation of a style of an artist, a specific artwork or a period/style of art.

Patina A change of a surface through age and exposure. Usually relates to metal sculptures such as bronze, but can be any material.

Pentimenti This is a visible trace of earlier painting beneath a layer (or layers) of paint on a painted surface.

Photomicroscopy High-magnification photography that uses a microscope and then photographs the magnified image. Allows details of paintings to be analysed in minute detail.

Plaster of Paris The material plaster (gypsum) of Paris is a fine white powder (calcium sulfate hemihydrate) which, when mixed with water, forms a white solid. It si called plaster of Paris because the quick-setting gypsum used is found in abundance near Paris.

Plinth A solid sturdy base for a sculpture to be attached to. Also gives the sculpture height to enable better viewing. It is also useful to attach a plaque about the sculpture.

Pouncing Similar to tracing, pouncing is a technique used to copy an image with the aid of a pouncing wheel. Small holes prick the tracing paper and then the image is transferred onto another surface when chalk dust is forced through the small holes.

Provenance The history of an artwork's ownership. Provenance can assist with authentication.

Rendering Visual interpretation through drawing.

Replica An exact copy of an original piece of art. It is virtually indistinguishable from the original.

Reproduction Often refers to a commercial copy of an artwork that involves no original creative input by the maker.

Sleeper A misattributed artwork that, because of the oversight of an expert, is priced far below its actual monetary value. In turn, they are often reattributed and sold on for a large profit.

Slub A knot or thicker part of a thread found in natural fibres used to weave canvas.

Smalt A pigment made of cobalt oxide and molten glass. It is a deep blue colour.

Solander Box Named after the botanist Daniel Solander, this is a book-form case used for storing precious and vulnerable objects. Made of acid-free archival materials for conservation.

Studio of An artwork that is painted in the studio of a well-known artist. In some cases, the artist whose studio it is may have overseen the making of the artwork and may have contributed to it but cannot be attributed full to them. Sometimes they are the work of artists in training. Can also be described as 'workshop of'.

Stanza (pl. stanze) The Italian word for room. Raphael decorated suites of rooms at the papal apartments in Rome known as the: Stanza della Eliodoro, Stanza della Segnatura and Stanza dell'incendio del Borgo.

Style of An interpretation of the artist's style done by another artist at a later date; usually described as 'in the style of' or 'in the manner of' the artist.

Tronie A painting of a person, but not a specific portrait. The sitter often wears costume or makes an exaggerated expression. They were popular in the Golden Age of Dutch Painting. Often art school students painted tronies using the same sitter but in a variety of costumes.

Version An artwork made by the original artist that has been slightly changed.

NOTES

1. https://www.tate.org.uk/art/art-terms/a/authenticity
2. https://www.tate.org.uk/art/art-terms/e/edition
3. https://www.royalacademy.org.uk/article/how-to-read-it-richard-earlom-great-spectacle-summer-exhibition-1771
4. https://www.tate.org.uk/art/art-terms/m/multiple

BIBLIOGRAPHY

CHAPTER 1

Françoise Benhamou and Victor Ginsburgh, *Copies of Artworks: The Case of Paintings and Prints*, in *Handbook of Economics of Art and Culture*, December 2006, Amsterdam: North-Holland, pp. 253–283.
Jo Nesbø, *Headhunters*, London: Random House, 2008.
Heather Straka, *The Asian*, Dunedin: Dunedin Public Art Gallery, 2010.

CHAPTER 2

Ashley, Melissa. *the birdman's wife*. Melbourne: Affirm, 2016.
Burke, Janine. *Australian Women Artists 1840–1940*. Australia: Greenhouse, 1988.
Charney, Noah. *The Art of Forgery: The Minds, Motives, and Methods of Master Forgers*. London: Phaidon, 2015.
Gaze, Delia (ed), 'Copyists' in *Concise Dictionary of Women Artists (first edition)*. New York: Routledge, 2001.
Ginsburgh, Victor A. and David Throsby. *Handbook of the Economics of Art and Culture, Volume 1*. Amsterdam: North Holland, 2006.
Gould, John. *The Birds of Australia*. Published by the author and printed by Richard and John E. Taylor, London, 1840–69.
Greer, Germaine. *The Obstacle Race: The Fortunes of Women Painters and Their Work*. London: Secker & Warburg, 1979.
Harris, Ann Sutherland and Linda Nochlin. *Women Artists 1550–1950*. New York: Alfred A. Knopf and Los Angeles County Museum of Art, 1977.

© The Author(s), under exclusive license to Springer Nature 227
Switzerland AG 2022
P. Jackson, *The Art of Copying Art*,
https://doi.org/10.1007/978-3-030-88915-9

Johnston, Alexa. *femme du monde: Frances Hodgkins.* New Zealand: Dunedin Public Art Gallery, 2009.

McCormick, E.H. *Portrait of Frances Hodgkins.* New Zealand: Auckland University Press, 1981.

Pollock, Griselda. *Mary Cassatt: Painter of Modern Women.* London: Thames & Hudson, 1998.

Preston, Margaret. 'From Eggs to Electrolux' in *Art in Australia*, Third Series, No. 22, December 1927.

CHAPTER 3

Blackley, Roger. 'The Greek Statues in the Museum' in *Art New Zealand*, Vol. 48, Spring 1988, pp. 96–9.

Breen, Laura. 'Dargie's "Wattle Queen": Popular monarchism in mid-twentieth-century Australia', 'reCollections', *National Museum of Australia*, Vol. 6, Number 1, April 2011.

Koh, Tommy and Scott Wightman (eds). *200 years of Singapore and the United Kingdom.* Singapore: Straits Times Press, 2019.

Osborne, Robin. *Archaic and Classical Greek Art.* Oxford: Oxford University Press, 1998.

Wee, Low Sze (ed). *Artist and Empire: (En)countering Colonial Legacies.* Singapore: National Gallery, 2016.

Woodford, Susan. *The Art of Greece and Rome.* Cambridge: Cambridge University Press, 1987.

CHAPTER 4

Ackroyd, Peter. *J.M.W. Turner.* London: Vintage, 2006.

Briefel, Aviva. *The Deceivers: Art Forgery and Identity in the Nineteenth Century*, USA: Cornell UP, 2006.

Charney, Noah. *Stealing The Mystic Lamb: The True Story of The World's Most Coveted Masterpiece.* New York: Public Affair Books, 2010.

Hensick, Teri. 'The Fogg's Copy after a Lost Van Eyck: Conservation History, Recent Treatment, and Technical Examination of the Woman at Her Toilet', *Recent Developments in the Technical Examination of Early Netherlandish Painting: Methodology, Limitations and Perspectives*, Turnhout: Brepols, January 2003, pp. 83–93.

Jackson, Penelope. *Art Thieves, Fakers & Fraudsters: The New Zealand Story.* Wellington: Awa Press, 2016

Musacchio, Jacqueline Marie. 'Infesting the Galleries of Europe: The Copyist Emma Conant Church in Paris and Rome', *Nineteenth-Century Art Worldwide*

10, no. 2 Autumn 2011, http://www.19thc-artworldwide.org/autumn11/infesting-the-galleries-of-europe-the-copyist-emma-conant-church-in-paris-and-rome

Roach, Catherine. *Pictures-within-Pictures in Nineteenth-Century Britain.* New York: Routledge, 2016.

Schabacker, Peter and Elizabeth Jones. 'Jan van Eyck's "Woman at Her Toilet"; Proposals concerning Its Subject and Context', Annual Report (Fogg Art Museum), No. 1974/76, 1974–6, Massachusetts: Harvard College, pp. 56–78.

Waterford, Giles and Timothy Clifford (eds). *Palaces of Art: Art Galleries in Britain 1790–1990.* London: Dulwich Picture Gallery, 1991.

Willoughby, Anne-Louise. *Nora Heysen: A Portrait.* Western Australia: Freemantle Press, 2019.

CHAPTER 5

Charney, Noah (ed). *Art and Crime: Exploring the Dark Side of the Art World.* California: Praeger, 2009.

Charney, Noah. 'Are museums displaying fakes?', 30 March 2020, https://www.msamlin.com/en/chart-hub/english/are-museums-displaying-fakes.html

Conklin, John E. *Art Crime.* Westport CT: Praeger, 1994.

CHAPTER 6

Aston, Dore. *Rosa Bonheur: a Life and a Legend.* New York: Viking, 1981.

Dwyer, Britta C. *Anna Klumpke: a Turn-of-the-century Painter and Her World.* Boston: Northeastern University Press, 1999.

Reed, Tiffany M. 'Elizabeth Gardner: Passion, Pragmatism, and the Parisian Art Market', *Woman's Art Journal,* Vol. 20, No. 2, Fall 1999/Winter 2000, pp. 7–12.

Robertson, Kate. *Identity, Community & Australian Artists: Paris, London, & Further Afield 1890–1914.* New York: Bloomsbury Visual Arts, 2019.

Swinth, Kirsten. *Painting Professionals: Women Artists & The Development of Modern American Art, 1870–1930.* Chapel Hill: The University of North Carolina Press, 2001.

Treves, Letizia et al. *Artemisia.* London: National Gallery, 2020.

Treves, Letizia. *Beyond Caravaggio.* London and New Haven: Yale University Press, 2016.

Quinn, Bridget. *Broad Strokes: 15 Women Who Made Art and Made History (in that order).* San Francisco: Chronicle Books, 2017.

CHAPTER 7

Charney, Noah. 'Museums display perfect reproductions of fragile works and visitors can't tell the difference. Is nothing in art sacred?', *Aeon*, 5 February 2016.

Freeman, Charles. *The Horses of St. Marks: A Story of Triumph in Byzantium, Paris and Venice*. New York: Overlook Press, 2010.

Gombrich, E.H. *The Story of Art*. Oxford: Phaidon, 1978 (13th edition).

O'Toole, Kevin. 'The Hellenic Gallery at the Museum of Perth – Is it a Story of Contested, or of Complementary, Heritage?', *The Rag*, Vol. 2, Issue 4, June 2007, pp. 1–3.

Pyne, Lydia. *Genuine Fakes: How Phony Things Teach Us About Real Stuff*. London: Bloomsbury, 2019.

Sandis, Constantine. 'An Honest Display of Fakery: Replicas and the Role of Museums', Royal Institute of Philosophy Supplements, Vol. 79: Philosophy and Museums: Essays in the Philosophy of Museums, Cambridge University Press, 14 October 2016, pp. 241–59.

Tompkins, Arthur. *Plundering Beauty: A History of Art Crime during War*. London: Lund Humphries, 2019.

CHAPTER 8

Bellavitis, Maddalena (ed). *Making Copies in European Art 1400–1600: Shifting Tastes, Modes of Transmission, and Changing Contexts*. Leiden: Brill, 2018.

Butlin, Martin and Evelyn Joll. *Paintings of J.M.W. Turner* (Vols 1 and 2). New Haven: Paul Mellon Centre for Studies in British Art and the Tate Gallery by Yale University Press, 1984.

Townsend, Joyce H. 'The materials and techniques of J.M.W. Turner: primings and supports', *Studies in Conservation* 39:3, 1994, pp. 145–53.

CHAPTER 9

Amore, Anthony M. *The Art of the Con*. New York: St Martin's Griffin, 2015.

Casement, William. 'Fakes on Display: Special Exhibitions of Counterfeit Art', *Curator: The Museum Journal*, Volume 58, Number 3, July 2015, pp. 335–50.

Charney, Noah. *The Art Thief's Handbook: Essays on Art Crime*. Middletown, DE: ARCA, 2020.

Jackson, Penelope. *Females in the Frame: Women, Art, and Crime*. London: Palgrave Macmillan, 2019.

Jackson, Penelope. *Edward Bullmore: A Surrealist Odyssey*. New Zealand: Tauranga Art Gallery, 2008.

Weiseman, Marjorie E. *A Closer Look: Deceptions & Discoveries*, London: National Gallery, 2010.

INDEX[1]

[1] Note: Page numbers followed by 'n' refer to notes.